Barbara Kruger

Barbara Kruger

Edited by
Peter Eleey
Robyn Farrell
Michael Govan
Rebecca Morse
James Rondeau

Art Institute of Chicago
Los Angeles County Museum of Art
The Museum of Modern Art

DelMonico Books · D.A.P.

Thinking of You
I Mean Me
I Mean You

Essays by
Peter Eleey
Robyn Farrell
Michael Govan
James Rondeau
Zoé Whitley

Additional texts by Hannah Black, Pierre Bourdieu, Keller Easterling, Andrea Fraser, Emma Goldman, Gary Indiana, Fred Moten and Stefano Harney, Georges Perec, Elaine Scarry, Christina Sharpe, Gary Shteyngart, Hito Steyerl, Lynne Tillman, and Eyal Weizman

Selected by Barbara Kruger
with introduction by Rebecca Morse

Los Angeles
6:39 PM PT

LIVE

CNN

REATENS MILITARY CRACKDOWN

6:39 PM PT

PLANS TO ACCOUNT FOR CORON CUOMO PRIME TIM

WHO BUYS THE CON?

New York

March 30–April 12, 2020

THE CHURCHES WILL BE PACKED AND EASTER WILL BE A BEAUTIFUL TIME

NEW YORK

October 31–November 13, 2016

LOSER

And
what he's
already
won.
(Starting on p.28)

$6.99 USA/CANADA

NYMAG.COM

4 5

0 71486 01912 1

GOOD. HAPPY IS SAD. IGNORANCE IS B

WHOSE HOPES? WHOSE

PLENTY SHOULD BE ENOUGH

WHOSE VALUES?

Poor Nations Also Need A Vaccine

Seth Berkley

An outbreak of the coronavirus anywhere is a risk everywhere.

(body text largely illegible)

SETH BERKLEY, *a medical doctor and epidemiologist, is the chief executive of Gavi, the Vaccine Alliance, a public-private partnership that helps provide vaccines to developing countries*

A CORPSE IS NOT A CUSTOMER

BARBARA KRUGER *is an artist who works with pictures and words.*

Adapt Architecture to Nature. Don't Fight It

Matt Shaw

AT Monad Terrace, a new high-end development in Miami South Beach, luxury isn't just about uninterrupted views and a juice bar. The developers behind the 14-floor tower, designed by the Pritzker Prize-winning French firm Ateliers Jean Nouvel, are marketing its readiness to survive the oncoming impact of climate change.

Monad Terrace is "the first luxury condos Miami has seen be built above updated flood and sea level elevations," the marketing material claims. It is "designed to reflect the light and water of its surroundings, while living in harmony with the time and place in which it rises."

We have entered an era when fortification against sea-level rise is a core selling point, a luxury amenity alongside porte-cochère drop-offs, 116-foot swimming pools and hot tubs with views of Biscayne Bay.

At first glance, this might seem like just common sense; some might even praise its nod to climate awareness. But Monad Terrace's version of resiliency is limited. The building is simply lifted above the flood line (and the height of competing developments) to avoid sea-level rise. It does nothing to mitigate the impact beyond the property line — and in fact, a flood-fortified tower in low-lying Miami Beach could make things worse for its neighbors by directing runoff into the already volatile water table.

Taken further, the vision behind Monad Terrace's strategy of resilience is dystopian: As water levels rise, what will happen to waterfront neighborhoods that can't afford similar defenses? What if in some distant future, flood-resilient housing is a luxury affordable only to the privileged few?

Resilience — defending current conditions as a response to climate change, rather than fully adapting to and antici-

pating it — is a slippery concept, and in general it needs to be a part of any climate response. But on its own, it represents an outdated way of thinking, the idea that we can somehow stop or contain the forces of nature. It can also be exclusionary and unjust; if we can never stop or contain nature, we will just deflect it — onto those who cannot afford to get out of the way.

Instead, we should focus on equity-minded climate adaptation, on structural changes that will reimagine new urban futures under climate change. Effective adaptation will protect both the physical environment and the social fabric of neighborhoods.

The problem is that adaptation at scale requires collective action; resilience can mean simply leveraging power. Take, for example, the efforts by Peter Secchia, a Michigan businessman, Republican political donor and former U.S. ambassador to Italy, to secure funds to stop beach erosion along a stretch of Lake Michigan — along which Mr. Secchia happens to own a $6 million summer home. When at first his request failed to get a response, he wrote to lawmakers: "This lack of concern mystifies me. Our property values will diminish greatly" — adding, as if to say the quiet part out loud, "hence, our donations will also diminish."

In California beachfront communities like Pacifica, just south of San Francisco, sea walls are going up to fortify individual homes to protect from coastal erosion. But they come with a cost, disrupting tide patterns and erasing publicly accessible beaches. The plan is controversial, and it has spurred a debate about whether managed retreat — moving inland — would be a more socially and economically viable solution. Needless to say, many opponents of managed retreat stand to benefit from the "resilient" sea walls.

If single homes in Pacifica raise big questions about what to save and how, imagine the difficult decisions when

large, dense cities are forced to triage usable land and limited relocation resources. Or will cities simply wall off financial districts and wealthy neighborhoods, in the name of protecting jobs and the tax base? Could Manhattan below the 14th Street, for instance, be turned into one massive Monad Terrace?

And even if we could do resilience equitably, it comes at an enormous cost — both in dollars and in the opportunity to pursue alternative strategies. Can we buy our way out of the dire situation posed by climate change?

This cynical co-optation can be used to assert economic control over how neighborhoods are built. Like all progressive ideas, resilience rhetoric can be used as a smokescreen to further economic interests that disproportionately affect vulnerable communities, such as minorities, older people and the working class.

In fact, America's entire disaster-response strategy is designed to push back against nature, rather than adapt to it. Federal aid, like the Stafford Disaster Relief and Emergency Assistance Act, aims at recovery to pre-disaster conditions rather than preparedness for weather future storms, further reinforcing the status quo and preventing adaptation at the structural or ecological level.

It doesn't have to be this way. To adapt to climate change, rather than resist it, is a more equitable, sustainable and affordable long-term strategy. It means rethinking and reinventing the urban landscape.

Reject green-washed versions of what is already not working.

Note to the Reader

This catalogue was originally scheduled for release in conjunction with the opening of the exhibition *Thinking of ~~You~~. I Mean ~~Me~~. I Mean You.* at the Art Institute of Chicago on November 1, 2020; however, in the wake of the COVID-19 global pandemic and the closure of our respective museums in March 2020, this exhibition, like many, was postponed by several months. The texts had all been edited and the catalogue designed when we suddenly all found ourselves sheltering in place and working remotely. During that time, no doubt responding to the heightened sense of collective experience and the redefinition of public space that was taking place worldwide as never before, the artist had the idea to open the book with a new suite of images that feature her works in public spaces. These include works published in newspapers and magazines, and televised images of street-facing projects in Los Angeles that bore witness to the anti-racism protests in spring 2020, as well as a photo taken in the aftermath of earlier uprisings, in 1992.

In this way, the book has come to encapsulate numerous "pre-" and "post-" moments that occurred during its making. While the prescience of her work is often remarked upon, Barbara Kruger is not a clairvoyant; she is a committed and sharply observant critic (and consumer) of culture. The continued relevance of her work before, during, and after a period of such enormous upheaval attests to its remarkable balance of topicality and timelessness. The future remains unknown, but it is easy to imagine as we go to press that her questions about power—especially who holds and protects it—will be no less pertinent and no less necessary when the exhibition opens in 2021.

October 2020

Directors' Foreword

Among the most extraordinary artists of our time, Barbara Kruger has consistently deployed a graphic form of public address to question oppression, the concentration of capital, and the abuse of power. For five decades, her practice has been on the front lines of a broader contest of values, insisting that art can be part of an urgent public discourse. This exhibition is Kruger's largest in twenty years, a retrospective by definition, though it refuses a static chronology in favor of a critical reappraisal of her work. More than half the exhibition is new, with iconic pieces being updated and site-specific work being commissioned by each museum. Beginning with Kruger's pasteups of the 1980s, the exhibition disperses into various digital mediums she has experimented with over the years — not so much critiquing new technology as commenting on how we as humans craft cultural engines to shape or anesthetize ourselves.

This exhibition and catalogue were organized in the midst of the global COVID-19 pandemic and the socially transformative uprisings of the Black Lives Matter movement. On April 30, 2020, Kruger published a black-and-white artwork in the Opinion section of the *New York Times* that featured the words A CORPSE IS NOT A CUSTOMER, and in June 2020 her work appeared on the nightly news, the words WHO BUYS THE CON? forming a backdrop against which police lined up handcuffed protesters. Around the same time, in twenty-eight-by-fifty-foot white type on blue, she posed the question WHO IS HOUSED WHEN MONEY TALKS? on the Sunset Boulevard–facing side of the Housing Is A Human Right office (and Rental Affordability Act campaign headquarters). Two decades after her work *Untitled (Questions)* appeared on the side of the Museum of Contemporary Art, Los Angeles's Temporary Contemporary building, asking, WHO IS BEYOND THE LAW? WHO IS BOUGHT AND SOLD? WHO IS FREE TO CHOOSE?…, Kruger continues to ask difficult questions in the context of a public conversation about current issues.

The Art Institute of Chicago, the Los Angeles County Museum of Art (LACMA), and The Museum of Modern Art (MoMA) are honored to co-organize *Barbara Kruger: Thinking of ~~You~~. I Mean ~~Me~~. I Mean You.* Chicago is proud to have played a small but important role in Kruger's early career; she was a visiting professor at the School of the Art Institute of Chicago in 1975 and 1979, and later had three exhibitions of new work at Rhona Hoffman Gallery, in 1984, 1986, and 1990. One of the artist's earliest shows was organized by Carol Squiers in 1980 at New York's P.S.1 Contemporary Art Center — which subsequently became MoMA PS1 — and in 1988, Kruger curated *Picturing "Greatness"* at MoMA, an exhibition of artist portraits that she selected from the museum's photography collection to question "how photography creates prominence, freezes moments and makes history." LACMA's 1985 show *Barbara Kruger: Untitled Works* was the first major West Coast museum exhibition of her work. It also played a significant role in the

museum's history as belonging to the first series of exhibitions organized by LACMA's newly formed Photography Department. Twenty-three years later, when LACMA embarked on its transformative campus expansion with the Broad Contemporary Art Museum (BCAM), Kruger created the building's defining work, the three-story elevator-based *Untitled (Shafted)*, which shapes the visitor experience. Los Angeles has been Kruger's home since 1987, and her work is woven into the fabric of this institution and this city.

As directors of these institutions, we are privileged to present—and in Chicago and Los Angeles, to co-curate—this retrospective thanks to a dedicated team. Robyn Farrell of the Art Institute, Rebecca Morse of LACMA, and Peter Eleey, formerly of MoMA PS1, have expertly realized this catalogue and exhibition, unique to each city. Special thanks go to Ann Goldstein, Deputy Director and Chair and Curator of Modern and Contemporary Art at the Art Institute, whose longstanding commitment to Kruger's work informed the development of this exhibition. Loans from across the globe demonstrate Kruger's wide reach and influence, and are crucial to the success of this presentation. We are grateful to those who have temporarily parted with cherished works so that the public may be given the opportunity to contemplate the impact of Kruger's career. We acknowledge Kruger's previous association with Mary Boone Gallery, and we thank Kruger's gallerists, Monika Sprüth and Philomene Magers of Sprüth Magers, Cologne, and David Zwirner, New York, for their assistance with facilitating loans.

We offer our deep appreciation to the generous donors who have made this exhibition possible. In Chicago, lead funding was generously provided by Liz and Eric Lefkofsky. We also thank The Andy Warhol Foundation for the Visual Arts, Margot Levin Schiff and the Harold Schiff Foundation, Shawn M. Donnelley and Christopher M. Kelly, Constance and David Coolidge, and the Auxiliary Board Exhibition Fund for their major support, and Helyn Goldenberg and Michael Alper and the Susan and Lewis Manilow Fund for their additional support. Members of the Luminary Trust provide annual leadership support for the museum's operations, including exhibition development, conservation and collection care, and educational programming. The Luminary Trust includes an anonymous donor; Neil Bluhm and the Bluhm Family Charitable Foundation; Jay Franke and David Herro; Karen Gray-Krehbiel and John Krehbiel, Jr.; Kenneth C. Griffin; Caryn and King Harris, The Harris Family Foundation; Josef and Margot Lakonishok; Robert M. and Diane v.S. Levy; Ann and Samuel M. Mencoff; Sylvia Neil and Dan Fischel; Anne and Chris Reyes; Cari and Michael J. Sacks; and the Earl and Brenda Shapiro Foundation. In Los Angeles, the exhibition is part of The Hyundai Project at LACMA, a joint initiative between Hyundai Motor Company and LACMA since 2015.

Kruger will integrate new works into our buildings and onto our façades, bringing her messages out of the gallery space to the wider public. This in some sense represents a full circle. Kruger has always thought in terms of architectural space and the built environment, and installations in Chicago, Los Angeles, and New York will allow visitors familiar with and new to her work to move through and react to her direct addresses—lingering in this "triple immersion of pleasure, resistance, and commentary" she has developed over almost fifty years.

James Rondeau
President and Eloise W. Martin Director
The Art Institute of Chicago

Michael Govan
CEO and Wallis Annenberg Director
Los Angeles County Museum of Art

Glenn D. Lowry
The David Rockefeller Director
The Museum of Modern Art, New York

UP IS GOOD
BAD IS DOWN

ANYTHING GOES
TRUTH IS FICTION

ANYTHING GOES

NOTHING IS TRUE

TRUTH IS FICTION

RIGHT IS WRONG

DENIAL DISSENT DELIGHT DOUBT DISGUST DESIRE

THIS IS ABOUT LOVING AND LONGING. ABOUT SHAMING AND HATING. ABOUT THE PROMISES OF KINDNESS AND THE PLEASURES OF DOING DAMAGE. THIS IS ABOUT CRAZY DESIRE AND HAVING A GIFT FOR CRUELTY. THIS IS ABOUT THE DIFFERENCE BETWEEN THE FIGURE AND THE BODY. ABOUT THE FICKLENESS OF RENOWN. ABOUT WHO GETS WHAT AND WHO OWNS WHAT. ABOUT WHAT IS REMEMBERED AND WHAT IS FORGOTTEN. HERE. IN THIS PLACE. THIS IS ABOUT YOU. I MEAN ME. I MEAN YOU.

... WORLD OF HURT.
... FOR THE MOMENT.
... BECOMES CONTEMPT.
... ING ONE ANOTHER.
... NING ONE ANOTHER.
THE WAR FOR ME TO
... I MEAN ME. I MEAN YOU.

WHO OWNS W

SM IS REACTIONARY SCARY DEADLY.

THIS IS ABOUT LOVING...
SHAMING AND HATING. ABOUT...
OF KINDNESS AND THE PLEASU...
DAMAGE. THIS IS ABOUT CRAZ...
HAVING A GIFT FOR CRUELTY...
IS ABOUT THE DIFFEREN...
THE FIGURE AND THE BODY...
FICKLENESS OF RENOWN. ABOU...
AND WHO OWNS WHAT. ABOUT W...
AND WHAT IS FORGOT...
THIS IS...

The Work Is About: On Barbara Kruger's (Re)Play in Space

Robyn Farrell

1
Miwon Kwon, "A Message from Barbara Kruger: Empathy Can Change the World," in *Barbara Kruger* (New York: Rizzoli, 2010), 90.

A puzzle piece floats from the center of the pile to the upper-right corner of the frame. As if guided by a magnetic pull, two more follow suit, accompanied by the distinct sound of a computer mouse's click. Then another piece travels to the opposite corner, followed by three more, and so on until each finds its place. Once formed, the puzzle reveals Barbara Kruger's *Untitled (Your body is a battleground)*.

Originally produced as a poster for the Women's March on Washington in 1989 — in support of abortion rights as established in 1973 with *Roe v. Wade*—Kruger's image features a bisected portrait of a female face, the exposure half-positive and half-negative. The face stands in for the iconic and symbolic body, and its division renders embattlement formally, tonal contrast underscoring the Manichean dualism of this debate. The conceit of the body as a contested site speaks to the experience of many whose civil liberties continue to be challenged today. By using the pronoun *your*, the artist implicates the viewer, regardless of gender, in the objectification of this anonymous person. And the specificity of the image somehow serves to enhance the anonymity of Kruger's chosen pronoun. As art historian Miwon Kwon explains:

Kruger doesn't instruct us on what position to take so much as reveal how positions are made: what we take to be our naturally or innately personal positions and identities are, in fact, publicly constructed. Her work demands that each of us recognize the fact that our identities and positions, our mark of difference from one another in terms of gender, class, race, age, religion, etc. are defined within the structuring powers of language, image and space, that is, cultural systems of representation.[1]

Kruger deploys her images throughout such systems of representation. In looking at the lineage of *Your body* … we see how she translates the same text-and-image combination to the different contexts in which it is displayed. In addition to the poster for the Women's March and several 1990 works — a Berlin subway poster; posters in Warsaw, Poland; and a billboard commissioned by the Wexner Center for the Arts in Columbus, Ohio — Kruger also produced *Your body* … as a nine-by-nine-foot silk-screen-on-vinyl work (1989), which is in the collection of the Broad Museum in Los Angeles. Today, the iconic image continues to proliferate across social media and on screen-printed T-shirts around the globe. The artist also revised the iconic phrase to YOUR BODY IS STILL A BATTLEGROUND in an image for the *New York Times* op-ed page. On the occasion of *Barbara Kruger: Thinking of ~~You~~. I Mean ~~Me~~. I Mean You.*, the artist's first solo museum exhibition in the United States since 1999, Kruger has animated the iconic work with new associations for the twenty-first century. Displayed at the same dimensions as the vinyl and amplified by the latest LED technology, this 2019 iteration also features the same, now-universal image of protest, but just as the animated puzzle pieces align, the text starts to

2

Barbara Kruger, *Remote Control: Power, Cultures, and the World of Appearances* (Cambridge, MA: MIT Press, 1993), 40.

3

Barbara Kruger, quoted in Marcia Froelke Coburn, "Kruger's Art Talks to 'You,'" *Chicago Tribune*, October 24, 1986, https://www.chicagotribune.com/news/ct-xpm-1986-10-24-8603200203-story.html.

Fig. 1: Still from the video version of *Untitled (Your body is a battleground)*, 1989/2019

shift, moving through ten phrases in Kruger's signature white Futura Bold Oblique font. Among these are YOUR WILL IS BOUGHT AND SOLD (fig. 1), MY BODY IS MONEY, MY BELIEFS ARE SHORT AND SWEET, YOUR HUMILITY IS BULLSHIT, YOUR NECK IS SQUEEZED, and YOUR SKIN IS SLICED. The video both retains the power of its original message and expands its trenchant cultural commentary, offering an array of declarations for the current fame-obsessed, social-media-driven attention economy, even while many of our personal freedoms continue to remain at risk.

This work, along with four other animated "replays," as the artist calls them—*Untitled (I shop therefore I am)* (1987/2019); *Untitled (Remember me)* (1988/2020); *Untitled (Admit nothing/Blame everyone/Be bitter)* (1987/2020); *Untitled (Our Leader)* (1987/2020)—uses Kruger's earlier work as source material, injecting it with contemporary wordplay. In borrowing from her own works, Kruger is rethinking and remaking in a way that does not entrench chronology but instead confounds the conventional temporal unfolding of a "retrospective" by looking at the philosophical and physical institutions that inform our daily lives.

For five decades, Kruger has been a keen critical observer of the way images circulate through culture. The meaning of her works is always contextual, informed by the specific site and moment of their presentation. Although best known for black-and-white images superimposed with text, the artist for over three decades has presented her ideas

in three-dimensional form as well, including large-scale room wraps, multichannel videos, and installations on building façades. The urgency of Kruger's work, as it migrates from printed surface to screen and from interior to exterior walls, lies perhaps less in its graphic immediacy than in the ways it is continually "replayed" in the present:

> There is no doubt that video technology has enlarged both the performative and spectatorial aspects of our lives and transformed us all into either actors or viewers simultaneously. It permeates the social fabric, changes the feel of our human contacts, and rearranges the choreography of family affairs, sexual forays, and gatherings of all kinds. The video camera has indeed replaced the mirror as the reflection of choice, putting us in a constant state of either watching or being watched, and transforming the emancipatory notion of "play" into the relentless realm of "instant replay."[2]

The artist's choice of words in 1990, as well as her taking the word *replay* to describe the aforementioned new series of video works, initiates the shifting subjectivities of power and place that have marked Kruger's career. Kruger's "replays" and other recent work featured in the exhibition examine the accelerated flow of images and words through contemporary culture.

Who Speaks? Who Is Silent?

How we experience images and the way they shape culture are central concerns in Kruger's practice. Born in Newark, New Jersey, in 1945, she attended the School of Art at Syracuse University in 1964, studying art and design with Diane Arbus and Marvin Israel at Parsons School of Design in New York the following year before accepting a position at Condé Nast in 1966. Part of the first generation to grow up with television, Kruger also considers her exposure to pop culture a major influence: "Basically my education was the experience of how we receive images—through movies, billboards, TV—and how those images work in today's culture."[3] Both her personal media literacy and her time in art school aided Kruger as a page designer and picture editor at *Mademoiselle* and *House & Garden* magazines, where she received firsthand experience in the conception, creation, and circulation of consumer culture, learning strategies that commanded attention within

the economy of page design. At the time, the technique for physically arranging a page's contents was that of manual "cut and paste," a method professionally known as "pasteup" that would in fact motor the artist's conceptualization and crafting of content throughout her career:

> When I did layouts, the copy hadn't been written yet. So I'd use photographs that I'd pick and crop and mock type. It wouldn't say anything, just big lines of ABCDEFG. So in many ways I see my work now as being a substitutional activity, giving meaning to something which was, at first, meaningless and, secondly, where the meaning was supplied by someone else.[4]

Kruger's tenure at Condé Nast also led to her preferred graphic typeface: the bold yet simple letterforms of Futura Bold Oblique or Helvetica Ultra Compressed. She chose sans-serif fonts for their readability and, as she has said, because "they could really cut through the grease."[5] Kruger carried the Futura Bold and Helvetica typefaces with her into independently designed projects like posters and book covers, as well as into her emerging art practice that began with appropriated black-and-white photographs superimposed with text.[6] Included in the exhibition as the earliest examples of Kruger's work, her "pasteups" (1980–92) provide fundamental insight into the artist's conceptual framework and creative process. They show the analog cut-and-paste aesthetic ubiquitous to commercial design and reveal her photomechanical method for producing the iconic work we know today. Kruger's "pre-digital" works—as she now calls them—tackle monumental topics like gender, class, race, economy, history, desire, voyeurism, and fact vs. fiction on a small, concentrated scale.[7] YOU DESTROY WHAT YOU THINK IS DIFFERENCE. YOUR FACT IS STRANGER THAN FICTION. WE ARE NOT MADE FOR YOU. YOUR GAZE HITS THE SIDE OF MY FACE. Kruger's biting statements poke at the very identity-shaping media-sphere that she had most recently trained in—but also that we all still reside in. Exposing the insidious power structures and cultural divides of late capitalism, the pasteups are as relevant in our digital age as they were forty years ago.

She then shifted to the large-format chromogenic and digital prints for which she is most widely recognized. These iconic montages of image and text (1988–present) offer seductive images and provocative phrases, such as WHO SPEAKS? WHO IS SILENT? DO I HAVE TO GIVE UP ME TO BE LOVED BY YOU? IT'S OUR PLEASURE TO DISGUST YOU. "My work is about how we are to one another," the artist often says, exposing notions of belief and doubt, kindness and cruelty, and humor and empathy inherent to the human condition but also subject to the vagaries of technology. Relatively recent works, *Untitled (Truth)* (2013) and *Untitled (Feel is something you do with your hands)* (2020) are born of our contemporary moment, one that is characterized by fleeting attention spans, "Bravolebrities," and mis-/disinformation from both the media and the highest offices of political power. In both works, Kruger presents hands—twisting the word TRUTH and placed atop a skeletal X-ray, respectively—as stewards of a message that resides in the tactile culture of "likes" and "personal truths" that obfuscate facts and numb feelings.

This initial transition from small analog arrangements to large-scale chromogenic and digital prints as well as commissioned work in magazines was prompted by her access to and flexibility within print media. The exhibition thus charts each material development within her oeuvre. For example, Kruger first produced *Untitled (It's our pleasure to disgust you)*—a black-and-white image of a nude woman wearing a gas mask and nailed to a cross with white text layered atop her body—in pasteup form in 1982, following it up with a large, framed version, which was remade again in 1991 for an installation at New York's Mary Boone Gallery, and an additional work with a blue background and horizontal format. The artist, as we have seen, is still remaking works, often in new mediums.

Forever

"I think architecture is one of the predominant orderings of social space. It can construct and contain our experiences. It defines our days and nights. It literally puts us in our place."[8] In the mid-1980s, Kruger shifted her focus to include public space—in works ranging from public service announcements that aired on the Spectracolor light board in New York's Times Square in 1983 and appeared on bus placards in Atlanta in 1985, to a billboard at Navy Pier for the Chicago International Art Expo in 1986. By the close of the decade, Kruger was creating immersive environments with large-scale text directly on the gallery floor, underfoot, at Fred Hoffman Gallery in Santa Monica, California (1989); Rhona

4
Kruger, quoted in Coburn, "Kruger's Art Talks to 'You.'"

5
Barbara Kruger, "On Barbara Kruger," *Artforum* 51, no. 1 (September 2012): 94.

6
Ann Goldstein, "Bring in the World," in *Barbara Kruger*, exh. cat., ed. Goldstein (Los Angeles: Museum of Contemporary Art; Cambridge, MA: MIT Press, 1999), 31.

7
Pre-digital was also the title of Kruger's 2009 solo exhibition at Skarstedt Gallery, New York.

8
Barbara Kruger, "Interview with Barbara Kruger," by Lynne Tillman, in Goldstein, *Barbara Kruger*, 189.

9
Barbara Kruger, "A Conversation with Barbara Kruger: Spaces, Phrases, Pictures, and Places," by Beatriz Colomina and Mark Wigley, in *Barbara Kruger: Believe + Doubt*, ed. Yilmaz Dziewior (Bregenz, Austria: Kunsthaus Bregenz, 2014), 125.

Fig. 2: *Untitled (Forever)*, 2017, installation view, Amorepacific Museum of Art, Seoul, 2019

Hoffman Gallery in Chicago (1990); and the Kölnischer Kunstverein in Cologne, Germany (1990), and covering walls and the ceiling of Mary Boone Gallery in New York (1991). If Kruger's early work interrogated the complex strategies of messaging from the perspective of the page, this new turn enveloped the viewer physically and psychologically within the rhetoric of images and idioms.

The process by which Kruger conceives a site-specific installation begins with her own quick, intuitive response to a space: "All the work is done in my head anyway.... I walk into a space and pretty much know how I'm going to engage that space."[9] Such is the case with *Untitled (Forever)*, which will wrap the galleries at each venue to which *Thinking of ~~You~~* travels. First produced in part as a lobby installation at the UCLA Hammer Museum in Los Angeles (2014) and later enlarged for the artist's 2017–18 solo exhibition at Sprüth Magers in Berlin, the work is adaptable to a range of spaces, evidenced most recently by a monumental presentation at Amorepacific Museum of Art in Seoul, South Korea (fig. 2). Emblazoned on two opposing walls in a direct address to the visitor was the word YOU. This enlarged pronoun is also the first word of an excerpt from Virginia Woolf's *A Room of One's Own*,

which continued on each of the room's other two facing walls. [YOU] KNOW, they both read, THAT WOMEN HAVE SERVED ALL THESE CENTURIES AS LOOKING GLASSES POSSESSING THE MAGIC AND DELICIOUS POWER OF REFLECTING THE FIGURE OF MAN AT TWICE ITS NATURAL SIZE. Meanwhile, text on the floor announced, IF YOU WANT A PICTURE OF THE FUTURE, IMAGINE A BOOT STAMPING ON A HUMAN FACE—FOREVER; the phrase is taken from George Orwell's *1984*, a text that Kruger has included in numerous works, including *Untitled (Past, Present, Future)*, an installation commissioned by Amsterdam's Stedelijk Museum in 2010 and acquired by the institution in 2012 (fig. 3).

In Chicago, Kruger will also reprise a work adapted from the prose of French West Indian philosopher Frantz Fanon (1925–1961), *Untitled (Blind Idealism Is...after Franz Fanon)*, which reads, BLIND IDEALISM IS ~~REACTIONARY SCARY~~ DEADLY. Fanon's original phrasing, "Blind idealism is reactionary," addresses, as do Kruger's additional adjectives, the enduring necessity of contextual responsiveness. Installed across the expanse of Griffin Court's floor at the Art Institute—the main thoroughfare of the museum's Modern Wing—this text is visible from multiple angles and heights, both to visitors moving over/alongside it and to those

Fig. 3: *Untitled (Past, Present, Future)*, 2010, installation view, *Taking Place*, Stedelijk Museum Amsterdam, 2010–11

10
Kruger, "A Conversation," 134.

11
Kruger, "A Conversation," 134.

12
Kwon, "A Message," 94.

at rest in the mezzanine café above. Kruger's chosen siting of the revolutionary's message thus transfers it from the "space" of political discourse to an institutional, and literal, space. But like so many of her text works, this one too has had many previous lives. The artist made this work as a 2007 lithograph, using Fanon's quotation in unedited form for a newspaper project with the *Guardian* that same year; the amended text appeared in a 2013 vinyl and in New York's 2016–17 High Line commission (fig. 4).

The polemicism and publicness of Kruger's installations—site-specific works that address both architectural and relational space—have brought her recognition as a public intellectual.[10] Although the artist does not consider herself in this way, she has described herself as a kind of choreographer who arranges images and text in space:

I think I try to be vigilant about the ways in which power is threaded through the everyday. It makes me stop and focus, even for a second. And I think this plays out in the difference between the separate works and the installations. When images were framed and placed in a white space, we go from one to the other to the other whereas in the more immersive work your body is more implicated or I think a better word would be positioned.[11]

Kwon describes the impact of Kruger's environments on the viewer, who is "force[d]… to experience in a visceral way the queasy feelings that accompany the recognition of one's own smallness, pettiness, prejudice, lust, arrogance, greed, ignorance, anger, fear, and powerlessness."[12] Moreover, Kruger always seeks to fit into not only architectural but cultural contexts, translating her texts into the language of the country in which a work is installed. That she does so speaks to her continuous process of remaking, but also stems from her desire to imbue her work with empathy and a clear message. Recent examples include *Untitled (No puedes vivir sin nosotras / You Can't Live Without Us)* (2018), for a mural commission on an abandoned grain silo in Puerto Madero in Buenos Aires, Argentina, and her incorporation of hangul, the Korean alphabet, into Korean versions of *Untitled (Plenty should be enough)* (2018) or her new work *Please laugh Please cry* (2019), installed in her 2019 exhibition at Amorepacific.

The accumulation of the artist's immersive iterations speaks to the textual and temporal malleability of the work and to the fluid

Farrell　　The Work Is About

13
Kruger, "On Barbara Kruger," 94.

14
Kruger, "On Barbara Kruger," 94.

15
Barbara Kruger in *Picturing Barbara Kruger*, directed by Pippa Bianco (Los Angeles: Los Angeles County Museum of Art, 2015), video, 5:26, https://vimeo.com/111582602.

16
Kate Linker, *Love for Sale: The Words and Pictures of Barbara Kruger* (New York: Harry N. Abrams, 1990), 76.

Fig. 4: *Untitled (Blind Idealism Is . . . after Franz Fanon)*, 2016, a High Line commission, installation view, High Line, New York, 2016–17

dispersion of her style and rhetoric across space and the bodies that are contained by it. Kruger's art for the consumer—including magazine covers, T-shirts, mugs, tote bags, sunglasses, and even skateboard decks—ensured a captive and wide-ranging audience. No matter the site or material, Kruger's self-proclaimed "preference for commercial and industrial formats" is a primary driver in her production. As the artist explained in 2012, such formats "are incredibly effective at graphically communicating an idea.... I like that my work retains its identity regardless of size or medium. Of course this means it also lends itself to easy reuse by other people, but I'm fine with that."[13]

In taking advantage of mass media, Kruger has ensured her continuous presence in the cultural landscape. Among those who have adopted her style are, for example, the designer brand Supreme, Instagram, and Mamamoo, an all-girl pop band from South Korea. Such pirating is inherent to our overshared, oversaturated moment, but Kruger sees intellectual property as mainly a euphemism for corporate control, and a futile one at that.[14] As she put it, "The way my still images have traveled online in various forms—done by myself and other people—is

satisfying and amusing to me."[15] This shuffling has been a recurrent theme in Kruger's work, but in recent years she has explored the mobility of her own images, more specifically image likeness, with the appropriation of her "style" both IRL and online. In 2011 the artist was invited to participate in an exhibition titled *That's the Way We Do It. Techniques and Aesthetic of Appropriation* at the Kunsthaus Bregenz in Austria, for which she produced a two-hundred-foot-long wall vinyl that reprised *Untitled (I shop therefore I am)* (1987). However, instead of holding a placard with the now-famous phrase, the work's giant black-and-white hand presented a compilation of 550 Google images that reflected the artist's aesthetic, turning her "look" into a brand/style itself. Kruger is inevitably implicated in such proliferation as well. As early as 1990 Kate Linker elucidated how the artist's mimetic strategies, tactics of production, and frequent use of red frames commodify her own images, "announcing their market status and pointing to the market as the irrefutable condition that no object—least of all art—can evade."[16] The explosion of Kruger's images in this 2011 installation tipped closer to acceptance than to advocating for regulation. A visual retort to the pervasive pilfering of her aesthetic on

Fig. 5: View of *Barbara Kruger: Power Pleasure Desire Disgust*, Deitch Projects, New York, 1997

17
Kruger, "On Barbara Kruger," 94.

18
Kruger, "A Conversation," 140.

19
Kruger experimented with time-based media in the slide performance *Seven Minutes in the Bathroom* (1979) and *Messages to the Public* (1983); the artist attributes her later cinematic turn to her 1985–90 TV Guides column in *Artforum*, which focused on film, television, and music. Her first moving-image production, a collaboration with director Mark Pellington, emerged from a commission for MTV's Silence the Violence campaign in 1993. The piece combined an audio countdown with found black-and-white images and red-on-white text that stated, EVERY 15 SECONDS A WOMAN IS BEATEN IN THE U.S. In 1996 Kruger explored televised mass communication further with her PSA project, which emerged from a residency in the Film/Video Studio Program at the Wexner Center for the Arts (which subsequently provided support to include the PSAs in this exhibition). Recorded material for the Heide Museum of Modern Art, Melbourne, Australia, and Deitch Projects iterations of *Power Pleasure Desire Disgust* (1997) was also produced during Kruger's residency.

20
Power Pleasure Desire Disgust premiered as a single-channel installation in Melbourne. This preceded the expanded, three-channel version that opened Deitch's space in 1997. It was also Kruger's first video installation.

a global scale, Kruger's appropriation of her own appropriated style raises questions about art and authenticity/authorship in the digital age and about the alarming rate of proliferation of visual information we are exposed to every day.

That's the Way We Do It

Kruger has said, "I don't believe that you can stop the flow of images."[17] Instead, she is creating work that adapts to "the dispersion and aerosol immersion of the internet" that have permanently altered the ways in which we see and experience the world.[18] For *Thinking of ~~You~~*, she has reprised the Google-sourced image iteration from Bregenz in a work that additionally borrows that show's title: *Untitled (That's the way we do it)* (2011/2020) features prominently in Chicago and L.A., repeating as well as extending the tidal wave of white-on-red Futura riffs found on the World Wide Web. Situated within the same space as the artist's new "replay" *I shop…*, Kruger's image morphs from wallpaper surface to LED screen as the text superimposed on the iconic card-holding hand is animated with each "cha-ching" of a cash register. With phrases that move from I SHOP THEREFORE I AM to I SHOP THEREFORE I HOARD, I LOVE THEREFORE I NEED,

and so on, Kruger revisits her hallmark phrase aligning consumption with identity while mocking the emotional compulsion bound up in the mechanisms of the consumer industry. The pairing of these two works, which simultaneously replicate and parody the strategies and maneuvers of commodity production and sale, propels the artist's thirty-year-old concept into an echo chamber that feels specific to the devices and the egos of the second decade of the twenty-first century.

Kruger is keenly aware of how cinematic language can spark interest and sustain attention, and she has long employed editorial and directorial techniques to construct the viewing experience. Having worked with and written about media since the late 1970s, Kruger credits her residency at the Wexner Center in Columbus as a key transition point in her practice.[19]

In her early multichannel installations Kruger experimented with the enveloping environment of her spatial wraps and cinematic conventions to produce an immersive experience of image and sound. In 1997, she debuted her first multichannel video installation, *Power Pleasure Desire Disgust* (fig. 5), for the inaugural exhibition at Deitch Projects at 18 Wooster Street, New York.[20] The artist described the space as a cacophony

21
Barbara Kruger, "Interview with Barbara Kruger," by Claire Bishop, *MAKE: The Magazine of Women's Art*, 90 (December 2000): 10.

22
Martha Gever, "Like TV: On Barbara Kruger's Twelve," in *Barbara Kruger*, 121.

23
Homi K. Bhabha, "Double Visions: 'Circa 1492,'" *Artforum* 30, no. 5 (January 1992): 88.

24
Gever, "Like TV," 121.

25
Shot/reverse-shot is a film technique where one character is shown looking at another character, and then the other character is shown looking back at the first character. Since the characters are shown facing in opposite directions, the viewer assumes that they are looking at each other.

26
David Frankel, "Barbara Kruger: Mary Boone Gallery/Deitch Projects," *Artforum* 36, no. 6 (February 1998): 88.

27
Marshall McLuhan coined/introduced the phrase "The medium is the message" in his 1964 book *Understanding Media: The Extensions of Man*. McLuhan proposed that a medium itself, not the content it carries, should be the focus of study. He said that a medium affects the society in which it plays a role not only through the content delivered over the medium, but also through the characteristics of the medium itself.

28
Linker, *Love for Sale*, 76.

Fig. 6: *The Globe Shrinks*, 2010, installation view, Sprüth Magers, Berlin, 2010

of pictures and people talking, and the experience of inhabiting it as akin to "being inside a movie."[21] Kruger produced the environment with over one hundred slide-projected texts and three twenty-foot-long tunnels, each housing a single video channel of "talking heads" declaring emotive phrases, such as "You're not cool enough!" "You're not loved enough!" "Who do you think you are?" Martha Gever compared the experience of watching Kruger's 2004 video *Twelve*—a four-channel installation that positions the viewer between large projections of reality-TV-like characters delivering dramatic dialogue on various themes—to that of "being inside a TV set and, after spending time inside, being left with a peculiar perspective, as if the place just exited is where televisual representations coincide with ordinary life."[22] In these works and *The Globe Shrinks* (2010), Kruger approaches exhibition design with the same precision with which she approached her pasteups from the 1980s. The twelve-minute four-channel video installation fills the gallery walls from edge to edge, juxtaposing cultural theorist Homi K. Bhabha's declaration that "the globe shrinks for those who own it"[23] with divergent vignettes of a stand-up comedian, a road rage incident, prayer gatherings, and textual quips like SHOVE IT, DOUBT IT, and BELIEVE IT (fig. 6). Similar to *Twelve*, this installation projects a cross section of interpersonal relations, teetering between teleplay and reality TV.[24] Indicative of the artist's multichannel video works, *The Globe Shrinks* oscillates between opposing projections, utilizing shot/reverse-shot[25] editing and episodic scenarios that punctuate both live action and word interplay on various screens. Although Kruger includes seating as part of the installation's design, the visitor's point of view is more fluid than static: One must literally move through the space, adjusting the direction of one's vision, to fully experience each scene. The work's inclusion in the exhibition stands as an example of the artist's multifaceted approach in addressing and positioning the viewer in relation to the on-screen activity.

In David Frankel's review of Kruger's simultaneous exhibitions at Mary Boone Gallery and *Power Pleasure Desire Disgust* at Deitch's space in 1997, he wrote, "Attention paid was rewarded."[26] At the time (in the 1990s), access to mainstream viewers and the mass reach available through television's broadcast network allowed for a McLuhanesque[27] extension of the artist's practice and was the ideal mode for her direct address. Today Kruger adjusts for audiences with shrinking attention spans. She often speaks about her own short attention span as an attribute rather than a flaw. Knowing that a visitor can walk away at any time, she has employed temporal choreography to elicit attention and pique interest at varying points in her works. We see this with Kruger's LED works, like *Untitled (Your body is a battleground)* (1989/2019), which disperses and recollects an image with overlaid messages. The crescendo of timed video loops, engineered to play at varying times, positions the gallery as a stage, embodying, as Kate Linker defined it, "manipulation through display," which "manifests itself in [the artist's] control over construction, distribution, and reception of information."[28]

With her new body of video work—video replays, single- and two- channel animated texts, multichannel projections, and a selfie installation—Kruger employs multiple modes of address through visual and temporal strategies that situate the viewer both in- and outside of media, blurring the roles of actor and witness within each installation. This approach elicits an overall sense of anticipation and readied attention in the viewer. In her series of videos featuring white text on red screens *Pledge*, *Will*, and *Vow* (all 1988/2020), Kruger rolls through the traditional language of a final will and testament, marriage vows, and the Pledge of Allegiance. Once again, Kruger animates new work from old forms, but in this case she deconstructs and disrupts familiar phrasing with jarring adjustments such as I PLEDGE ALLEGIANCE TO THE FLAG OF THE UNITED STATES OF AMERICA AND TO THE REPUBLIC / RESENTMENT / RETRENCHMENT/RESILIENCE / RESISTANCE / REPUBLIC FOR WHICH IT STANDS / FALLS / FAILS / SURVIVES / STANDS.... Installed together in the same gallery, the three flat-screen works perform a temporal unfolding as one, two, and then all three play simultaneously, imploding the senses and concepts of superiority and privilege through a cacophony of words and sound. Activated from the original iterations that preceded them, these videos play with the words that define us and our relationships to others and to our culture.

Thinking of ~~You~~. I Mean ~~Me~~. I Mean You.

Today, we might understand the smartphone as the nexus of advertising and capitalist culture; certainly it is the primary tool via which we receive and transmit information.[29] Kruger wrote about the flattened space of such personal yet collective screens in 2011, deeming us all "exhibitionists and voyeurs." Indeed, "online picturing and confessing and showing and telling constantly remind us that we are nearly unable to experience the moments of our lives unless it's done in front of or behind a lens or on a screen."[30] *Untitled (Selfie)* (2020) puts this observation to work: Outside its gallery, a declarative text states, PLEASE DO NOT ENTER UNLESS YOU CONSENT TO BE PICTURED WHILE PICTURING. A PHONE/CAMERA IS NEEDED FOR ENTRY. THANKS. Inside, two walls are covered in wallpaper that reads, respectively, I HATE MYSELF AND YOU LOVE ME FOR IT, and I LOVE MYSELF AND YOU HATE YOU ME FOR IT. This work is about social media and the body and the endless effort to craft ourselves for virtual likes (and lives). It's about attention

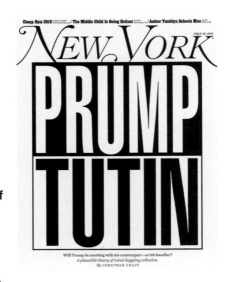

New York **magazine cover, which appeared on the July 9, 2018, issue and in postings throughout New York City**

spans that wax and wane and our own images of perfection. Meanwhile, the footage captured in the gallery will be broadcast elsewhere—in or outside the museum. But to avoid the all too frequent exploitation of bodies and their picturing, the entry text suggests that it's the viewer's choice whether or not to allow their image to be circulated. Kruger reprised this work's wall text from her cover design for the May 1992 issue of *Esquire*, overlaying on a close-up black-and-white portrait of radio personality Howard Stern the words I HATE MYSELF AND YOU LOVE ME FOR IT on the front cover and I LOVE MYSELF AND YOU HATE ME FOR IT on the back. In her essay on Stern, Kruger described him thus: "Zigzagging between self-degradation and megalomania, political clarity and dangerous stereotyping, temper tantrums and ridiculously humble ingratiation, he is both painfully unsettling and crazily funny."[31] Accurately describing Stern, Kruger's text also represents (and skewers) the cultural zeitgeist of social media influencers and posters/posers today.

"I'd like my work to be a visual contribution to the discussions that determine the way we live our lives."[32] In a culture obsessed with the act of looking and being looked at, Kruger poignantly and humorously questions our contemporary collision of narcissism and voyeurism. Sliding from video and photomontage to text, public installations, and, most recently, bandanas and masks, Kruger's maneuvers decode and deconstruct the messaging that mass media and social technologies perpetuate. The means by which Kruger addresses

29
Linker, 76. Linker wrote that Kruger writes about advertising advancing "the home as the nexus of receivership, relocating visual and commercial reception."

30
Kruger, "A Conversation," 132.

31
Barbara Kruger, "Prick Up Your Ears: The Raging Riffs of Howard Stern Are So Funny They Make Us Scream," *Esquire*, May 1992, 95.

32
Kruger, "A Conversation," 140.

33
Barbara Kruger, email to the author, September 2019. This text was at that time newly written for the east wall of The Donald B. and Catherine C. Marron Atrium at The Museum of Modern Art, New York.

Mask designs by Barbara Kruger. **BETTER SAFE THAN SORRY produced by the Museum of Contemporary Art, Los Angeles; SIGN LANGUAGE produced by the Wedel Art Collective; SAY DON'T SPRAY produced by Visionaire. All 2020**

and antagonizes structures of value and power reach a zenith in her new video installation *Untitled (No Comment)* (2020). Like her *Selfie* installation, the ten-minute multichannel work explores the notion of being present and mediated presence in our digital existence. As the video unfolds, it mimics the path of an aimless surfer online. From scrolling type set to a soundtrack of particularly prominent speech patterns to a cat lip-synching to the powerful melodic hook of the Lady Gaga hit "Shallow" and photos of polarizing political figures, Kruger provides the visual language for our "world in shambles," as the video describes it. The artist also includes texts and images from past and present work, many of which relate to works included in the exhibition, as well as Instagram posts of people posing in front of her work. Confusing and conflating conventions of media, spectatorship, pop culture, and politics, *No Comment* serves as an essay on the life of her work and on our contemporary lives online. In this way, the video is the artist's "visual contribution" to the ongoing cultural commentary, mining the themes at play throughout her career.

Kruger addresses many of these themes explicitly through her video *Untitled (The work is about…)* (1979/2020). She has said that the work, installed as a single-channel projection in *Thinking of ~~You~~*, is about a host of topics and does not necessarily refer to her own work, but to art practice in general, as characterized by MONEY AND THE VELOCITY OF POWER… THE FRAME AND THE CONFINES OF ARTICULATED SPACE… DISLOCATION AND THE SUBVERSION OF THE HABITUAL… SHOPPING AND THE IMAGE OF PERFECTION, and so on. Situated near the entrance or exit of the exhibition, depending on the show's iteration, the video tracks in part the underlying issues of Kruger's nearly five-decade career in her signature white Futura Bold Oblique text scrolling across a black screen, highlighting each title line — THE WORK IS ABOUT — in red. The artist once again leans into appropriation, replaying her own work, as variations of this text appeared as early as 1979 (with the original title *Job Description*), in an issue of *Cover* magazine, and nearly thirty years later for her 2008 elevator shaft installation, *Untitled (Shafted)*, for the Renzo Piano–designed Broad Contemporary Art Museum (BCAM) at the Los Angeles County Museum of Art, and even her latest video, *No Comment.* The exhibition's title similarly illuminates the why and what of her work. A play on the title of the artist's 1999 retrospective *Thinking of You* and the November 2010 *W* magazine cover featuring the artist's signature words IT'S ALL ABOUT ME, I MEAN YOU, I MEAN ME superimposed over a photo of reality-TV star Kim Kardashian, *Barbara Kruger: Thinking of ~~You~~. I Mean ~~Me~~. I Mean You.* is about identity and ego, and how people bring their own backgrounds and contexts into the work. Kruger wants to demonstrate how the reader generates meaning each time the text is read. The artist expands on this framework in one of the exhibition's installations, in which she states:

THIS IS ABOUT LOVING AND LONGING. ABOUT SHAMING AND HATING. ABOUT THE PROMISES OF KINDNESS AND THE PLEASURES OF DOING DAMAGE. THIS IS ABOUT CRAZY DESIRE AND HAVING A GIFT FOR CRUELTY. THIS IS ABOUT THE DIFFERENCE BETWEEN THE FIGURE AND THE BODY. ABOUT THE FICKLENESS OF RENOWN. ABOUT WHO GETS WHAT AND WHO OWNS WHAT. ABOUT WHAT IS REMEMBERED AND WHAT IS FORGOTTEN. HERE. IN THIS PLACE. THIS IS ABOUT ~~YOU~~. I MEAN ~~ME~~. I MEAN YOU.[33]

Kiss-and-Tell Justice: Barbara Kruger and Statuary

James Rondeau

The author acknowledges the significant contributions of Alex Jen in the writing of this essay.

1
Barbara Kruger, interview with the author, October 8, 2019.

2
Hannah Black, "Clout Theory: Hannah Black on Roy Cohn," *Artforum* 58, no. 4 (December 2019): 201–3.

3
The gallery walls were painted gray to allow the gleaming white statues to come starkly into focus.

"I can go into any medium and speak about the abuse of power."[1]
—Barbara Kruger, 2019

"Hypocrisy isn't ethically important, but it can be dazzling."[2]
—Hannah Black, 2019

Barbara Kruger works on the brink of saturation. Refocusing the ordinary or advertorial—a grainy mushroom cloud, a face-palming stockbroker, a tray of frosted cakes—the artist renovates found images just enough to introduce anxiety into their innocuity. Kruger uses direct address: GIVE ME ALL YOU'VE GOT, demands the pink cursive from the corners of her 1986 collage featuring the aforementioned confectionary bait. Harmonizing with the pastel sweetness, the letters turn affirmation into confiscation, snapping viewers out of their glazed-over acceptance of advertising's enticements.

Kruger has long weaponized her early professional education in magazine design, zeroing in on products and their proliferation, dismantling the fictions that inculcate our ubiquitous, monotonous desire for novelty and approbation. From the beginning, the artist has exposed the morals, vices, and personas—the human qualities—behind this greed. Her enduring subject is power as product, in terms of both the anonymous collective machinations of social control and its accumulation and abuse by singular worthies.

In 1997 Kruger took a detour into a self-consciously historicized mode of saturation: commemorative statuary. For a solo exhibition at New York's Mary Boone Gallery, she created four fiberglass renditions of American notables in compromising situations. The operation of fame and its attendant shame was clear, but the life-size figures appeared at the time to be a disjunctive departure from her cool and flat graphic practice. Classicizing in their bright white finish, the statues—not sculptures, Kruger specifies—are titled *Good/Evil*, *Justice*, *Faith*, and *Family* and render, respectively, a Janus-faced sex doll opposite a completely shrouded woman, Roy Cohn and J. Edgar Hoover kissing energetically, Jesus Christ and Santa Claus dazed from excess, and John and Robert Kennedy hoisting an exposed Marilyn Monroe like a cheerleader (fig. 1).[3]

In *Justice*, Hoover places his hands gingerly on Cohn's back; Cohn, in turn, cups Hoover's balding head as he tilts in to kiss him (fig. 2). The folds in both men's suit jackets suggest passionate movement. Cohn is depicted wearing an American flag skirt with his high-heeled right leg kicked back in a campy stock gesture played out in early Hollywood romantic comedies and iconized, perhaps more sincerely, as an amorous trope in Alfred Eisenstaedt's 1945 photograph *V-J Day in Times Square*. The couple's initials are etched in a heart on the sole of Cohn's shoe, and the men stare into each other's wide-open eyes. Their intimacy betrays an attentive, almost alert offensiveness.

Justice, along with the other statues, is irreverently satirical and obvious in a way that

4

The gamble led her to pull the one work that was not a portrait, *Good/Evil*, from the exhibition a few weeks before its opening. "I think [*Good/Evil*] was incredibly threatening to some people.... [It evoked] the war for a world without women." Kruger, interview. *Good/Evil* was only exhibited on one other occasion: in Kruger's 1999 retrospective at the Museum of Contemporary Art, Los Angeles.

5

Kim Levin, "Absolute Kruger," *Village Voice*, November 18, 1997, 107.

6

David Frankel, "Barbara Kruger: Mary Boone Gallery/ Deutsche Projects," *Artforum* 36, no. 6 (February 1998): 88.

7

Frankel, "Barbara Kruger," 88.

8

Barbara Kruger, "Interview with Barbara Kruger," by Lynne Tillman, in *Barbara Kruger*, exh. cat., ed. Ann Goldstein (Los Angeles: Museum of Contemporary Art; Cambridge, MA: MIT Press, 1999), 195–96.

Fig. 1: View of *Barbara Kruger*, Mary Boone Gallery, New York, 1997

Kruger's previous work, though incisive, had not been. This group of objects also marked the first time the artist had focused so heavily on the proper noun as subject and, synchronously, moved beyond themes of public perception and stereotype to directly confront conspicuous political and cultural figures.[4]

Contemporary reviews of the exhibition mostly fixated negatively on this turn to figuration. Kim Levin of the *Village Voice* called the works "totalitarian deco extravaganzas...as spurious as the carved reliefs on the Warner Brothers store next door."[5] David Frankel, writing for *Artforum*, said their "surfaces were uninvolving and their points quickly graspable."[6] Frankel did posit that Kruger's statues were "miscast as gallery work," suggesting that they would have been better if seen "unexpectedly and in passing" in a public space.[7] Indeed, the artist initially intended to situate them outdoors in a "dense, urban setting" in order to question how we recognize public heroes. As she told Lynne Tillman in a 1999 interview, "I mean, you can spend a lifetime walking past public monuments and not give them a thought. But commemorative statues are really such

Fig. 2: *Justice* (detail), 1997

a loaded convention, tied to myth-making, narratives, and histories."[8]

An adjacent gallery at Mary Boone held four nine-foot-square individual vinyl portraits of Andy Warhol, Marilyn Monroe, Malcolm X, and Eleanor Roosevelt, each emblazoned with a pejorative epithet: NOT CRUEL ENOUGH, NOT STUPID ENOUGH, NOT ANGRY ENOUGH, NOT UGLY ENOUGH (fig. 3). Here, Kruger taps into a more piercing social critique to show how the mockery of public figures can range from

Fig. 3: View of *Barbara Kruger*, Mary Boone Gallery, New York, 1997

puerile to caustic, twisted, and vengeful. If the statues attempt to derail our cravings for purity through a lens of gossip and slapstick, the vinyl works operate more brutally, distilling the rabidity of public expectation to its illogical ends. Reading NOT UGLY ENOUGH across Roosevelt's face or NOT DEAD ENOUGH below a solemn portrait of Malcolm X is petrifying; these pictures move past denunciation into a deeper, existential deconstruction.

In the mid- and late 1990s, Kruger was not alone in examining the cruel calculus of authority and ignominy. Similar interests can also be traced in the work of artists as various as Cady Noland, Tom Otterness, and Lisa Yuskavage, which can help us to recover the concerns around power and representation as they appeared in the cultural slipstream of the moment. If the latent obscenity of celebrity, major and minor, in the Boone works models how fixation becomes appraisal, this is a subject that Noland also trenchantly identified at the time.[9] In a 1994 exhibition at Paula Cooper Gallery in New York, Noland memorialized in one work the auspicious moment in Wilbur Mills's career when he announced his 1972 presidential run — before stripper Fanne Foxe bolted from his limousine, jumped into the Tidal Basin on the National Mall, and torpedoed his reputation. Noland took the Arkansas congressman's campaign poster — poised countenance, bold Pepsiesque lettering, and all — and applied it to sheets of honeycomb aluminum small and large, the partially tarnished plates smudging and eroding his forgotten image (fig. 4). Roberta Smith called Noland's exhibition a "newspaper morgue file writ large," not for any tragic reason, but rather because it was so "mired in pettiness, false morality and the collective forgetfulness that, as [George] Santayana pointed out, enables history to repeat itself."[10]

Granted, Noland recuperated lapsed material, while Kruger confronted what was then more conspicuous (today, also, superannuated) fodder.[11] Noland's matter-of-fact revelations operate on the mechanics of public shame, whereas Kruger's more editorial, if burlesque, satires caricature the very act of moral hypocrisy. *Family* calcifies the Kennedy brothers' tawdry perfidies, and *Justice* Cohn's and Hoover's dissembling sexualities. "I was trying to break down the sanctity around the rallying calls for 'Justice' and 'Family' and deal with the complex contradictions of public and private lives. Of how

9
Noland and Kruger both showed in SoHo in the 1990s, when the New York art world was still concentrated there. Kruger's work was also included alongside press photos of gruesome accidents and the work of Peter Nagy, Steven Parrino, Wallace & Donohue, and Sherrie Levine to illustrate Noland's important essay "Towards a Metalanguage of Evil," first published in *Balcon*, no. 4 (1989): 70–85.

10
Roberta Smith, "Dark Side of the American Psyche," *New York Times,* April 8, 1994, C23.

11
Trashing celebrities is a temporary fix for feeling stuck in anonymity, but Noland goes deeper by addressing the human obsession with ascending the hierarchy of importance. What does it take to become famous? Something outrageous, violent enough for the media to notice. Bruce Hainley astutely recognizes how Noland's work consistently deals with the "unbreachable differences" between social classes in America, particularly the normal and the famous. Bruce Hainley, "Cady Noland: Museum^MMK für Moderne Kunst," *Artforum* 57, no. 10 (Summer 2019), https://www.artforum.com/print/reviews/201906/cady-noland-79927.

12
Kruger, "Interview," 196.

13
Yuskavage expanded on this precarious narrative by painting the models, tracing their engorged breasts, impossibly arched backs, and swollen eyes, closed like a newborn's, with a lambent, alluring edge. Of the *Bad Habits* series (1996–98), she remarked, "In going from painting to painting I was 'recasting' my characters every time. I had to get to know them one by one and understand what they mean." Referencing Rainer Werner Fassbinder and Tintoretto's wax figures, Yuskavage said, "I could have kept working on that series forever but I made myself stop. I realized that as an artist I was about more than that, so I forced myself to move on." Yuskavage, "In the Studio: Lisa Yuskavage," interview by Jarrett Earnest, *Art in America*, September 30, 2015, https://www.artnews .com/art-in-america/features /in-the-studio-lisa-yuskavage -63113/.

Fig. 4: View of *Cady Noland*, Paula Cooper Gallery, New York, 1994

narrative, innuendo, and fact accumulate into something that is called 'history,'" Kruger told Tillman.[12]

The humor in Noland's sculpture is both dark and abstruse, several notches above Otterness's and Yuskavage's grafting of vulgar buffoonery onto conventions of traditional figuration to advance self and social critique. Otterness, one of America's most prolific public artists, was a founding member of the New York activist artists' group Colab, along with Jenny Holzer, Kiki Smith, and others in Kruger's circle. His anthropomorphic bronze farces of human greed and futility adorned parks and courthouses across the country, and in September 1997, he had a solo exhibition of models from recent commissions at New York's Marlborough gallery, concurrent with Kruger's Boone show. In those works, figuration also operates as a vehicle for tragicomic representations of opprobrium. *King* and *Queen* (both 1997), blown up from Otterness's classical chess set series, tower over scenes of debauched bureaucracy, the former bulging in a too-tight three-piece suit and the latter bedecked in a pearl necklace. The artist's figures, here and elsewhere, are effective in their accessibility, thinly veiled

vignettes discomfiting in their seeming triviality. Both *King* and *Justice* begin in lampoon but diverge: Otterness takes the ribald route of a graphic satirist, and Kruger stays concentrated on Cohn's and Hoover's vindictive, canting self-delusion.

Although Yuskavage is best known for sardonic paintings of unclothed women that lure viewers through stages of garish unease, for her October 1996 exhibition at Boesky & Callery Fine Arts in New York, she, too, momentarily pivoted to sculpture in a semiclassicizing vein. In a skylit back room, she clustered on a pedestal ten dysmorphic figurines, all approximately a foot tall, eyes closed in ecstasy and humiliation (fig. 5). Brilliantly and collectively titled *Asspicking, Foodeating, Headshrinking, Socialclimbing, Motherfucking Bad Habits* (1996), the curios personify an uncouthness that became funny, then glorious, in its subversion of dainty expectation.[13] Yuskavage pursued a certain vulnerability in these statues. As in her paintings, she arrested a complicated discomfort alongside a willful complicity with misogyny, especially as it is self-internalized. In a conversation with Claudia Gould, the artist explained, "I am a great deal more empathic

Fig. 5: Lisa Yuskavage, *Asspicking, Foodeating, Headshrinking, Socialclimbing, Motherfucking Bad Habits*, 1996. Cast hydrocal with artificial pearls and artificial flowers; five pieces: dimensions variable. Courtesy of the artist and David Zwirner

than ironic toward the paintings. I think you can see that if you look at the light and how they are painted. I don't work from an elevated place looking down; if they are low, then I am in the ditch with them, and by painting them, I am trying to dig us out together."[14] Yuskavage evinces both solidarity and compassion. Kruger, on the other hand, knowingly risks the occupation of an empathy-free zone.

Returning to Kruger's *Justice*, it is imperative—today, as much or more so than it was for audiences in 1997—to excavate Cohn's and Hoover's biographies, as well as their prehistories in the artist's cultural orbit and oeuvre. *Justice* is among numerous portrayals of Cohn's life and personality that sprouted up after his death in the form of biographies, plays, and movies. Perhaps most salient is Tony Kushner's *Angels in America: A Gay Fantasia on National Themes* (1991–92), an epic cycle that made bitterly clear the moral consequences of Cohn's repeated denial of both his homosexuality and AIDS.[15] Another, more focused interpretation of his character emerges in *Roy Cohn/Jack Smith* (1992), a one-man double

portrait conceived and performed by Ron Vawter, and cowritten by Gary Indiana and Jack Smith, at the Museum of Contemporary Art, Los Angeles.[16] In the play, Cohn delivers a jaundiced speech to the fictional American Association for the Preservation of the Family right before the experimental filmmaker Smith drones on about the art of acting as a debilitated pharaoh (fig. 6). Obviously, the two were opposites, yet the piece holds together in its consideration of repression and self-hatred in the face of larger social persecution. Critic Sylvie Drake regarded the work as "restless, even irritable." She continued, "Yet from behind the words, the fuss, the phrases, the sighs and silences, a touching composite emerges: that of a deeply anguished, deeply dissatisfied man at sixes and sevens with himself and the unaccommodating world."[17]

In 1986, the year Cohn died, Kruger made *Untitled (Roy toy)*, which pictures a glaring Bengal cat with a large piece of meat in its mouth, and the words MAKE MY DAY jammed into the bottom-left corner. A tiny, arrogant portrait of Cohn peers from above, playfully

14
Lisa Yuskavage, "Screwing It On Straight," interview by Claudia Gould, in *Lisa Yuskavage*, exh. cat. (Philadelphia: Institute of Contemporary Art, University of Pennsylvania, 1999), 10.

15
In a lighter turn—and one that most mirrors Kruger's caricature in *Justice*—Kushner also wrote a one-act sketch titled *G. David Schine in Hell*, first published in the *New York Times Magazine* in 1996 as "A Backstage Pass to Hell." Hell is a dinner theater in Orange County, California, complete with Andrew Lloyd Webber medleys playing in the background, and all of Cohn's quirks are on display. One imagines his gruff delivery as he sticks his finger in a fellow gentleman's drink to taste it, only to find out the banana daiquiri belongs to an aged G. David Schine. Cohn rambles along, later demanding that Schine change back into "the gorgeous rich boy for whose sake I nearly sank the anti-Communist movement!" He's wearing an "aggressively busy plaid red-green-heather-and-mustard dinner jacket" with matching bow tie and cummerbund and continues to entertain Schine, Alger Hiss, and Richard Nixon as they arrive one by one in hell. Then, at the very end, the stage directions announce a new character: "*(The Glinda entrance music is heard. A bubble with an oily, iridescent sheen descends from the lightning grid. Out steps a dumpy man with a face like a Walt Kelly bulldog, wearing a black Chanel dress, hose and stiletto pumps, on which he teeters uncertainly.)*" It's J. Edgar Hoover. Kushner wrote this play only three years after Anthony Summers's biography

of Hoover was published, so it's possible the rumor was still widely believed at this point.

16
Knowledge of Vawter's performance helpfully comes from Ann Goldstein. Smith, who died of AIDS in 1989, was an exuberant and trailblazing filmmaker, actor, and photographer of New York's underground scene. His films set belly dancing against *natures mortes*, exploding Greek myth into manic-seductive drag fantasies, carried along by triumphant marches and twangy yodels. Vawter also had HIV/AIDS and died in 1994 of a heart attack.

17
Sylvie Drake, "Stage Review: 'Cohn/Smith' a Jolting Juxtaposition," *Los Angeles Times*, August 8, 1992, https://www.latimes.com/archives/la-xpm-1992-08-08-ca-4408-story.html.

18
J. Edgar Hoover, speech before the House Committee on Un-American Activities, March 26, 1947, Voices of Democracy, last modified April 26, 2007, https://voicesofdemocracy.umd.edu/hoover-speech-before-the-house-committee-speech-text/.

19
Guy George Gabrielson, "Perverts Called Government Peril," *New York Times*, April 19, 1950, 25.

Fig. 6: Announcement card for the performance *Roy Cohn/Jack Smith*, conceived and performed by Ron Vawter, at The Performing Garage, New York, 1992. Photos by Paula Court

recalling a cat's nine lives. Cohn's and Hoover's conflicting private and public personas are ripe with savage irony and laced with the abuse of power; for Kruger, the act of exposing them seems almost low-hanging fruit.

Justice is bold and straightforward, visualizing the rumors around Hoover and the facts on Cohn: that the former endlessly disavowed his penchant for cross-dressing and gay orgies, and that the latter was a similarly closeted homosexual who fervently rejected his AIDS diagnosis until the day he died. In other words, they were both bad actors, the embodiment of bigotry and hypocrisy. For both men sex was clearly and inextricably connected to power; each responded to his own self-abnegation through acts of compensatory violence, shaping homosexuality as a political threat, perhaps as a misguided way of conquering his perceived weakness.

In 1951, riding a wave of anti-communism insidiously disguised as patriotism, Cohn worked with Judge Irving Kaufman to sentence Julius and Ethel Rosenberg to death by electric chair. The decision was an unsympathetic, hugely controversial one that resulted in nationwide protest and accusations of anti-Semitism, but it was one that impressed Hoover, who just four years earlier, before the House Un-American Activities Committee, had forcefully condemned communism as an "evil and malignant way of life."[18] As a result, he recommended Cohn, who was just twenty-four, to assist Senator Joseph McCarthy in McCarthy's ongoing investigation of suspected communists, a crusade later known as the Second Red Scare.

In 1950 Guy George Gabrielson, the Republican national chairman, asserted in a party newsletter, "Perhaps as dangerous as the actual communists are the sexual perverts who have infiltrated our government in recent years. The State Department has confessed that it has had to fire ninety-one of these."[19] (Gabrielson gave no elaboration in regard to his connection of sexuality to political ideology, but it stuck.) McCarthy, with Cohn as chief counsel, posited that gay men and women would be more susceptible to emotional manipulation and blackmailing, ultimately firing scores from government employment.

57

The fact that Hoover was unmarried and lived with his mother until he was forty resulted in much speculation as the media tried to identify his sexuality. He was known to be close to his protégé, FBI associate director Clyde Tolson; they vacationed together, and Tolson inherited Hoover's estate.[20] To be sure, Hoover was sex-obsessed, collecting pornography, even underwear, from other politicians and public figures to blackmail them into submission. He knew how dangerous it was to be homosexual; understanding the public's fear of difference, he engineered it into a form of legal persecution, investigating the pre-Stonewall Mattachine Society and attempting to out Adlai Stevenson to preserve his own aggressive, hard-line persona in the face of persistent rumors.

Cohn, too, repressed his sexuality, and the results of his mendacity were often pitiful. During the 1954 Army-McCarthy hearings, he was accused of trying to secure preferential treatment for his friend, fellow McCarthy consultant G. David Schine. The two men had traveled Europe together the year before, ferreting out suspected communists potentially working for the US Information Service — making the March 22, 1954, cover of *Time* with the headline "McCarthy and His Men."[21] Film records of the hearings contain a moment wherein Cohn is taunted by Senate subcommittee chief counsel Ray H. Jenkins, who asks if he and Schine might be considered "warm personal friends." Cohn answers affirmatively, but Jenkins presses further, adding mockingly, "Isn't it a fact that [Schine] is one of your best friends? We all have our best friends; there is no criticism of you on that account." Cohn attempts to answer, but Jenkins continues his patronizing, homophobic drawl: "We have friends whom we love; I do" — at which point the audience bursts into laughter.[22] Cohn is left staring at nothing in particular. He chuckles lightly, awkwardly, his eyes darting around as he searches for the punch line in Jenkins's leading questions, although he knows that he is it.

Twenty-five years later, that flustered reaction — Cohn might have called it an embarrassing misstep — is gone, hardened into the steely, aggressive persona that made him one of the most famous, feared lawyers in New York, or a "legal executioner," as *Esquire* aptly opined in the late 1970s.[23] When Cohn appeared on *Tomorrow with Tom Snyder* in 1979, the host asked him about his reputation for being relentless in court. Cohn interrupted huskily to supply the rest: "Tough, mean, vicious, so on," nodding and whirling his finger in a circle in a gesture of proud admission. Only his lips move when he talks; his pale blue, nearly gray eyes stay flat and unfazed. The interview continued as follows:

TS: What does that kind of publicity do for your business in New York?
RC: Oh, it's fantastic. The worse the adjectives, the better it is for business.
TS: What are they looking for, what are they buying?
RC: Scare value.[24]

In early November 1985, ten months before he died, Cohn quietly called upon President Ronald Reagan for privileged access to the experimental AZT treatment. Reporters found out and moved in aggressively; the result was a column for the United Feature Syndicate in which Jack Anderson and Dale Van Atta divulged medical records related to Cohn's deteriorating condition.[25] Still, Cohn played his ruse to the end, and eventually it slipped. Five months later, Mike Wallace asked him on *60 Minutes,* "Do you have AIDS?" A flash of fear crossed Cohn's face. Then he smiled, said no, and laughed, averting his eyes, his lower lip and jaw quivering.[26]

Cohn was by all accounts a malicious individual; his suffering under AIDS might elicit some sympathy, but as a historical figure, he offered neither apologies nor excuses. However, the repeated attempts at viciously outing him in life (and even after death) should raise doubts. Yuskavage cites Aleksandr Solzhenitsyn regarding moral gray areas such as this: "If only it were all so simple! If only there were evil people somewhere insidiously committing evil deeds, and it were necessary only to separate them from the rest of us and destroy them. But the line dividing good and evil cuts through the heart of every human being."[27] When *Esquire* writer Ken Auletta conceded that he enjoyed making Cohn "squirm" by questioning his sexuality, it was revenge, not justice.[28] It was a complicity in malice passing as journalism — a revealing, insensitive succumbing to power of the interviewer realizing he could now prosecute the prosecutor — that Kruger both expounds upon and exploits. In *Justice* the artist subverts Cohn's and Hoover's sanctimonious deceit by transposing the former's piercing, awkward gaze with the latter's eager grasp, revealing each man's inner conflict but also our own, as we are forced to toggle between our hatred and our empathy. Can we condemn Cohn's

20
Nothing concrete regarding their relationship ever materialized. Claire Bond Potter writes that whether Hoover was a cross-dressing homosexual or not is beside the point; instead, she examines his sophisticated understanding of the power of gossip. Claire Bond Potter, "Queer Hoover: Sex, Lies, and Political History," *Journal of the History of Sexuality* 15, no. 3 (2006): 355–81: http://www.jstor.org/stable/4629668.

21
Time, March 22, 1954.

22
This particular moment in the hearings was excerpted in *Where's My Roy Cohn?*, directed by Matt Tyrnauer (Los Angeles: Sony Pictures Classics, 2019), Fandango.

23
Ken Auletta, "Don't Mess with Roy Cohn," *Esquire*, December 1978, 39–60.

24
Tyrnauer's insightful 2019 documentary *Where's My Roy Cohn?* was indispensable to my preliminary research on Cohn and included this segment from *Tomorrow with Tom Snyder*, February 13, 1979.

25
The authors revealed that Cohn confused details and needed help showering and shaving, and that medical personnel were warned to wear gloves to treat his cracked and bleeding lips. Jack Anderson and Dale Van Atta, "NIH Treats Roy Cohn with AIDS Drug," United Feature Syndicate, July 25, 1986, https://www.newspapers.com/clip/26009219/azt_column/.

26
Roy Cohn, interview by Mike Wallace, *60 Minutes*, CBS, March 30, 1986. Practicing the same "politics of propriety," President Ronald Reagan and First Lady Nancy Reagan did not show up to Cohn's October 1986 memorial, though in his casket Cohn wore a tie bearing Reagan's name. Nicholas von Hoffman, "The Snarling Death of Roy M. Cohn," *Life*, March 1988, https://www.maryellenmark.com/text/magazines/life/905W-000-035.html.

27
Aleksandr Solzhenitsyn, *The Gulag Archipelago: An Experiment in Literary Investigation* (New York: Harper & Row, 1974); cited in Yuskavage, "In the Studio."

28
Trynauer, *Where's My Roy Cohn?*.

29
"I don't do interventions." Kruger, interview.

30
Michael Brenson, "Free Speeches," *New York,* July 31, 2000, http://images.nymag.com/nymetro/arts/art/reviews/3583/.

31
The title of the documentary *Where's My Roy Cohn?* derives from a comment President Donald Trump reportedly made in relation to Jeff Sessions, whom he characterized as insufficiently devoted in comparison to Trump's former personal lawyer and confidante. See Steve Appleford, "The 'Where's My Roy Cohn?' Documentary Director Reveals Trump's Machiavelli," *Los Angeles Times*, September 24, 2019.

Fig. 7: Entrance to the Roger McCormick Memorial Court, Art Institute of Chicago

and Hoover's actions without reveling in their outing? Can we understand their shame as connected to the wider persecution of homosexuals in their lifetimes and instead focus our criticism on their cowardly lust for power?

In the Chicago iteration of *Barbara Kruger: Thinking of ~~You~~. I Mean ~~Me~~. I Mean You.*, Kruger has placed *Justice* in the sculpture court of the Art Institute of Chicago's American galleries, where it nests among the sincere products of nineteenth-century virtue (figs. 7 and 8). One encounters Hoover and Cohn in profile; the circular pedestal, engraved with the word JUSTICE in a widely spaced Roman font, makes the work look like an oversize trophy or something more twee—a pirouetting music box dancer, perhaps. The statue's imposing gravity fits perfectly in Hammond, Beeby, and Babka's 1988 postmodern shell, whose clean lines and hollow, faux-weathered columns are designed to imbue the space with a sense of ersatz old-world authority.

Though *Justice* appears somewhat slick compared to the other weighty, rough-hewn marble sculptures in the court and is over a century newer than most of them, Kruger does not view its placement among the neoclassical works as an intervention.[29] Flanking the entrance to the sculpture court are *America* (1850/54) and *Ginevra* (1865/68), refined portrait busts by Hiram Powers, who in these appropriated classical forms equates beauty with democracy. Both women look resolutely, if somewhat melodramatically, into the distance; together with Daniel Chester French's *Truth* (1900), who gazes into a delicate mirror, the sculptures encourage viewers to aspire to a kind of majestic morality. The stars that tip *America*'s crown represent the Union's thirteen original states, a history Powers revered as a patriot and an abolitionist. "Liberty and justice for all" is at once a credo Powers believed and one that Kruger interrogates. The pure American art created earlier in our nation's history expresses virtue as ultimatum; Kruger draws a total continuity between its symbolic generalizations (which held that Pocahontas's savagery could be ennobled via contrapposto, for example) and her statues that question single-issue commemorations. Allegories, once represented as elegant and alluring female figures, have been morphed into larger-than-life celebrities—though, as critic Michael Brenson writes, American attitudes toward sexuality and gender shape the formation and memory of them just the same.[30]

Interest in Cohn has resurfaced in recent years because he was the young Donald Trump's consigliere beginning in the 1970s.[31] It is tempting, then, to think that *Justice* is more relevant today than ever. But that is a blissfully narrow framework in which to view

32
Barbara Kruger, "Decadism"
(2004), in *Barbara Kruger* (New
York: Rizzoli, 2010), 257–59.

Fig. 8: Rendering showing *Justice*, 1997, installed in the Roger McCormick Memorial Court, Art Institute of Chicago

the sculpture; brutality and affliction are constant in American culture, and Kruger's ideas are not limited by medium or stylistic trend. *Untitled (Our Leader)* (1987), which Kruger recast as a video for *Thinking of ~~You~~. I Mean ~~Me~~. I Mean You.*, features a pasty puppet, tight-lipped but, from the look of the incised lines around its mouth, ready to inculcate its chosen lessons (fig. 9). And *Untitled (An erotic relationship to proper names)* (1988) is a clear lead-in to the arguments of the 1997 Mary Boone exhibition. Kruger's indictment captions a photograph of three men on suspended scaffolds, chiseling away at what will become Abraham Lincoln's Mount Rushmore portrait. The artist illustrates how foolish our reverence for celebrity is, enrapturing enough to justify risking some lives to elevate others deemed more important.

Thinking of ~~You~~. I Mean ~~Me~~. I Mean You. is, in Kruger's words, an "anti-retrospective," an exhibition that pushes against the notion of a career as a relic or chronological checklist. In her 2004 essay "Decadism," she balks

at how social and historical movements are encapsulated in ten-year periods—the "high-roller" '80s or "rollicking but volatile" '90s—arguing that all experience is filtered through a subjectivity shaped by sex, money, race, geography, and age, and that the expectation that artists must respond in specific, defined mediums is limiting. As she put it, "Cultural productions have broadened and engage the choreographies of social relations, the hybridity of bodies, the relational possibilities of objects and events, the invasive constancy of surveillance, the intensive orderings of design, and the punishments and pleasures of the built environment."[32] Kruger's ideas have a continuous presence, and given the new contexts within and without the museum, she has elected to update her most iconic pieces. More than half the exhibition is new, with works such as *Untitled (Your body is a battleground)* (1989/2019) and *Untitled (I shop therefore I am)* (1987/2019) reconsidered as animations. The puppet in *Our Leader* stretches and liquefies over a few

Fig. 9: *Untitled (Our Leader)*, 1987. Pasteup; 8 ³⁄₈ × 5 ⅛ in. (21.3 × 13 cm). Courtesy of the artist and Sprüth Magers

slow seconds before setting and swapping out its label to the harsh clang of a boxing bell: OUR LOSER, OUR LONER, OUR LEADER.

But *Justice* remains the same. Have its meanings migrated into the present tense, unaltered? Is understanding the work dependent on knowing Cohn's and Hoover's biographies? Or is this the rare example in Kruger's work of a souvenir, an emblem of two discrete points in time — long-standing past perceptions of the two men, on the one hand, and the art-historical moment in 1997 at Mary Boone? *Justice* may be more past than present, which is why the work naturally gravitates to the Art Institute's sculpture court. Cohn and Hoover may have faded in public memory, but Kruger resituates them as a resolute assertion that individuals who have chosen to abuse their power do not deserve our pity. Such sympathy is a waste of time and energy when there is other, and more urgent, work to be done, more or less dazzling hypocrisy in need of scrutiny.

To Buy or Not to Buy

Michael Govan

1
Gustav Klutsis, "Photomontage as a New Problem in Agit Art" (1931), in Charles Harrison and Paul Wood, *Art in Theory, 1900–2000: An Anthology of Changing Ideas* (Oxford, UK: Blackwell, 2003), 489–91.

Our culture *is* media culture. To paraphrase Marshall McLuhan, "Ads are the cave art of the twentieth century." No artist has grasped and/or challenged that idea as Barbara Kruger has. Beginning her career by appropriating the language of propaganda and advertising, she has made work over almost fifty years that is so influential, distinctive, and ubiquitous that it has now become appropriated by other artists, as well as by commercial brands. Now, bringing her practice full circle, Kruger has begun to reappropriate her own previous work for recent exhibitions (including this one), not only drawing recursive circles around practice, but also creating a new kind of proof, and offering critique, of the pervasive, insidious permeability between the art and advertising, art and media, that is our culture.

It was just over one hundred years ago that Russian avant-garde artist El Lissitzky created his lithograph *Beat the Whites with the Red Wedge* (1920, fig. 1), whose bold black, white, and red text and images helped codify a new language of propaganda posters and banners of direct address (agitprop) that continued to evolve through the shaping of the Soviet Union in the late 1920s and early 1930s. Another revolutionary artist, Gustav Klutsis (fig. 2), perhaps more than any other, applied the Constructivist ethos and its desired honest and utilitarian approach to create the graphic techniques of text and photomontage, mass produced and made to appeal to a wide audience, that dominate our image of Soviet graphic communication and inspired much of modern graphic design. Kruger has absorbed all of that history

and its aftermath in her own construction—not of an art of propaganda, but rather of an art that helps us deconstruct the propaganda all around us. In his 1931 essay "Photomontage as a New Problem in Agit Art," Klutsis indicated that he had intended his photomontage to be "not a form but a method" that would resist "canonization" and the "clichés of aesthetic convention."[1] As visual history has proved, nothing yet has escaped those traps. But as Kruger has suggested in her art, clichés and canonized tropes of propaganda can be appropriated, magnified, and recontextualized to become subverted and exploded.

Kruger's now-iconic 1987 photomontage *Untitled (I shop therefore I am)* (fig. 3) shows a black-and-white image of a hand seemingly holding (or presenting or framing) a white rectangle with bold red text declaring, I SHOP / THEREFORE / I AM. This work has become as much a part of art history as Lissitzky or Klutsis. Much has already been written about how Kruger, like the latter, appropriates and conflates propaganda and advertising, in this case with a riff on René Descartes's famous philosophic aphorism ("I think therefore I am"), entirely subverting expectation by complicating it. Of course, the language of propaganda is supposed to be direct and uncomplicated. Advertising might be less direct at times, but its objective, like that of propaganda, is to cause us to act definitely—usually to get us to buy something, to *shop*. Descartes's existential aphorism reveals its truth provisionally, and only upon reflection. Kruger juxtaposes two kinds of language—the direct address of

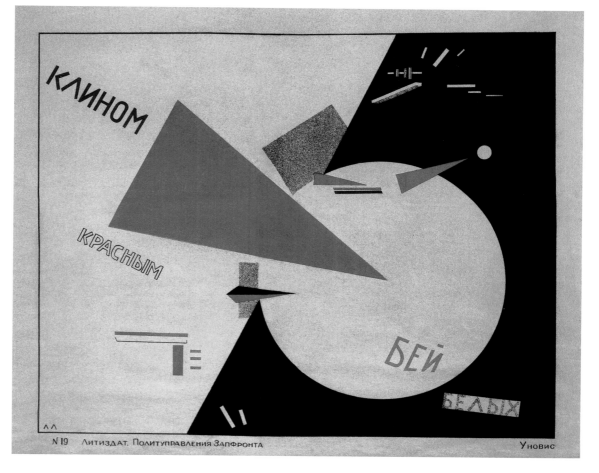

Fig. 1: El Lissitzky, *Beat the Whites with the Red Wedge* (*Klinom krasnym bei belykh*), 1920. Poster; 20 ⅛ × 24 ⅜ in. (51 × 62 cm). David King Collection, Tate Archive, London

advertising and propaganda, and the reflective and questioning language of philosophy. It's important that the reference to Descartes is as common in popular culture as the language of advertising. In another work, Kruger extends the question with an equally engaging riff on a popular Shakespearean phrase that ends up as TO BUY OR NOT TO BUY. Her usual choice of typeface, Futura, is also important because it was designed, like Klutsis's posters, in the 1920s, with the goal of honesty and utility, announcing a march into a modern epoch with a clarity and simplicity to appeal directly to all. Conceived in opposition to the ornate, elitist history of serif typefaces, Futura has itself become a cliché, representing a positivism of technological progress (as on the commemorative plaque of the 1969 NASA lunar lander), or the unintended consequences of the future (as in its use in marketing materials for Stanley Kubrick's *2001: A Space Odyssey* [1968]). All the individual elements of Kruger's composition are canonized clichés of aesthetic

convention. They are indeed arranged boldly and beautifully, not as a call to action, but rather to articulate possible meanings: Could it be that in our capitalist society we are existentially defined not by thinking but by participating in the regime of commerce? Or perhaps Kruger's work *is* a call to action—for us as viewers to be aware enough to look critically at what we see all around us and to understand that if we don't pay attention, we may be unknowingly subsumed within that regime. Is Kruger constructing a "red wedge" with which to pierce our bubble of complacency and complicity?

Kruger's approach differs from that of her revolutionary predecessors. Rather than seamlessly integrating text into photomontage, as Klutsis did, Kruger in much of her early work usually set her text apart, framing it within rectangles in a manner that feels even more honest and utilitarian than her modernist references. As with all things made by Kruger, boldness and clarity constitute just

Fig. 2: Gustav Klutsis, *Worker Men and Women: Everyone Vote in the Soviet Elections* (*Raboche i rabotnitsy: vse na perevybory sovetov*), 1930. Color offset lithograph; 47 ⅛ × 33 ⅜ in. (119.7 × 84.7 cm). The Art Institute of Chicago, Ada Turnbull Hertle Fund, 2011.876

one aspect of her art. Some of her earliest works are presented as "pasteups," mimicking the actual camera-ready mechanical layouts that, before desktop publishing, were used in the creation of magazines, advertising, and other printed images. Kruger herself worked as a graphic designer creating mechanicals. Transitioning from the commercial world to the art world, she constructed numerous pasteup-like objects that are intended to be read as artworks in that provisional-looking form, of cut-out typography pasted or taped over images, with crayon and pencil marks connoting instructions and information for the final design and printing process. Later works like *I shop…* retain the pasteup quality of text blocks laid on top of images. Rather than resembling a seamless trompe l'oeil, the effect is sometimes ambiguous and awkward; for instance, in the cited work, the hand isn't quite holding the text block. The pasteup is not final; it feels temporary. This unfinishedness creates space for the questions we as

viewers have. Her critique, which resides in the artwork, is then joined by our critique—of her work, and also of the subjects addressed in her work.

Consciously and creatively reframing a whole history of propaganda, advertising, and media, Kruger has created her own brand, knowingly appropriating techniques such as the consistent use of a typeface and a color palette. One measure of success for an artist is the cultivation of a recognizable kind of image, like a brand, but Kruger is adept at complicating that idea, too. For one thing, by placing so much of her work in public space, she allows new readings to be made by a non-art-world audience not already familiar with her work. If Kruger's work looks a little like advertising when installed in an art museum, in the real world, the ways in which it does *not* resemble advertising garner it a second and third look. The artist is constantly aware that the environment in which her work is seen is as relevant as the way in which it is composed.

One result of the success of her own "brand" is that her work has been appropriated back into the consumer milieu that she has made the subject of her critique. Most recently, the fashionable skateboard and clothing brand Supreme seems to have based its logo on her work; the company admitted that it did, in the process of suing another company for appropriating Supreme's artwork into its commercial brand.[2] Kruger never pursued litigation herself, preferring to observe the increasingly insidious relationships between art and commerce from a distance. Nowadays even the very biggest and most established international brands, like Louis Vuitton, Marc Jacobs, and Rimowa, are enhancing themselves through paid collaborations with artists. A Google search will bring up a fair number of knockoffs of these products—some made in homage, others created by designers unaware of the connection to a specific artist. It's as if Kruger knew all along that this was the future. Instead of suing those who have appropriated her, she has continued to evolve her work to take account of imitators, finding new ways to critique the seemingly endless cycle of appropriation between art and commerce.

Kruger confounds the mechanics of branding and advertising with a bold appeal to our senses—not to buy, but to consider the process of being appealed to in the first place, and to think about what choices we may have: buying or not buying, being or not

2
Jian DeLeon, "Supreme™ Court: The 12 Greatest Moments of Supreme's Battle with Leah McSweeney," *Complex*, May 1, 2013, https://www.complex.com /style/2013/05/supreme-court -the-12-greatest-moments-of -supremes-legal-battle-with -leah-mcsweeney/112.

Untitled (Surrounded), 2017, with Gustav Klutsis, ***Screen-Tribune-Kiosk***, 1922, realized 2017, installation view, ***Space Force Construction***, V-A-C Foundation, Palazzo delle Zattere, Venice, 2017

being. In this way we develop an awareness of not just *what* is presented to us, but *how* it is constructed and presented, and in what context, with what goal. Kruger's own intellectual capacity for critique is obviously extraordinary, honed by her own experience as well as by an intimate understanding of the critical theory of her generation of artists and thinkers. She emerged as an artist in the 1980s, in the wake of an explosion in critical theory encompassing ideas of deconstruction and post-structuralism, which mostly originated in France and proliferated via academic institutions in Europe and North America, including art schools in the US. Feminist theory evolved simultaneously, albeit with American feminism developing around its own historical and theoretical foundations rather than being imported from Europe. The journal *October*, named to conjure the same Bolsheviks symbolized by Lissitzky's red triangle, assumed a leadership role in translating these ideas into the visual arts. If *October* had an opposing White Army, it could be said to be the virulent return of expressionist and figurative painting in the 1980s. In art circles there was a battle between intellect and emotion, inquiry and spectacle, photography and painting,

Fig. 3: ***Untitled (I shop therefore I am)***, 1987. Photographic silk screen on vinyl; 111 ⅝ × 113 ¼ in. (284 × 288 cm). Glenstone Museum, Potomac, Maryland

conceptualism and figuration, critique and beauty, and, perhaps, theory and everything else real. Derided by some as advancing dense and incomprehensible writing, this

Fig. 4: René Magritte, *The Treachery of Images (This is Not a Pipe)* (*La trahison des images [Ceci n'est pas une pipe]*), 1929. Oil on canvas; 23 ¾ × 32 in. (60.3 × 81.1 cm). Los Angeles County Museum of Art, purchased with funds provided by the Mr. and Mrs. William Preston Harrison Collection, 78.7

3
Craig Owens, "'Art Criticism Is Not a Particularly Reputable Profession': A Rare Interview with *October* Co-founder Craig Owens Resurfaces" (1984), by Lyn Blumenthal, *Artnet News*, February 28, 2018, https://news.artnet.com/art-world/art-criticism-craig-owens-new-book-1232852.

4
Barbara Kruger, quoted in Hal Foster, "Seriously Playful," in *Barbara Kruger* (New York: Rizzoli, 2010), 19.

age of theory was for others inspiring and revelatory.

For me, this moment of philosophical coalescence contained the secrets of the world. As the late art critic and *October* magazine associate editor Craig Owens said, "Theory is that which enables an understanding of how natural and utterly mistaken it is to think that one is unique."[3] Owens found Kruger's work sympathetic to these ideas, as did another prominent member of the *October* editorial team, Hal Foster. The title of Foster's 2010 essay on Kruger, "Seriously Playful," emphasizes the artist's ability to have it both ways and quotes her as saying: "The richness and complexity of theory should periodically break through the moats of academia…and enter the public discourse via a kind of powerfully pleasurable language of pictures, work, sounds, and structures."[4] I was an aspiring artist in the mid-1980s, who found theory seductive and beautiful. What held my excitement about Kruger's work then—just as it does now—was how it embodied, in a visually

arresting way, the critique of spectacle. Her art isn't for or against spectacle; it engages spectacle.

For her own part, Kruger is as interested in the controversial explicit radio personality Howard Stern as she is in the controversial French theorist Jacques Derrida; she consumes popular culture in the same breath as theory. If media of all kinds surround us now like air, Kruger's art reveals the danger and the opportunity that reside in media-amplified language and images. Seeing Kruger's art, I realized that the great gift of the whole of art and thinking of the twentieth century was not the simple beauty of modern style, nor the life-extending and comforting innovations of industry and technology, nor even the connectedness of people across the globe; rather, it was the revelatory understanding that meaning, in life or in words or in pictures, is not absolute, not given, not obvious. Meaning of all kinds is constructed and is continuously in flux. "Context is everything," as they say. As context changes, so does meaning. If *context*

literally translates to "with text," then through her art Kruger literally, with text, creates context. Just as the modern Belgian Surrealist René Magritte (fig. 4) used text to disrupt our perception of an image—for instance, inscribing a painted pipe with text declaring it not so—Kruger's inventive pictorial texts (or textual pictures) invite us to see many possibilities even in a single image.

By the late 1980s, Kruger had become so adept at creating context with text that she began to eschew any image in favor of the graphic arrangement of text, first in two dimensions, and then later in three-dimensional environments, temporary public interventions, and permanent installations. In 2008 the Los Angeles County Museum of Art (LACMA) commissioned Kruger to make a permanent work in its then-new Broad Contemporary Art Museum (BCAM). Designed by Renzo Piano, the large three-story building features a huge custom-designed elevator with glass doors revealing not only the red interior of the truck-size cab but also, when the elevator is parked or moving to other floors, a distinctive architectural space as monumental as the building's galleries. I hoped it would be possible to install art within this huge empty space—better to have the playful and critical voice of an artist, rather than the institutional one of the museum, address visitors experiencing the new building. However, to hang an artwork in this complex space was impractical and inappropriate—and perhaps unsafe—so we asked Kruger if she would consider making a new work specifically for the site. The foundation of the building's patrons, Eli and Edythe Broad, owned many artworks by Kruger, and such a work's quality of direct address would create a powerful immediate experience for visitors to the museum.

Despite the challenges of the unusual site, as well as the fact that the building was still under construction and final architectural details were somewhat unclear, Kruger agreed. The resulting work, *Untitled (Shafted)* (2008, fig. 5), has become a landmark of LACMA's campus. Seventy feet high and spanning three stories, the work creates an entirely different experience of Piano's architecture, never entirely revealing itself in a single gestalt. As the elevator cab moves from floor to floor, it variously reveals and obscures parts of an artwork too big to be taken in all at once. Integrated into, behind, and around the elevator's expressive and intentionally exposed industrial and mechanical components of chromed and painted steel, Kruger's installation is the focal point of the building's

interior public space. One's experience of it depends on how one enters the building and what floor the elevator is on at that moment. The visitor who ascends three stories to the top floor via Piano's fifty-foot-tall exterior escalator is likely to be greeted by the largest text of the artwork: the word PICTURE in red, ten feet high and forty feet wide. A closer look reveals PICTURE to be framed on top and bottom by smaller, mostly black type; the text together comprises an entire sentence declaring, IF YOU WANT A PICTURE OF THE FUTURE, IMAGINE A BOOT STOMPING ON A HUMAN FACE, FOREVER—the last word in red for emphasis—the whole attributed to the famous author of dystopian futures, George Orwell. Montaged behind and below the text is a huge contrasty black-and-white image of the serious, shadowy eyes of a middle-aged male staring toward the viewer, as if the words are a thought bubble of his voice. Certainly the museum wouldn't of its own volition greet the visitor with that.

Those who enter the building on the ground floor are likely to be greeted by an equally huge black-and-white image of the pant legs and black leather dress shoes of a man stepping aggressively toward the viewer, giving the impression that he is as tall as the elevator shaft. The picture is bisected vertically by a red stripe with white text that extends the length of the shaft; the viewer is able to see only the last fragment of a two-story-high line of text reading, PLENTY SHOULD BE ENOUGH—RIGHT? On either side of that, two big words in all capitals in white jump out at us: SHOP on the left, and STARE on the right. Connecting them together in a strongly graphic composition across are smaller words in red creating a full descriptive sentence: HE ENTERED SHOP AFTER SHOP PRICED NOTHING, SPOKE NO WORD, AND LOOKED . . . AT ALL OBJECTS WITH A WILD AND VACANT STARE. Seemingly extracted from a noir novel describing the life of this man, the text takes on an obviously different meaning at the entrance to an art museum. In fact, the quotation is from an Edgar Allan Poe story with a distinctly noir flair, "The Man of the Crowd." The eponymous subject of the narrator's pursuing gaze is shopping and staring, presumably as a way of distracting himself from a more sinister reality. Might someone visit a museum just to be "of the crowd"? How should we look in a different way?

Above and below the quotation, on the second-floor zone of the shaft and in its subterranean bottom, is a long list in white text on black in all caps, fragments of which

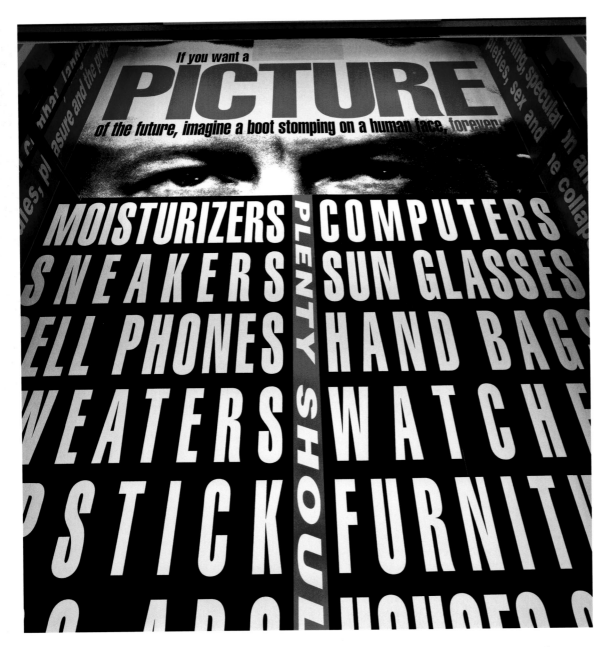

Fig. 5 and opposite: *Untitled (Shafted)*, 2008. Digital-print installation; 94 × 18 × 12 ft. (28.7 × 5.5 × 3.7 m). Los Angeles County Museum of Art, gift of Carole Bayer Sager, commissioned by the Los Angeles County Museum of Art for the opening of the Broad Contemporary Art Museum, M.2012.20

the visitor arriving on the second floor may apprehend on looking up and down. In total, the list comprises things that might be desired and acquired in contemporary life: MOISTUR- IZERS COMPUTERS SNEAKERS SUN GLASSES CELL PHONES HAND BAGS SWEATERS WATCHES LIPSTICK FURNITURE CARS, ABS HOUSES & ART SPIRITUALITY VACATIONS CHOCOLATE SMALLER NOSES SPAS, SUSHI FLAT SCREENS COUTURE BIGGER BREASTS BOOTS, GAMES BOATS, PLANES

WINE, PETS FULLER LIPS GADGETS GOLD, DRUGS DIAMOND JEANS & BJS. It's obviously ironic, even funny, to walk into a museum and see a list of things you'd think were diametrically opposed to the contemplative experience of art. Humor and irony are also tools of pleasure, and of advertising. Or as Foster suggested of Kruger's work in general, it's "seriously playful"; and by that he means the playfulness leads the seriousness.

incidents, simultaneity and the

real memory and the defeat of
signs that say bought and sold, a
rubbing of skin, quotation and the

SHUT
word, and looked

priced

at all

SIA

ENOUGH · RI G

IT

ALITY VA

SHI FLA

IONS

REENS

LANES

CHO C

OU

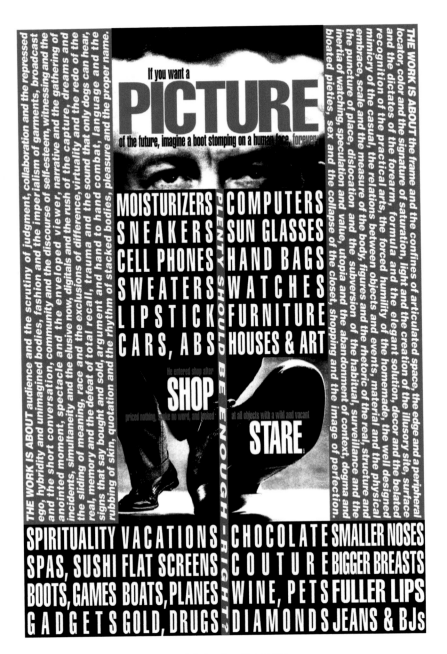

Fig. 6: Design for *Untitled (Shafted)*, 2008

As not only the contents of the museum but also its patronage come under increasing scrutiny, the question arises as to whether the museum itself, named (or, some might say, purchased) by a donor, might be considered a commodity, one nominally belonging to the wealthy. The experience of going to museums has often been equated with that of shopping, even as shops are evolving to appropriate the style of museum presentations. Ironically, looking away from Kruger's work on the top floor of the museum galleries, one is treated to a view of Los Angeles featuring Hollywood and the HOLLYWOOD sign in the distance behind one of L.A.'s most well-known shopping malls, the Grove, which boasts almost ten times the number of annual visitors that the museum receives. How do we read Kruger's list, her references to the mindless daze of shopping, a gesture of excess holding together a compendium of purchasable bourgeois desires? And what about Orwell's bleak portrayal of the future? Are the museum and the art within it included among that litany of products, experiences, and bodily enhancements that define a perhaps vapid dystopian existence

Kruger recently appropriated and lengthened her list in a new video titled *Untitled (The work is about…)* (1979/2020). In reworking her earlier art-works, she usually adapts her ideas for a new moment/con-text. In this case, she added to the list, for example, *[The work is about…] liking and friend-ing.* Indeed, *the work is about* many things.

as implied by the vacant stare of Poe's subject and by Orwell's "picture"? PICTURE is the most prominent word, so large and graphic that it transforms itself from word to picture, from sign to signified, and might be equated with *picture* meaning "work of art." Isn't the danger that the art museum, and art, does become consumed by the machinery of the capitalist enterprise of advertising and shopping? And what kind of energy, what kind of work, must be brought to the experience, by artist and viewer, to avoid that Orwellian future?

Kruger's subtitle for her LACMA work, *Shafted*, is as direct and potentially aggressive as Orwell's quotation. The word SHAFTED reads like a tabloid headline. Who is being shafted? The artist? If so, is the (female) artist "shafted" by the authoritarian museum? By the architect or the patron? Kruger is adept at combining direct critique with humor to make a complex statement. As it happens, her title was inspired by her actual feelings of frustration toward the museum, its architect, and its patron for not making more significant changes to the elevator that might have enhanced the visibil-ity of her work. Ultimately happy with her final solution (as the work ended up on the cover of her Rizzoli-published monograph), Kruger added the parenthetical declaration in her title as a way of being humorous as well as of announcing the general aspect of institutional critique embedded in this work. All too often, museums don't live up to their promises and can create an inadvertently inhospitable envi-ronment for artists' work. *Shafted* addresses the problematic aspirations of a contemporary art museum and its multifaceted relationships to its artists, artworks, and audiences. On its surface, Kruger's artwork is a potentially harsh critique of the whole art museum enter-prise. But it's also funny!

Perhaps most difficult to decipher at first glance, but visible in a design document (fig. 6), is the white-on-red text on the east and west interior walls of the elevator shaft. Each side begins with the phrase THE WORK IS ABOUT, which is followed by a long list of conjunctive phrases. (On the east wall, the list opens with THE FRAME AND THE CONFINES OF ARTICULATED SPACE and ends with SHOP-PING AND THE IMAGE OF PERFECTION; on the west wall, AUDIENCE AND THE SCRUTINY OF JUDGMENT are named first, with PLEASURE AND THE PROPER NAME coming last.) The language on the east wall is at first of the formal type that could have been lifted from art criticism or a graduate-school discussion but becomes ever more eccentric and directed at the wider

world. The text on the west wall begins by limning concerns of content and audience and moves somewhat toward describing the physicality of human experience. Despite the paired elements being joined by the word AND, the relationship between the terms is ambig-uous. Perhaps the lists comprise a catalogue of Kruger's own subjects,[5] or those of other artworks. Or perhaps they are simply a regis-ter of the words that swirl around art. Certainly the two lists convey the complexity of what "the work," as in the artwork, is "about" on the level of meaning, but presumably what's also referenced is the work that the artist performs continuously. In addition, as the lists are long and difficult for the viewer to apprehend at once, they suggest the work the viewer must do to comprehend Kruger's artwork—or any artwork, for that matter.

Looking is also work. The intensity and specificity of these long lists exist in opposi-tion to the "vacant stare" in the description of the shopping man, and to the banal and generic quality of the purchasable items named. Kruger seems to be reframing the dystopian future of the man in the crowd with many other more subtle and complex pos-sibilities. While those possibilities lie on the periphery of the list of consumer products that greets us first, they lead in many directions. Kruger's monumental LACMA artwork isn't a friendly welcome from a museum docent. It is powerfully graphic, beautifully and subtly situated in its architectural circumstance; its provocative ironies are clearly intended to wake us from our complacency to suggest what's at stake in our visit to the museum. Are we consumers of objects and images? Or will we be consumed by the regime of con-sumption? Navigating today's complex media environment has become a matter of survival. Lucky for us, Kruger is here to help us develop a critical apparatus with which to tackle this new reality. Her bold art opens the door to other ways of seeing and to a greater aware-ness of the many unobvious implications of the representations that increasingly and aggressively surround us, everywhere, likely forever, in the cave of our brand-conscious, media-inscribed world.

The Future Is Female
Peter Eleey

1
John Sculley, *Moonshot! Game-Changing Strategies to Build Billion-Dollar Businesses* (New York: RosettaBooks, 2014), 123–24.

2
Barbara Kruger, "Interview with Barbara Kruger," by W. J. T. Mitchell, *Critical Inquiry* 17, no. 2 (Winter 1991): 438.

YOU MAKE HISTORY WHEN YOU DO BUSINESS, the text says, ringing in the mind with the dulcet tones of executive reassurance. It dresses up the leather oxfords and crisply creased trousers worn in the accompanying picture, and subtly dresses down the headless men who are its subject and presumed target—the kind of men who write management memoirs and tomes of advice that celebrate their genius. Men who equate making with doing, and have things to teach us. Men like the marketing impresario and tech investor John Sculley, who invented the Pepsi Challenge before going on to run Apple, and who tells us that you make history when you understand that "the future belongs to those who see possibilities before they become obvious."[1]

In the days before Big Data's dominance, when history was still mostly being made by other businesses, advertising sold us things. It messaged us stories about ourselves, manipulated us, and condensed culture into seductive images and texts that could be delaminated and played around with. "I'm interested in pictures and words," Barbara Kruger explained early on, "because they have specific powers to define who we are and who we aren't."[2] Kruger's montages of the 1980s made remarkably effective use of visual forms and forms of address familiar from the common culture. In 1981, when she made *Untitled (You make history when you do business)*, those businessmen talking and relaxing were as recognizable as the figure of the attentive woman whose carefully posed foot is barely visible at the bottom edge of the

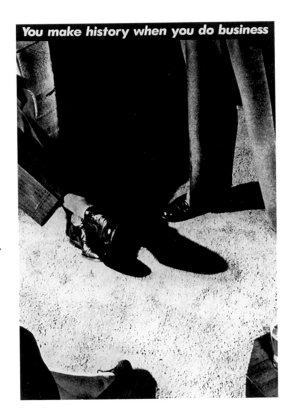

Fig. 1: *Untitled (You make history when you do business)*, 1981. Gelatin silver print; 68 ⅝ × 47 ⅞ in. (174.2 × 121.6 cm). Courtesy of Skarstedt

picture (fig. 1). Unsettling these found images and texts with virtuosic crops and disjunctive overlays, Kruger used one to interfere with the other so that she might, as she put it,

3

Barbara Kruger, quoted in Anders Stephanson, "Barbara Kruger," *Flash Art*, no. 136 (October 1987): 55.

4

Kate Linker, *Love for Sale: The Words and Pictures of Barbara Kruger* (New York: Harry N. Abrams, 1990), 12.

5

See Kruger, "Interview," 444. Addressing Linker's summary, she says, "Sometimes it could be the opposite, too. There is no recipe."

6

Kruger, 446.

7

See, for example, Kirk Varnedoe and Adam Gopnik, *High & Low: Modern Art and Popular Culture*, exh. cat. (New York: The Museum of Modern Art, 1990), 390.

8

See Mignon Nixon's important reading of the destabilizing effects of Kruger's visual-rhetorical positioning. Nixon, "You Thrive on Mistaken Identity: Female Masochism in the Work of Barbara Kruger," *October* 60 (Spring 1992): 58–81.

Fig. 2: *Untitled (Look for the moment when pride becomes contempt)*, **1990, installation view, Monika Sprüth Galerie, Cologne, 1990**

"interrupt the stunned silences of the image with the uncouth impertinences and uncool embarrassments of language."[3]

It can be hard to pick apart the order of things in Kruger's works—what is doing what to what, who is addressing whom—but most contemporary critical assessments of these montages tried to analyze her art's semiotic machinations and methods. Kate Linker, for example, summarized what she identified as Kruger's "characteristic program: seduce, dislocate, deter," describing how her pieces "entice and beguile only to accost us with accusatory words."[4] (Kruger has pointed out that it works just as well the other way around, mobilizing the seductions of language against aggressive pictures.[5]) These formal strategies of interference were designed to open things up. Making use of the visual regimes of power most familiar from mass media and advertising, the artist sluiced off some of the slick force of cliché and thickened it up "to create new spectators with new meanings." Explicitly feminist in her redirections, she clarified, "I would hope to be speaking for spectators who are women, and hopefully colleagues of mine who are spectators and people of color."[6]

Because Kruger trafficked in the reductive and objectifying tropes that were both her target and her medium, she opened herself to charges that she was simply reproducing what she claimed to be critiquing.[7] Part of the problem, it seemed, was that Kruger made it difficult to tell who was in control. Moreover, her works retain some of the strangling authority of their source material. The uniformed white police officer's gaze in *Untitled (Look for the moment when pride becomes contempt)* (1990), for example, still stings with judgment and threat (fig. 2); the source of the pins that restrain the hunched-over female figure who features in *Untitled (We have received orders not to move)* (1982) is uncomfortable to consider. Kruger's use of images of female subjugation in particular is inflected with icky questions about women's masochistic submission to enforced codes of gender conduct.[8]

A tight crop, for example, initially confuses the agency and acquiescence of the female subject in *Untitled (The future belongs to those who can see it)* (1997, fig. 3). A hand holds a menacing eyedropper over the mascaraed eyes of the woman's upturned face, while another hand seems to hold her down. Looking more closely, however, we realize that the woman may be administering the drops to herself. The titular phrase tumbles

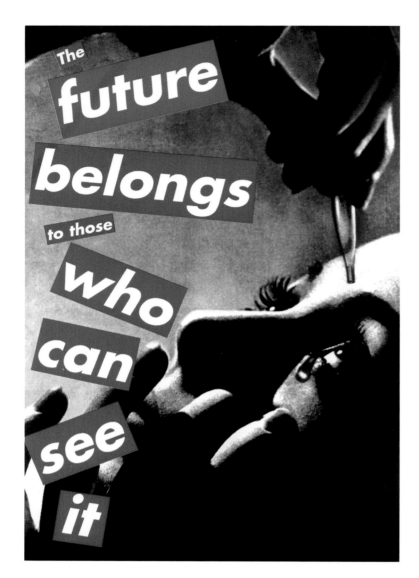

Fig. 3: *Untitled (The future belongs to those who can see it)*, 1997. Silk screen on vinyl; 85 × 60 in. (215.9 × 152.4 cm). Private collection

down from above in a pile of words that follow the gravity of the liquid. Are the drops meant to clarify her vision, or blind her to what is coming?[9]

Kruger made this picture for the op-ed page of the *New York Times*, which ran it in black and white in the fall of 1997 next to articles about the internet. Their subjects suggest some of our preoccupations in these early days of the web, when we mostly used email, searched for information, and bought a few things online. One of the opinion pieces focuses on "protecting children against the dangers of new technology," and the other argues that "monopolies have a place in the computer age."[10] Around that time, the

federal government was in the process of trying to determine what, if any, regulations to apply to cyberspace and to the companies that were quietly settling its vast landscape. "Consumers not currently using the Internet," the Federal Trade Commission told Congress in 1998, "ranked concerns about the privacy of their personal information and communications as the top reason they have stayed off the Internet. These findings suggest that consumers will continue to distrust online companies and will remain wary of engaging in electronic commerce until sufficient consumer privacy protections are implemented in the online marketplace."[11] Such protections were never enacted. As John Sculley would

9
While Kruger intended the eye drops to be clarifying in this particular image, allusions to blinding and assaults on the eye feature in other of the artist's works. An early lenticular photograph employs the text IF IT SEES, BLIND IT, and a later wallpaper installation that Kruger created for her survey at the Museum of Contemporary Art, Los Angeles, in 1999 and again at Sprüth Magers Lee in London in 2003 included the text THEY BLIND YOUR EYES AND DRAIN YOUR BRAIN over an image of a medical tool approaching an eye held open. That same image appeared in a billboard project that she realized two years later in Melbourne, Australia, with DRAINED BRAIN overlaid across it; an adjacent panel reprised the eyedropper image that Kruger had employed in 1997 in the *New York Time*s, joined with the text BLIND EYE.

10
Robert Coles, "Safety Lessons for the Internet," *New York Times*, October 11, 1997, https://www.nytimes.com/1997/10/11/opinion/safety-lessons-for-the-internet.html; and Jaron Lanier, "The Care and Feeding of Digital Behemoths," *New York Times*, October 11, 1997, https://www.nytimes.com/1997/10/11/opinion/the-care-and-feeding-of-digital-behemoths.html.

11
David Medine, "Prepared Statement of the Federal Trade Commission on 'Internet Privacy' Before the Subcommittee on Courts and Intellectual Property of the House Committee on the Judiciary, United States House of Representatives," March 26, 1998, https://www.ftc.gov/sites/default/files/documents

/public_statements/prepared
-statement-federal-trade
-commission-internet-privacy
/privacy.pdf.

12
See, for example, "We agree
that truth has been splintered
into an aerosol of demi-
articulate self-interest…."
Barbara Kruger, "Untitled,"
in *Barbara Kruger*, exh. cat.
(New York: Mary Boone/
Michael Werner, 1987), n.p.

13
For an exhibition in 2009, this
period was defined as 1980–
92. *Barbara Kruger: Pre-digital
1980–1992*, Skarstedt Gallery,
New York, March 18–April 18,
2009.

14
Untitled (The work is about…)
(1979/2020).

15
Barbara Kruger, quoted in
Gary Indiana, "Untitled (Art We
Having Fun Yet?)" (May 26,
1987), reprinted in Indiana, *Vile
Days: The "Village Voice" Art
Columns 1985–1988*, ed. Bruce
Hainley (South Pasadena, CA:
Semiotext[e], 2018), 431.

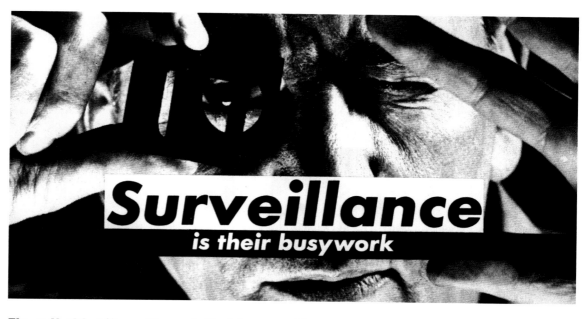

Fig. 4: *Untitled (Surveillance is their busywork)*, 1985. Pasteup; 4 ⅜ × 8 ⅝ in. (11.1 × 22 cm).
Private collection, courtesy of Sprüth Magers

later instruct us, effectively rephrasing
Kruger's slogan, the possibilities of what
seemed obvious and implicit in the FTC's hear-
ings left the future wide open. And the owning
of that future—what became our present,
and whatever follows—along with its con-
comitant radical refashioning of capitalism,
democracy, and public life has been difficult
to picture, much less acknowledge.

Long before all the cuddly emojis, funny
memes, "privacy" policies, and "clouds" of
data—what Kruger would term "aerosolized"
information[12]—occluded our vision, she warned
us. SURVEILLANCE IS THEIR BUSYWORK, she told
us in 1985, as some 1950s man scrutinized
us in the background (fig. 4). More ominously,
Kruger made another work with the same
image that year—*Untitled (Surveillance is
your busywork)*—suggesting a twisted shift
in who-is-doing-what-for-and-to-whom. In
retrospect, the two works taken together
anticipated how much of our daily lives would
become raw material for the surveillance
economy to come.

Other premonitions seem to abound in what
the artist has called her "pre-digital" period.[13]
MY FACE IS YOUR FORTUNE, we read in 1982,
and the declaration tips a hat to the future
development of facial recognition software.
*Untitled (We are the objects of your suave
entrapments)* (1984) provides a particularly
concise and discomfiting summary of the
coercive networks of participation and con-
sumption that have come to encircle us. In the

accompanying picture, a woman's manicured
hand touches—caresses? is caressed by?—
a knotted and elegant net (fig. 5). To borrow
from the litany of possible descriptors that
feature in one of Kruger's more recent videos,
all of this work may indeed be about "surveil-
lance and the constancy of control."[14]

This female subject and idealized "new"
feminine spectator of Kruger's 1980s works
were naturally aware of these policing bureau-
cracies and their objectifying mechanics. The
imperfections of real bodies had no place in
popular culture and commercial media, except
as items to be cleaned up and corrected.
Mass media, it seemed to Kruger, exploited
the viewer's body to its own ends. Describing
what she called "the images and products
around us," she noted that "they use us rather
than us using them."[15] *We are being made
spectacles of*, and devoured in the process.

That cyclical doubling—of looking and
being looked at, of consuming and being con-
sumed—operates differently in galleries, news
media, and public spaces, and Kruger has
always used each arena to maximum advan-
tage. Paradoxically, her work tends to be at its
most powerful when she allows it to flirt with
the natural conditions of its context, dissolving
some of its authority. Her billboards have
posed as public service announcements or
disembodied ads lacking products; practically,
they act as both. Kruger's curatorial projects,
pursued early in her career, slyly commingled
certain artworks with examples of the public

Fig. 5: *Untitled (We are the objects of your suave entrapments)*, **1984. Gelatin silver print; 48 ½ × 97 ½ in. (123.2 × 247.7 cm). Ella Fontanals-Cisneros Collection**

16
"Gathered" is used on the poster and checklist, but "curated" appears in the press release.

17
Press release for *Pictures and Promises: A Display of Advertisings, Slogans and Interventions* at The Kitchen, New York, January 8–February 5, 1981.

18
See Sturtevant, "Inherent Vice or Vice Versa," *Tate Papers*, no. 8 (Autumn 2007), https://www.tate.org.uk/research/publications/tate-papers/08/inherent-vice-or-vice-versa.

signage, logos, advertising, and material culture that the selected artists referenced or appropriated.

Pictures and Promises: A Display of Advertisings, Slogans and Interventions (1981) "gathered"[16] by Kruger at The Kitchen in 1981 featured greeting cards; ads for Chase Bank, *Gentleman's Quarterly*, Dow Chemical, General Electric, and Arco; "Jewel ads"; "Liquor, Clothes, Perfume (Male) ads"; "Female, Fashion and Gesture ads"; and a "Kodak Photographic Paper carton" (fig. 6). Interspersed among these materials were pieces by artists including Dara Birnbaum, Victor Burgin, Jimmy De Sana, Barbara Ess, Hans Haacke, Jenny Holzer, Richard Prince, Cindy Sherman, John Stezaker, and Hannah Wilke, as well as those by Kruger herself. Though it is infrequently mentioned, the show also included a video section that Kruger co-organized on a single monitor with Birnbaum, complete with an annotated checklist. Primarily consisting of commercials, the program included ads made for the US Navy and a "new steamer shower massage from WaterPik" that Kruger glossed with an evocative tagline: "Soothing and relaxing…from a gentle spray to a super hard pulse…"[17]

These "interventions," as she termed them, may now be most interesting for the demotions enacted by their confusions — the way in which, for instance, Kruger briefly returned Richard Prince's photographs of silver and gold watches to the realm of luxury retail commerce from which they had come. Prince's little deepfakes, following those that

Sturtevant had made of other artworks more than a decade earlier, pointed to ways in which new meaning could begin to be coded and signaled to attentive viewers from inside familiar forms, engaging what Sturtevant referred to as the "interior of art."[18]

Isolated and recirculated into a different context, the looped commercials in *Pictures and Promises* might also be regarded as a series of proto-memes, *avant* the network. We now recognize — if we notice them at all — similar strategies of communication designed to stealthily disperse political messages through the jokier and fun forms of "content" that we encounter and share online. What was once an overt visual and rhetorical system messaged *at* us has gone underground, with cues and emotional manipulation delivered at the intimate scale of our social media "feeds." There is greater power now in acting *through* us. Ratifying and repackaging rhetoric with a simple repost, we become the instruments for today's messaging, which hides great sophistication in low resolution. *Thank you for sharing.*

While many of us were debating the empowering and deleterious aspects of social media, cycling through discussions about narcissism and voyeurism, others — those whom Kruger would call "power," for short — were refining their mastery of these tools. By design, we helped refine it for them. Speaking of the meme and its political efficacy, the director of data for Trump's 2016 campaign said, "It's almost like a new means of communication — the image and emotion and creation." Kruger

19
Matt Braynard, quoted in Nellie Bowles, "The Mainstreaming of Political Memes Online," *New York Times*, February 9, 2018, https://www.nytimes.com/interactive/2018/02/09/technology/political-memes-go-mainstream.html.

20
See Kathleen Hall Jamieson, *Cyberwar: How Russian Hackers and Trolls Helped Elect a President; What We Don't, Can't, and Do Know* (New York: Oxford University Press, 2018).

21
Barbara Kruger, "Summer 1988," in *Remote Control: Power, Cultures, and the World of Appearances* (Cambridge, MA: MIT Press, 1993), 58.

22
Kruger, "Summer 1988," 59–60.

Fig. 6: View of *Pictures and Promises*, The Kitchen, New York, 1981. Courtesy of the artist and the Getty Research Institute, Los Angeles

would likely agree with his summary: "I don't want to call it literature, but it has an art."[19] The rhetorical field of social media had defined this new commercial art much as Madison Avenue, television, and fashion magazines had done in the postwar decades. But instead of creating and enforcing a common culture from above, the new art is designed to work through personalized channels of sharing, liking, and canceling from below. That this sounds and feels at times like democracy has confused things, especially once we learned how easily social media lends itself to interference in our political discourse and electoral systems.[20] *Your assignment is to divide and conquer.*

Back in the halcyon days of the 1988 presidential election, when American democracy found it easier to maintain a veneer of equity, Kruger wrote about the "fictive consensus" that the mass media conspired with electoral politics to create.[21] "For what and whose purposes are we allowed to bask in the warmth of civic affection promised by the democratic model?" she asked, trolling the rituals meant to bring the country together. "How aware are we of attempts to appropriate this process of plenitude, to convert it into a kind of figurative deficit, a battle cry for the stingy,

the laughless, the gangster?"[22] A few months earlier, for the *Yale Law Journal*, she had laid the words MAN'S BEST FRIEND over an image of the Supreme Court Building. In another variation of this work, executed around the same time, she added WHITE atop it all, a visual modifier and reminder of the racial hierarchy that undergirds American law. Kruger's text calls out the Court's sloganed façade, casting its proclamation of EQUAL JUSTICE UNDER LAW as just another deflated cliché whose idealism is tuned to mask its inherent contradictions (fig. 7).

Kruger's work over the past decade maps a tightening network of relationships between the themes that have long been her subjects, amplified by technology's blurring of intimate, commercial, and political communication. She has found her style mimicked and inscribed within these networks, and in retrospect this appears to have been pleasantly inevitable, if not purposeful. In 2011, Kruger reprised her classic *Untitled (I shop therefore I am)* (1987) for a wallpaper installation, using the image of the hand as a container for more than five hundred images she found online that adopt aspects of her aesthetic. More recent work has included Instagram posts of people posing with her original *I shop …* work in a 2018

Fig. 7: *Untitled (White man's best friend)*, 1987. Gelatin silver print; 7 × 8 in. (17.8 × 20.3 cm). Courtesy of the artist

23
Brand New: Art and Commodity in the 1980s, Hirshhorn Museum and Sculpture Garden, Washington, DC, February 14–May 13, 2018.

24
Barbara Kruger, quoted in Carol Squiers, "Diversionary (Syn) tactics: Barbara Kruger Has Her Way with Words," *Artnews* 86, no. 2 (February 1987): 84.

25
Kruger, "Untitled." Among many examples: "It's both frightening and compelling how, in this celebrity-crazed time, human beings, bodies, become 'figures.'" Kruger, "Interview with Barbara Kruger," by Lynne Tillman, in *Barbara Kruger*, exh. cat., ed. Ann Goldstein (Los Angeles: Museum of Contemporary Art; Cambridge, MA: MIT Press, 1999), 196.

26
See for example, Charlie Warzel and Stuart A. Thompson, "How Your Phone Betrays Democracy," *New York Times*, December 21, 2019, https://www.nytimes.com/interactive/2019/12/21/opinion/location-data-democracy-protests.html.

exhibition about the 1980s at Washington, DC's Hirshhorn Museum and Sculpture Garden, as if to remind her audiences that she still feels the same way she did when she made that piece.[23] "I wanted [my work] to enter the marketplace," she explained in 1987, "because I began to understand that outside the market there is nothing—not a piece of lint, a cardigan, a coffee table, a human being."[24]

What happens to our bodies in this ecosystem has long been one of Kruger's central concerns, what she called "the vulnerabilities of heartbeats" and "the incision-prone vagaries of skin."[25] How should we understand our bodies in an age in which apps have coerced us to provide our fingerprints, our heart rates, and information regarding our sleep and menstrual cycles to corporations that index these vital statistics against everything else they've been gathering on our habits, behaviors, preferences, and perversions? How do we make sense of those invisible data sets in relation to visceral images of violence against Black and Brown bodies that circulate ambivalently on devices in this same market of spectacle and surveillance? How should we understand the location data collected through our phones that makes searching for nearby restaurants easier, while also capturing and recording our presence at protests?[26] Hal Foster described the stakes of Kruger's work in the mid-1980s as centering around "the positioning of the body in ideology," but those stakes have changed as we have slowly, but also very quickly, submitted our bodies to a new and frightening kind of knowledge. *You molest from afar.*

Describing this epistemic economy mined from our bodies and lived experiences, Shoshana Zuboff in 2014 began referring to "surveillance capitalism." Sketching a terrain of extraction and exploitation upon which

27
Shoshana Zuboff, *The Age of Surveillance Capitalism: The Fight for a Human Future at the New Frontier of Power* (New York: PublicAffairs, 2019), 180.

28
Shoshana Zuboff, "You Are Now Remotely Controlled," *New York Times*, January 24, 2020. Here, the author updates her question: "Who knows? Who decides who knows? Who decides who decides who knows?"

29
See Bruce Schneier's blog *Schneier on Security*, http://www.schneier.com. I explored related subjects in a 2010 exhibition, *The Talent Show*, Walker Art Center, Minneapolis, April 10–August 14, 2010.

Fig. 8: Illustration by Erik Carter, from the *New York Times*, January 24, 2020

Silicon Valley has constructed itself, she poses a series of Krugeresque questions relating to the distribution of knowledge and authority: "Who knows? Who decides? Who decides who decides?"[27] In a perfect illustration of Kruger's influence and her continuing impact on public discussions of power, the *New York Times* mimed her style in framing a major Zuboff op-ed about the dangers of this new world order. Titled "You Are Now Remotely Controlled," the article was accompanied by an illustration by Erik Carter that plainly drew inspiration from Kruger's 1980s work (fig. 8).[28]

Zuboff lays out some of the many ways in which artificial intelligence is designed to predict and monetize our future behavior, and how companies like Google and Facebook run vast experiments to manipulate our emotions. She is among a number of people who in recent years have shown how these resources can be marshaled, weaponized, and sold for political and financial advantage.[29] Her argument is one for the future, where liberty is quite realistically at risk. One need only consider how the Chinese government is using its surveillance apparatus against disfavored minorities to stunningly repressive ends. *The future belongs to those who can see it.*

Kruger's most recent videos seem designed to activate her long-standing concerns in the context of these near-term dystopias. Remaking selected 1980s hits in animated form, she fractures and dissolves the images of these older works. The new version of *Untitled (Your body is a battleground)* (1989/2019), which Kruger originally created as a public poster for a march on Washington in support of legal abortion, birth control, and women's rights, begins as a disarticulated puzzle, the pieces of which are piled at the bottom of the screen. The shapes start to slowly float upward, as if guided by some omniscient digital hand, and snap into place, revealing a woman's face. The digital visage also features in *Untitled (Remember me)* (1988/2020), which conjures an image of a closely cropped eye

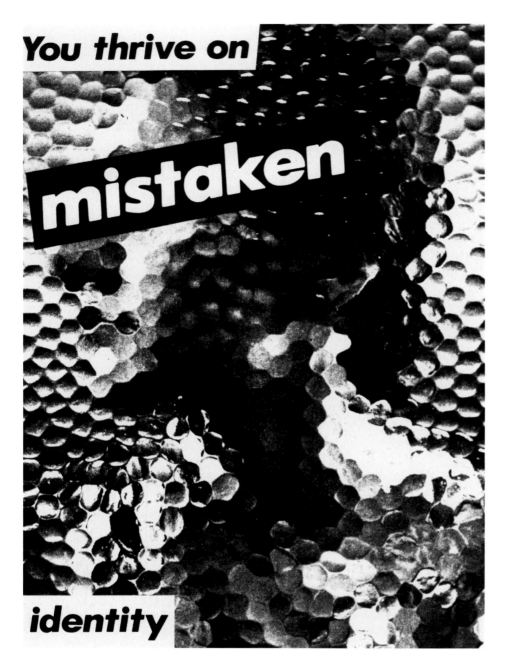

Fig. 9: *Untitled (You thrive on mistaken identity)*, 1981. Gelatin silver print; 60 × 40 in. (152.4 × 101.6 cm). Collection of Liz and Eric Lefkofsky

30
Kruger has noted similarities between our viewing behavior online and the ways in which we once consumed magazine images and content—what she calls the "speed of the read" in digital life, and its relation to the flipping of magazine pages—connecting her early professional involvement with the art direction of titles like *Mademoiselle* to her more recent videos. Conversation with the author, February 11, 2020.

from an aerosolized squall of pixels that evokes the graphic visualizations of data points.

Kruger's newest video, *Untitled (No Comment)* (2020), draws together a wide sampling of meme culture and what she clearly sees as dangerously narcissistic online predilections.[30] Sending up driving-navigation software, a computer voice directs us along the path of Adoration to Contempt, then onward to Jealousy and Revenge before we are instructed to "take the roundabout at

Denial." A number of Trump associates and predecessors flash past, beginning with Roy Cohn and his boss Senator Joseph McCarthy before moving on to Roger Stone (shown shirtless, displaying his back tattoo of Nixon), Steve Bannon, Vladimir Putin with aging action star Steven Segal, Michael Cohen, Stephen Miller, and Sarah Huckabee Sanders. Hairstyling videos join memes like "kitty in toilet bowl." Other cats, singing and talking, recall the various ventriloquist references in

31

"And sometimes ventriloquism is one of the moves I use to set the scene and make my points: to zig-zag between the vulnerabilities of tenderness and the unrelenting cruelty of humiliation and verbal violence." Kruger, "Interview," by Tillman, 193.

32

"If you see people's bookmarks, you can pretty much read their autobiography. That's interesting but also frighteningly reductivist." Barbara Kruger, "Resisting Reductivism & Breaking the Bubble," interview by Ian Forster, *Art21 Magazine* (Winter 2018), https://art21 .org/read/barbara-kruger -resisting-reductivism-break ing-the-bubble/.

33

For a discussion of meme culture in relation to Black identity, see Aria Dean, "Poor Meme, Rich Meme," *Real Life*, July 25, 2016, https://reallifemag.com /poor-meme-rich-meme/.

34

This quote comes from the text that Kruger wrote and installed within *Picturing "Greatness,"* an exhibition she curated from the collection at The Museum of Modern Art, New York, January 14–April 17, 1988.

her work, such as the dummy who features in *Untitled (Our Leader)* (1987).[31] Emojis dance, and teens preen. EVERYTHING'S THE MATTER. On the final red screen, a list in white text is typed out. THIS IS ABOUT THE DIFFERENCE BETWEEN THE BODY AND THE FIGURE, it begins. With what we might interpret now as a differently inflected irony, the list concludes with WHAT IS REMEMBERED AND WHAT IS FORGOTTEN.

Kruger knows that everything is remembered now, whether we like it or not. The eye at the center of *Remember me* stares intently out at us like the man in *Surveillance is their/ your busywork*. The skin that we see in such intimate proximity in the work likewise links *Remember me* to *Your body is a battleground*, and this confluence of references helps to politicize the act of remembrance differently, casting it more clearly now as another form of control. Those resisting the perpetual compilation of personal information, notably, speak of a right to be forgotten.

In this light, the woman whose face is refracted or distorted across a textured surface in *Untitled (You thrive on mistaken identity)* (1981) appears as a model of liberation and caution in the age of facial recognition technologies: We will only be free to flourish if corporations and government are prevented from knowing our entire data sets (fig. 9).[32] Resistant to summary herself, Kruger has moved fluidly among identities as an artist and a designer, a writer and a curator, a media critic and a "gatherer," an architect, a teacher, a feminist, and a citizen. Evading definition, she also avoids being pictured, undoubtedly in part because she recognizes the threat that photographs contain for both the private and public body today. "Cameras invade our exteriors and interiors," she notes in *Untitled (Artforum)* (2016/2020), "making for a kind of laparoscopic mapping of our weakest links." *Now you see us. Now you don't.*

While Trump's election highlighted the dark potentials inherent in the predations of Big Data, the alarms of unfreedom that Zuboff and others have sounded may be most frightening to those not already familiar with life under conditions of state surveillance, pop cultural distortion, and exploitation.[33] Put differently: The prejudicial assessments, objectification, and enforced submission to which patriarchal white American culture subjects women (and people of color) are now broadly—if mostly invisibly—applied across the society at large. We may regard the particular relevance to these discussions of Kruger's groundbreaking work of the 1980s as a mark of its enduring

significance, and we should. But the pointed bite it bears today should also remind us that the lessons of various intersectional feminisms are both instructive and expansive, linking together common concerns of historical and contemporary communities outside the strictures of gender. And that, too, is an achievement of Kruger's art.

How we continue to be "seduced into the world of appearances, into a pose of who we are and who we aren't," will shape the near future.[34] For that matter, will we be able to protect who we believe we are and aren't from the summarizing efficiencies of our government and corporations? And what, exactly, will be left to us? Will we be able to tell a secret even to ourselves? *I will not become what I mean to you,* she said, and we may take it as a motto to live by.

Enough about You. Let's Talk about Me: Barbara Kruger on Contemporary Cultures of Voyeurism, Stereotype, and Narcissism

Zoé Whitley

1
Barbara Kruger, *Remote Control: Power, Cultures, and the World of Appearances* (Cambridge, MA: MIT Press, 1993), 39.

2
Miwon Kwon, "A Message from Barbara Kruger: Empathy Can Change the World," in *Barbara Kruger* (New York: Rizzoli, 2010), 95.

"If someone isn't eyeing us, we're eyeing ourselves."[1]
—Barbara Kruger, 1990

For every artist who professes that her work "speaks for itself," Barbara Kruger is the rare artist who actually delivers on that promise. The directness of her messaging and its unmistakable legibility owe much to our fluency in typefaces such as Futura Bold Oblique and Helvetica Ultra Compressed— which read as recognizably as if they were Kruger's own signature, since she has used them consistently throughout her five-decade-long career as a conceptual artist. With the observational skill and rigor of a social anthropologist, Kruger has maintained a lifetime interest in recording human behavior in capitalist society, drawing on social semiotics and retinal perception to reflect our basest impulses and most selfish desires back to us.

In January 1991, Barbara Kruger created the first iteration of what would become her room wraps at Mary Boone Gallery in New York City. Room wraps are what the artist calls the space-enveloping texts with which she wallpapers all of the planes within an interior space, transforming it into a full, near-disorienting spatial environment. As viewers, we are enfolded by Kruger's words, statements, cautions, and admonishments. In this very first version, white text on red ground overtook the expanse of ceiling above and the floor below (fig. 1). As one entered the space and looked down, one was met with

ALL THAT SEEMED BENEATH YOU IS SPEAKING TO YOU NOW. ALL THAT SEEMED DEAF HEARS YOU. ALL THAT SEEMED DUMB KNOWS WHAT'S ON YOUR MIND. ALL THAT SEEMED BLIND SEES THROUGH YOU. ALL THAT SEEMED SILENT IS PUTTING THE WORDS RIGHT INTO YOUR MOUTH.

Upon looking up:

DON'T LOOK UP TO ANYONE BECAUSE POWER MAKES THEM HOT. THEY DON'T WANT TO LOSE IT AND THEY NEVER GIVE IT AWAY. SOMETIMES THEY ACT HUMBLE BUT DON'T BELIEVE THEM. THEY FOLLOW THE LAW AS LONG AS IT WORKS FOR THEM.

Kruger creates situations where we can meaningfully engage in systemic critique as well as self-reflection. How often might we otherwise consider the psychosocial stakes of feeling superior or inferior to others? Of examining our own actions when looking down on someone else, or reflecting upon the circumstances dictating whom we look up to? A clairvoyant narrator confronts us, conjuring images in the mind's eye of our vulnerabilities and those, unseen, who might exploit them. Caught between this proverbial rock and hard place, the viewer must choose where to stand between hierarchies of speaking up and hero worship. Miwon Kwon notes that Kruger can "radically explode the viewer's habituated complacency."[2] Kruger's use of language actively engages the enveloping architecture in order to immerse

3
The room also featured a wallpaper version of *Untitled (It's our pleasure to disgust you)* (1991).

4
Lemi Baruh, "Publicized Intimacies on Reality Television: An Analysis of Voyeuristic Content and Its Contribution to the Appeal of Reality Programming," *Journal of Broadcasting & Electronic Media* 53, no. 2 (June 2009): 190–210.

5
Kruger, *Remote Control*, 23.

6
Kruger, 23.

7
Kruger, 23.

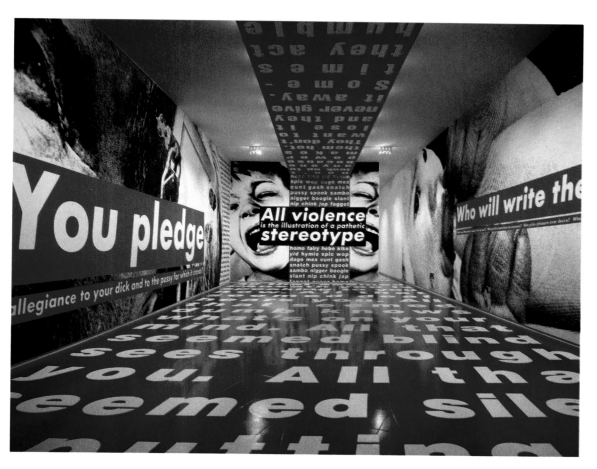

Fig. 1: View of *Barbara Kruger*, Mary Boone Gallery, New York, 1991

the body and reinvigorate the mind. Our surroundings become impossible to ignore.

The text for the floor of a second room of the installation (fig. 2) unfolds like a postscript:

THE VOMITING BODY SCREAMS "KISS ME" TO THE SHITTING BODY WHICH COOS "SMELL ME" TO THE VAIN BODY WHICH HISSES "I WANT YOU INSIDE OF ME" TO THE DEAD BODY WHICH IS HARD TO DISPOSE OF.

Like an involuntary bodily emission, Kruger's words regurgitate our unheard thoughts, suppressed urges, and unexpressed motivations. The bodies scream, excrete, struggle to verbalize, crave, whimper, and ultimately die — but not before seeing themselves being seen.[3]

In this way, Kruger engages our voyeuristic tendencies, not in the clinical, psychosexual meaning of the word *voyeurism* but as the term has been redefined by media studies. Lemi Baruh, a professor of advertising and communication, specifies, "Rather than emphasizing sexual deviance, recent accounts of contemporary culture conceptualize voyeurism as a common (and not solely sexual) pleasure derived from access to private details."[4] This "curious peeking into the private lives of others," notes Baruh, is exacerbated by the contemporary use of electronic media. Kruger, for her part, has long been aware of this societal trend. In her 1987 critique "Contempt and Adoration," the artist likened Andy Warhol to "any good voyeur"[5] for his ability through his films to be

a withholder who became the doorkeeper at the floodgates of someone else's expurgatory inclinations.[6]

Indeed, Kruger could be referring to any number of scripted "reality" television programs when she pinpoints Warhol's "ability to collapse the complexities and nuances of language and experiences into the chilled silences of the frozen gesture."[7] Our willing consumption of stereotypes, then, can be construed as an act of voyeurism.

Kruger summarizes, "In my production pictures and words visually record the collision

8
Barbara Kruger, quoted in Ann Goldstein, "Bring in the World," in *Barbara Kruger*, exh. cat., ed. Goldstein (Los Angeles: Museum of Contemporary Art; Cambridge, MA: MIT Press, 1999), 35.

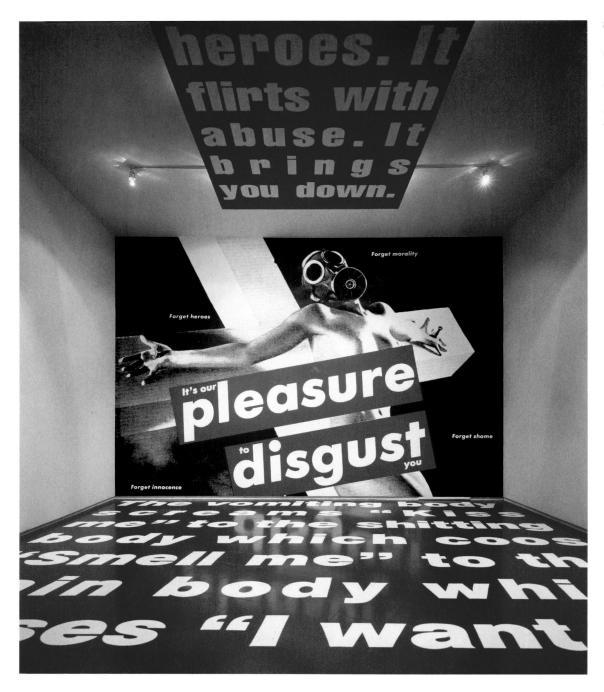

Fig. 2: View of *Barbara Kruger*, Mary Boone Gallery, New York, 1991

between our bodies and the days and nights which construct and contain them. I am trying to interrupt the stunned silences of the image with the uncouth impertinences and uncool embarrassments of language."[8] Whereas earlier works reveled in the difference/distance between the close-up depictions of figures in black and white, face-to-face with the physical presence of our own in-living-color bodies, in the room wraps, we become the observing bodies and the observed figures simultaneously. In *Untitled (Forever)* (2017, fig. 3), a central, bold YOU. is printed in black on white as if convex in shape, and addressing the viewer:

YOU. / YOU ARE HERE, LOOKING THROUGH THE LOOKING GLASS, DARKLY. / SEEING THE UNSEEN, THE INVISIBLE, THE BARELY THERE. YOU. / WHOEVER YOU ARE. WHEREVER

9
Conversations with James Baldwin, ed. Fred L. Standley and Louis H. Pratt (Jackson: University Press of Mississippi, 1989), 31.

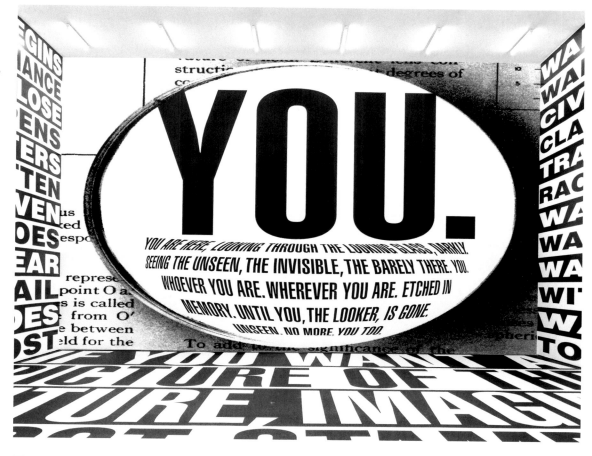

Fig. 3: *Untitled (Forever)*, 2017, installation view, Sprüth Magers, Berlin, 2017–18

YOU ARE. ETCHED IN / MEMORY. UNTIL YOU, THE LOOKER IS GONE. / UNSEEN. NO MORE. YOU TOO.

Kruger's YOU. recalls James Baldwin's 1962 insight in an interview with artist Ben Shahn and composer Darius Milhaud:

Art has this advantage: that you can see yourself in it, if you will bring yourself to it. The trouble with art in our time, it seems to me, is that most artists are not involved with that. They are involved with creating a fantasy that corroborates my fantasy of myself and yours of you and imprisons all of us in it. […] It is always you.[9]

Baldwin cites the then-popular soap opera *Peyton Place* (1964–69) as being inescapable in its appeal because its narrative validates private fantasies in which we wish to indulge. We binge on it like junk food, are left malnourished, yet come back for more.

As the viewer looks and makes value judgments as she reads, all the while being "read" by the onslaught of text from all sides, the room wraps enclose her physically while exposing her emotionally. There's no solace in the words, as we square up to reminders of our anonymity and mortality. By playing with perspective anamorphosis within the cartouche inscription, Kruger holds up a distorted mirror into which we peer, one that acknowledges the gawking subject only to dismiss and disregard that person. In the artist's recent work, she ensures that we the viewers are active participants rather than passive receivers of content. We have agency and must exercise it by moving around the room in order to fully apprehend the messages. The texts in our peripheral vision taunt us and court our attention. It could be argued that the only perspectives provided by contemporary media are varying degrees of anamorphosis, contributing to a social dysmorphia.

Barbara Kruger forces us to ask, "What constitutes the construction of self now?" In 1988, the artist was invited by The Museum of Modern Art in New York to curate an exhibition

10
Kruger, *Remote Control*, 222.

11
Homi K. Bhabha, "The Other Question: Stereotype, Discrimination and the Discourse of Colonialism," in *The Location of Culture* (London: Routledge, 1994), 73.

***Untitled (Rug)*, 1991–93**

drawn from MoMA's permanent collection. The result, *Picturing "Greatness,"* included forty black-and-white photographic portraits, capturing historical definitions of, in Kruger's own words, "what it means to look like an artist." At the time, the artists who had achieved greatness were mostly male and mostly white. Kruger was there to hold up the mirror, asking, "What tropes construct self-presentation?" While what an artist looks like has expanded greatly today, Kruger's observations remain relevant:

> These images can also suggest how we are seduced into the world of appearances, into a pose of who we are and who we aren't. They can show us how a vocation is ambushed by cliché and snapped into stereotype by the camera, and how photography freezes moments, creates prominence, and makes history.[10]

It is here worth bearing in mind that *stereotype* and *cliché* are both historical printmaking terms related to the cheap and quick reproduction and circulation of printed texts, describing a cost- and labor-saving mechanism—a single cast copy of all of the complex original component parts, and thus a simpler whole—that prevented the typesetter's having to reset individual letters each time a page of text was reprinted. *Stereotype* entered common parlance as the term for generalizing, over time being understood as a prejudicial behavior primarily motivated by the need to classify difference. The adherence to stereotype or the unfounded belief in differentiation between human beings has been helpfully described by Homi K. Bhabha as something fundamentally unstable and always in a state of flux, a "fixation which moves between the recognition of cultural and racial difference and its disavowal, by affixing the unfamiliar to something established, in a form that is repetitious and vacillates between delight and fear."[11]

Perhaps nowhere is that conflation of delight and fear more acute than on reality television, one of Kruger's sources of observational material. The phenomenology of reality TV is founded on reductive, fight-or-flight emotional states wrought from minor misunderstandings. On camera, individuals tend to small hurts until they flower into explosive outbursts for the viewer's voracious consumption. "We observe TV as it transforms people into personages, ironing out the complex pleats of the social into a flatly

12
Kruger, *Remote Control*, 98.

13
Kruger, 97.

14
Nikki Giovanni, "Poem for a Lady Whose Voice I Like," in *The Selected Poems of Nikki Giovanni* (New York: William Morrow, 1996). Also available at https://www .poetryfoundation.org/poems /48226/poem-for-a-lady -whose-voice-i-like.

15
Barbara Kruger, telephone conversation with the author, January 15, 2020.

fragmented continuum of demi-associated moments."[12] These moments of loose association to which Kruger refers are the editorial underpinning of reality television today. And yet they weren't invented by the producers of *Keeping Up with the Kardashians* or *The Real Housewives.* In psychology, illusory correlation is the phenomenon within human perception whereby we misperceive group differences and behaviors by overdetermining what we observe. This practice can cement an infrequent occurrence as a stereotype: We come to believe what we see, based on information as limited as a onetime occurrence. Observing and being become intertwined and conjoin.

Kruger's chosen medium, then, addresses the systems of prejudging in both form and content. Between Barbara Kruger's sharp demarcations of black, white, and red, she expands the frame for the existence of liminal spaces between self-doubt and self-belief, superiority and oppression, fiction and reality.

Kruger also cleverly remixes technologies new and old. Her earlier oeuvre presented two-dimensional scenarios in which the late Craig Owens identified that the artist mines a seam of recurrent, arresting immobility. Kruger has since turned to producing moving-image works and has also returned to previously static works, remixing them through a range of available technologies, first through lenticular prints and subsequently reinventing compositions through LED animation design. In Kruger's *Untitled (Selfie)* (2020), the mobile phone has become the mirror of choice. In order to enter the work, viewers enter a contract with the artist, agreeing to participate by being photographed within the gallery.

—

As stereotypes are relentlessly amplified around us through digital television, streaming services, and social media, we find ever more ways to be simultaneously repelled and beguiled by our own capacity for self-absorption. The audience is self-selecting, drawing on the artist's core motivators of questioning and casting doubt. Does one choose to avoid the room altogether or to indulge in narcissism in the name of art? Kruger makes way for multiple meanings to be elicited from the spectators as they participate voluntarily.

The effectiveness of Kruger's conceptual interrogations lies in their inclusiveness. To again quote Miwon Kwon, the artist's installations are "also a space for the possibility of intersubjective empathy."[13] Kruger's 1988 photographic silk screen on vinyl *Untitled (Heart)*, in which the question DO I HAVE TO GIVE UP ME TO BE LOVED BY YOU? is printed atop what looks like a dissected human heart, can be understood as either a self-centered complaint or a heartrending plea. It calls to mind the 1982 documentary *All by Myself: the Eartha Kitt Story*, directed by Christian Blackwood. An unapologetic and uncompromising Kitt drops such self-worth gems as "I feel very safe within myself and I like me very much," and on matters of love she offers: "Yes, I fall in love with myself and I want someone to share it with me. I want someone to share me with me." These affirmations have new afterlives online, as memes, YouTube clips, and #self-care GIFs. What out of context could be viewed as wholly selfish has been embraced by contemporary calls for self-love and unapologetic self-regard.

Selfie, like so much of Kruger's oeuvre, lays bare the performative strategies of ego construction and self-definition. A poetic forebear to this project can be read in the closing lines of Nikki Giovanni's "Poem for a Lady Whose Voice I Like":

and he said: you pretty full of yourself
ain't chu
so she replied: show me someone not
full of herself
and i'll show you a hungry person[14]

Barbara Kruger doesn't stand apart from the critiques she evinces, nor does she judge her audience for the positions individually taken to behold or to opt out. Instead, she optimistically offers, "There can be — and hopefully there is — separation between self-belief and narcissism."[15] For all its black-and-white clarity, Kruger's art ultimately revels in the gray areas, luring us into the nuances to be found in between extremes.

Works in
the Exhibition

pp. 90–93: Stills from the video *Untitled (No Comment)*, 2020

ot. An adoring
fatal blow. A
A bullshit an
brazen hustl
race of joy. A
nrelenting f
rplus of grief
disenchant
ling questio
A reality o

s, harden my heart, stone my face, and shatter my reluctant human surface.

This is about the beginning of the end. This is about the canny use of fear. About doing damage. About twisting the knife and slicing skin. This is about the memory of tenderness and the brutality of forgetting. This is about the perpetual lie. About greed, rage, and grievance. This is about pain and pleasure and the erasure of empathy. About the genius of evil and a kind of feral brilliance. This is about the failure of imagination and the end of shock.

A fluidity that suggests the breakdown and dispersions of the gender binaries that have narrow the definition of what can be a sexualized or asexualized body? Of what we might want and need? Of what makes us feel good or bad or anything in between? And this has been made possible, in part, by surgical procedures that alter, suture, and modify our possibilities, pleasure and desires. But they also throw into a tizzy the conventional divisions of gender, put pronouns crisis and make battlegrounds out of the places where we pass waste and wash hands.

A post used to be something you hooked a horse up to. And then it became what you did to get a message from one person to another. Following these semi ararchaisms, it became a prefix that indicates a condition, circumstance, event, or person whose time has passed. So what does it mean to stick the word post in front of the words "race", "gender", and "human"? Categories are useful tools that can parse the complexity and thickness of the world. But they are also canny devices that feed us that world in increments, in spoonfuls and slices that make for both understanding and misunderstanding. They are the forensics that might allow us to (mis)perceive wholeness.

Our brief: Today, in our endlessly pluralist and globalized world, we are supposedly post-identity, post-race, post-gender, even post-human. But at the same time, the most identitarian of politics is being mobilized, both by advanced culture—which has seemingly rediscovered cultural difference, both its aesthetic possibility and its market value—and by the extreme ideologies or fundamentalisms of the

Could this mean the blurring of surety around what is truly "other"? Is the loosening of racial naming and stereotype just a prompt for a kind of "colorblindness" a delusion that flatters the "sensitivities" of white culture? An alibi that motors business as usual? Who's selling this, and who's buying?

Who's advanced and who's advancing? Like the term "late capitalism," it's rife with optimism, notions of progress, and tinged with delusion.

Stills from the video version of *Untitled (Artforum)*, 2016/2020

So now we might assume that identity is malleable, fluid, shifting. Naming, pointing, and categorizing are no longer unexamined actions. Can you control the drive to name, assume, or point? If you could do that, would you? How?

Do gene-splicing, cryo-genics, super-hybridity, and virtuality nudge us out of our decrepit brick-and-mortar bodies in post-humanity? And does this postness also promise that we can live forever with a minimum of pain? Can that be part of the deal? Cameras invade our exteriors and interiors, making our kind of laparoscopic mapping of our weakest links. We can theorize our finality from here to the mortuary, but can we really hope for a post-end? Can we stop the Grim Reaper, that major show runner, from pulling the final curtain?

most reactionary forces, via continued racism, discrimination, nativist fervor, and violence. Technology, too, has created new beings and new bodies. Social media has blasted open but also reinforced ever more esoteric subcultures and identifications. It's clear that identity is back, and more urgent than ever. How can we think through new paradigms? How can we reimagine old ones?

OK, so now the term "new" prefaces beings and bodies? What could be more time-based than the word "new." It begins with the "n" and it's over by the "w." Tick tock. Can we live lives without looking through a lens or onto a screen? No eye contact. No empathy. The screen is the mirror of choice, the crash site of narcissism and voyeurism. Why look at anything if it's not you or about you?

Doubt as grounds for arrest, torture, and murder. The destruction of difference, the war for a world without women, the war for me to become you.

Where when and where did it go? Its new renditions come with the added features of agency, disruption, and exchangeability. In what venues, locations, events, and discourses was identity missing and mistaken? And why?

96 **Stills from the video version of *Untitled (I shop therefore I am)*, 1987/2019**

the edge and the tension of a peripheral locator
healing and delusion
color and the signature of saturation
less righteousness and more vigilance
light and the creation of the illusory site
surface and the dictates of the forearm
placement and the expository ground
formula and the elegant solution
The work is about
free zones and perpetual treachery

desire and the prolongation of stasis
shopping and the image of perfection
utopia and the abandonment of context
community and the discourse of self-esteem
negotiation and reconciliation
The work is about
the punishments of binaries
sex and perpetual churn
laughing and shaming
screens and mirrors

Stills from the video version of *Untitled (The work is about . . .)*, 1979/2020

figures and the rhetoric of the real
hybridity and unimagined bodies
structure and arranged meaning
buildings and the direction of task
dislocation and the subversion of the habitual
mapping and containment
histories and assorted facts and fictions
The work is about
the arena and the business of men

rehearsing the con
hooliganism and the lure of the picaresque
autonomy and various impossibilities
concealment and the enhancements of forensics
The work is about
submission and triumphalism
the forced humility of the homemade
the casual hack
the relation between objects and events
surveillance and the constancy of control

pp. 100–103: *Untitled (Forever)*, 2017, installation views, Sprüth Magers, Berlin, 2017–18

WAR TIME, WAR CRIME
WAR GAME, GANG WAR
CIVIL WAR, HOLY WAR
CLASS WAR, BIDDING WAR
TRADE WAR, COLD WAR
RACE WAR, WORLD WAR
WAR FOR PEACE
WAR WITHOUT END
WAR FOR A WORLD
WITHOUT WOMEN
WAR FOR ME
TO BECOME YOU

Picturing "Greatness"
The pictures that line the walls of this room are photographs of mostly famous artists, most of whom are dead. Though many of these images exude a kind of well-tailored gentility, others feature the artist as a star-crossed Houdini with a beret on, a kooky middleman between God and the public. Vibrating with inspiration yet implacably well behaved, visceral yet oozing with all manner of refinement, almost all are male and almost all are white. These images of artistic "greatness" are from the collection of this museum. As we tend to become who we are through a dense *(cont.→)*

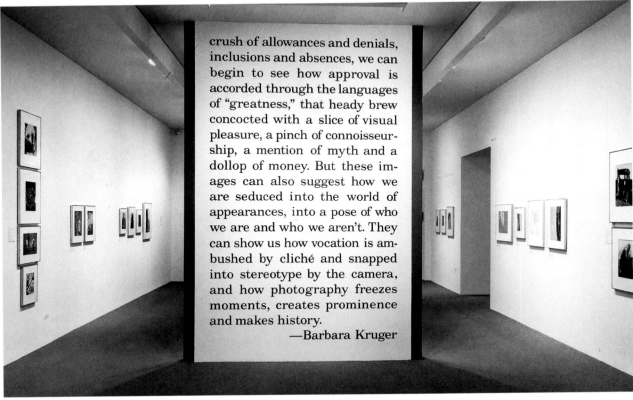

crush of allowances and denials, inclusions and absences, we can begin to see how approval is accorded through the languages of "greatness," that heady brew concocted with a slice of visual pleasure, a pinch of connoisseurship, a mention of myth and a dollop of money. But these images can also suggest how we are seduced into the world of appearances, into a pose of who we are and who we aren't. They can show us how vocation is ambushed by cliché and snapped into stereotype by the camera, and how photography freezes moments, creates prominence and makes history.
—Barbara Kruger

Views of *Picturing "Greatness,"* The Museum of Modern Art, New York, 1988

Untitled (Connect), 2015

pp. 107–09: *Untitled (Never Perfect Enough)*, 2020

COUPLE
GAME
PITCH
FACE
SCORE
MOMENT
STORM
PICTURE
LIFE
TIMING
PLACE
CRIME
KISS

PERFECT

OVERRATED, A MAJOR ARTIST, A MINOR FIGURE, A TIRED HACK, A SMALL FISH IN A BIG POND, FAMOUS, MARGINALIZED IN CERTAIN CIRCLES, RIDICULOUSLY DEMONIZED, CONSTANTLY RIPPED-OFF, A SERIAL APPROPRIATOR, A KEEN BULLSHIT DETECTOR, INSANELY SELF CON-SCIOUS, A GREAT DANCER, FRIENDLY, REMOTE, A SCARY GOOD READER OF PEOPLE AND THEIR PATHOLOGIES, TOTALLY CLUELESS, ICONIC, PERPETUALLY COASTING, HECTORING, BIG ON EMPATHY, ATTRACTS HATERS, NOT RIGOROUS ENOUGH, A SELL-OUT, CUTS THROUGH THE GREASE, BLAZINGLY ARTICULATE, HAS LITTLE TO SAY, HUMBLE, SELF-SERVING, FUNNY, GENEROUS, WARY, A BELIEVER IN DOUBT.

Advertisements for myself (project for the New York Times), 2014/2020

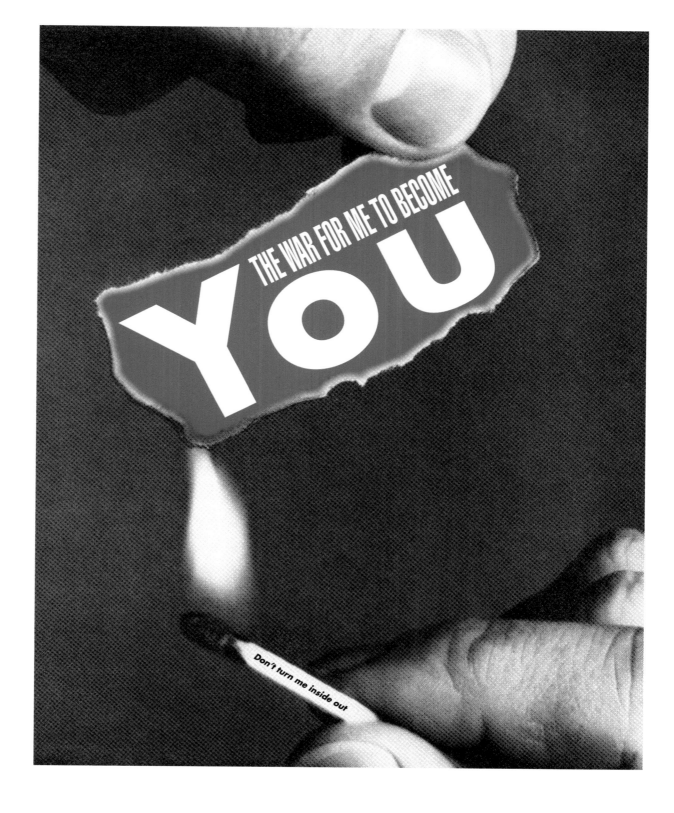

Untitled (The war for me to become you), 2008

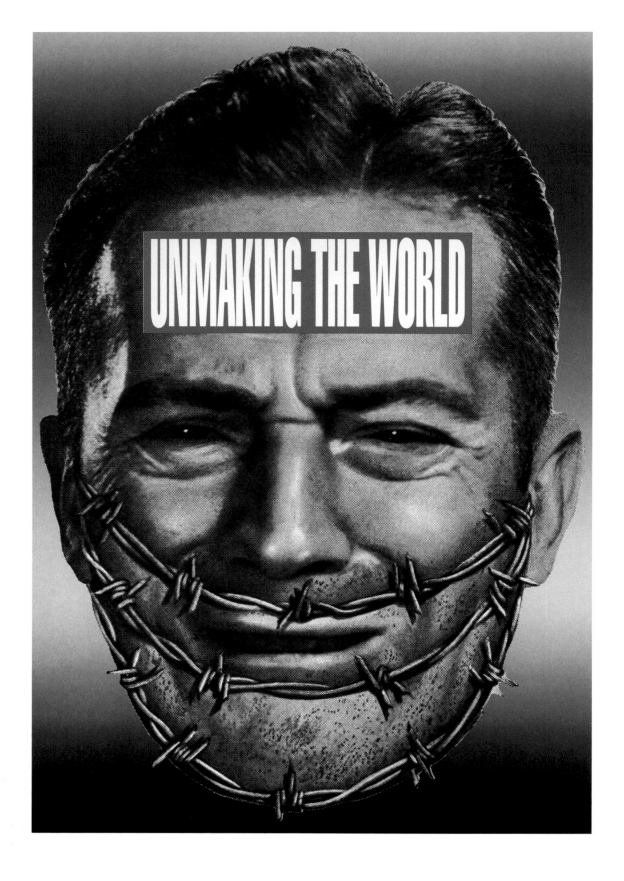

Untitled (Unmaking the World), 2008

OUR PEOPLE ARE BETTER THAN YOUR PEOPLE. MORE INTELLIGENT, MORE POWERFUL, MORE BEAUTIFUL, AND CLEANER. WE ARE GOOD AND YOU ARE EVIL. GOD IS ON OUR SIDE. OUR SHIT DOESN'T STINK AND WE INVENTED EVERYTHING.

Untitled (Our people), 1994/2017

I pledge allegiance

I pledge adherence

I pledge adoration

I pledge anxiety

I pledge allegiance to the flag of the Inherited Wealth

I pledge allegiance to the flag of the Marginalized Bodies

I pledge allegiance to the flag of the United States of America

I pledge allegiance to the flag of the United States of Amerika

I pledge allegiance to the flag of the United States of America and to the Resilience

I pledge allegiance to the flag of the United States of America and to the Resistance

I pledge allegiance to the flag of the United States of America and to the Republic for which it stands

I pledge allegiance to the flag of the United States of America and to the Republic for which it fails

I pledge allegiance to the flag of the United States of America and to the Republic for which it stands one nation, under my God is better than your God

I pledge allegiance to the flag of the United States of America and to the Republic for which it stands one nation, under God, indivisible

I pledge allegiance to the flag of the United States of America and to the Republic for which it stands one nation, under God, incoherent

I pledge allegiance to the flag of the United States of America and to the Republic for which it stands one nation, under God, insane

I pledge allegiance to the flag of the United States of America and to the Republic for which it stands one nation, under God, indivisible, with contempt

I pledge allegiance to the flag of the United States of America and to the Republic for which it stands one nation, under God, indivisible, with liberty and justice

I pledge allegiance to the flag of the United States of America and to the Republic for which it stands one nation, under God, indivisible, with liberty and judgement

I pledge allegiance to the flag of the United States of America and to the Republic for which it stands one nation, under God, indivisible, with liberty and power

I pledge allegiance to the flag of the United States of America and to the Republic for which it stands one nation, under God, indivisible, with liberty and grievance

I pledge allegiance to the flag of the United States of America and to the Republic for which it stands one nation, under God, indivisible, with liberty and justice for some

I pledge allegiance to the flag of the United States of America and to the Republic for which it stands one nation, under God, indivisible, with liberty and justice for a few

I pledge allegiance to the flag of the United States of America and to the Republic for which it stands one nation, under God, indivisible, with liberty and justice for the rich

Stills from the video version of *Pledge*, 1988/2020

I pledge affluenza

I pledge allegiance to the flag of the United States

I pledge allegiance to the flag of the Undefeated Teams

I pledge allegiance to the flag of the Divided Sentiments

I pledge allegiance to the flag of the United States of America and to the Rep

I pledge allegiance to the flag of the United States of America and to the Republic

I pledge allegiance to the flag of the United States of America and to the Resentement

I pledge allegiance to the flag of the United States of America and to the Retrenchment

I pledge allegiance to the flag of the United States of America and to the Republic for which it survives

I pledge allegiance to the flag of the United States of America and to the Republic for which it stands one nation

I pledge allegiance to the flag of the United States of America and to the Republic for which it stands one corporation

I pledge allegiance to the flag of the United States of America and to the Republic for which it stands one nation, under God

I pledge allegiance to the flag of the United States of America and to the Republic for which it stands one nation, under God, stitched together

I pledge allegiance to the flag of the United States of America and to the Republic for which it stands one nation, under God, indivisible, with liberty

I pledge allegiance to the flag of the United States of America and to the Republic for which it stands one nation, under God, indivisible, with exhilaration

I pledge allegiance to the flag of the United States of America and to the Republic for which it stands one nation, under God, indivisible, with reward

I pledge allegiance to the flag of the United States of America and to the Republic for which it stands one nation, under God, indivisible, with liberty and punishment

I pledge allegiance to the flag of the United States of America and to the Republic for which it stands one nation, under God, indivisible, with liberty and profit

I pledge allegiance to the flag of the United States of America and to the Republic for which it stands one nation, under God, indivisible, with liberty and revenge

I pledge allegiance to the flag of the United States of America and to the Republic for which it stands one nation, under God, indivisible, with liberty and clarity

I pledge allegiance to the flag of the United States of America and to the Republic for which it stands one nation, under God, indivisible, with liberty and justice for the poor

I pledge allegiance to the flag of the United States of America and to the Republic for which it stands one nation, under God, indivisible, with liberty and justice for the givers

I pledge allegiance to the flag of the United States of America and to the Republic for which it stands one nation, under God, indivisible, with liberty and justice for the takers

I pledge allegiance to the flag of the United States of America and to the Republic for which it stands one nation, under God, indivisible, with liberty and justice for all.

I take

I embrace

I arrange

I remove

I take you, to rent

I take you, to respect

I take you, to have and to hold

I take you, to have and to detain

I take you, to have and to hold, from this day forward, for contented

I take you, to have and to hold, from this day forward, for coopted

I take you, to have and to hold, from this day forward, for better or worse

I take you, to have and to hold, from this day forward, for better or shamed

I take you, to have and to hold, from this day forward, for better or worse, for richer, for poorer

I take you, to have and to hold, from this day forward, for better or worse, for richer, for ignored

I take you, to have and to hold, from this day forward, for better or worse, for richer, for unheard

I take you, to have and to hold, from this day forward, for better or worse, for richer, for poorer, in contagion

I take you, to have and to hold, from this day forward, for better or worse, for richer, for poorer, in sickness and rigor

I take you, to have and to hold, from this day forward, for better or worse, for richer, for poorer, in sickness and health, to love

I take you, to have and to hold, from this day forward, for better or worse, for richer, for poorer, in sickness and health, to elevate

I take you, to have and to hold, from this day forward, for better or worse, for richer, for poorer, in sickness and health, to isolate

I take you, to have and to hold, from this day forward, for better or worse, for richer, for poorer, in sickness and health, to love and to cherish till death

I take you, to have and to hold, from this day forward, for better or worse, for richer, for poorer, in sickness and health, to love and to cherish till the disappearing act

I take you, to have and to hold, from this day forward, for better or worse, for richer, for poorer, in sickness and health, to love and to cherish till death do us divorce

I take you, to have and to hold, from this day forward, for better or worse, for richer, for poorer, in sickness and health, to love and to cherish till death do us part, so help me God

I rape

I take you,

I take you, to have

I take you, to own

I take you, to have and to surround

I take you, to have and to capture

I take you, to have and to retain

I take you, to have and to hold, from this day forward, for better

I take you, to have and to hold, from this day forward, for better or injured

I take you, to have and to hold, from this day forward, for better or worse, for fraud

I take you, to have and to hold, from this day forward, for better or alienated

I take you, to have and to hold, from this day forward, for better or worse, for richer

I take you, to have and to hold, from this day forward, for better or worse, for richer, for poorer, in exhaustion

I take you, to have and to hold, from this day forward, for better or worse, for richer, for poorer, in neurosis

I take you, to have and to hold, from this day forward, for better or worse, for richer, for poorer, in addiction

I take you, to have and to hold, from this day forward, for better or worse, for richer, for poorer, in sickness and vigor

I take you, to have and to hold, from this day forward, for better or worse, for richer, for poorer, in sickness and health, to obsess

I take you, to have and to hold, from this day forward, for better or worse, for richer, for poorer, in sickness and health, to love and to cherish

I take you, to have and to hold, from this day forward, for better or worse, for richer, for poorer, in sickness and health, to love and to abuse

I take you, to have and to hold, from this day forward, for better or worse, for richer, for poorer, in sickness and health, to love and to worship

I take you, to have and to hold, from this day forward, for better or worse, for richer, for poorer, in sickness and health, to love and to cherish till death do us part, so help me the punisher

I take you, to have and to hold, from this day forward, for better or worse, for richer, for poorer, in sickness and health, to love and to cherish till death do us part, so help me the one

I take you, to have and to hold, from this day forward, for better or worse, for richer, for poorer, in sickness and health, to love and to cherish till death do us part, so help me the only

I take you, to have and to hold, from this day forward, for better or worse, for richer, for poorer, in sickness and health, to love and to cherish till death do us part, so help me God.

I

Me

Whoever

I, being of sound

I, being of sound mind and body

I, being of sound mind and chassis

I, being of sound mind and container

I, being of sound mind and body, but also aware of the uncertainties

I, being of sound mind and body, but also aware of the uncertainties of this life, do hereby make

I, being of sound mind and body, but also aware of the uncertainties of this life, do hereby create

I, being of sound mind and body, but also aware of the uncertainties of this life, do hereby concoct

I, being of sound mind and body, but also aware of the uncertainties of this life, do hereby collude

I, being of sound mind and body, but also aware of the uncertainties of this life, do hereby make, publish, and declare this instrument

I, being of sound mind and body, but also aware of the uncertainties of this life, do hereby make, publish, and declare this gift

I, being of sound mind and body, but also aware of the uncertainties of this life, do hereby make, publish, and declare this punishment

I, being of sound mind and body, but also aware of the uncertainties of this life, do hereby make, publish, and declare this instrument as and for my last

I, being of sane

I, being of sound mind

I, being of sound motor

I, being of sound computer

I, being of sound mind and body, but also aware of the catastrophies

I, being of sound mind and body, but also aware of the uncertainties of this life

I, being of sound mind and body, but also aware of the uncertainties of this narrative

I, being of sound mind and body, but also aware of the uncertainties of this movie

I, being of sound mind and body, but also aware of the uncertainties of this life, do hereby make, publish

I, being of sound mind and body, but also aware of the uncertainties of this life, do hereby make, expose

I, being of sound mind and body, but also aware of the uncertainties of this life, do hereby make, publish, and declare

I, being of sound mind and body, but also aware of the uncertainties of this life, do hereby make, publish, and disappoint

I, being of sound mind and body, but also aware of the uncertainties of this life, do hereby make, publish, and declare this instrument as and for my last will

I, being of sound mind and body, but also aware of the uncertainties of this life, do hereby make, publish, and declare this instrument as and for my last will and testament

I, being of sound mind and body, but also aware of the uncertainties of this life, do hereby make, publish, and declare this instrument as and for my last will and power

I, being of sound mind and body, but also aware of the uncertainties of this life, do hereby make, publish, and declare this instrument as and for my last will and testament.

Stills from the video version of *Untitled (Remember me)*, 1988/2020

Remember
Me

Dismember
Me

Delete
Me

Embrace
Us

Replace
Us

Release
Us

 Our Loser

 Our Loner

 Our Lender

 Our Lover

 Our Lawyer

 Our Liar

pp. 122–23: Stills from the video version of *Untitled (Our Leader)*, 1987/2020

Above: Stills from the video version of *Untitled (Admit nothing/Blame everyone/ Be bitter)*, 1987/2020

Admit nothing

Be bitter

Admit nothing

Be bitter

Admit everything

Blame no one

Be bitter

Know nothing

Tell everyone

Be happy

Believe anything

Forget everything

Be quiet

Admit nothing

Blame everyone

Be quiet

125

Your body is a battleground

My body is money

Your body is a piece of fruit

My coffee is a motorboat

Your will is bought and sold

My beliefs are short and sweet

Your neck is squeezed

Your heart is broken

Your skin is sliced

Stills from the video version of *Untitled (Your body is a battleground)*, 1989/2019

Who speaks?

Who is silent?

Untitled (Who speaks? Who is silent?), 1990

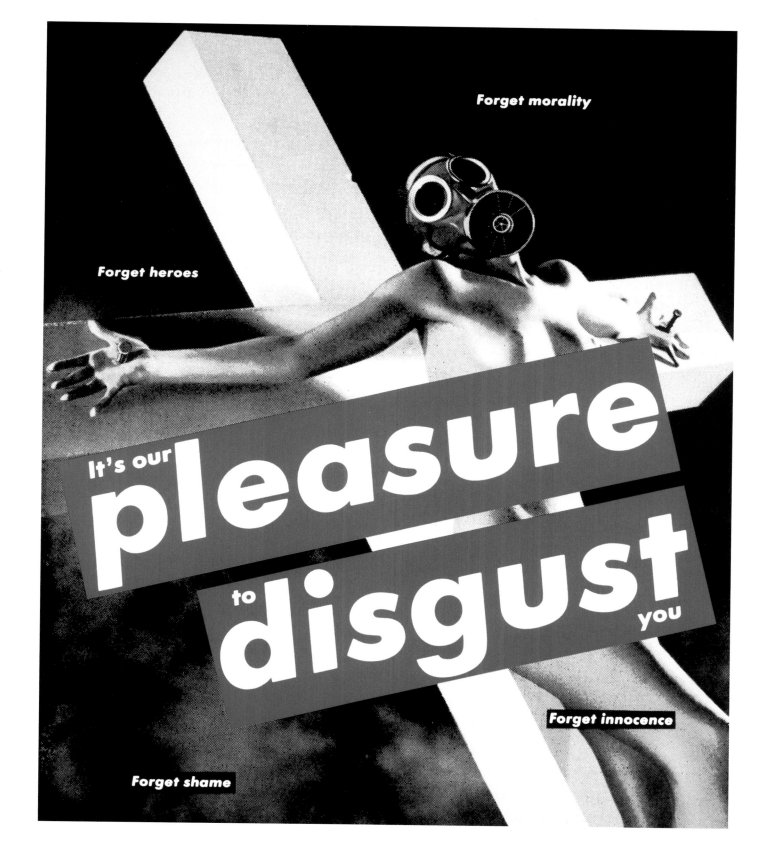

Untitled (It's our pleasure to disgust you), 1991

Untitled (Brain), 2007

Untitled (Truth), 2013

Untitled (Heart), **1988**

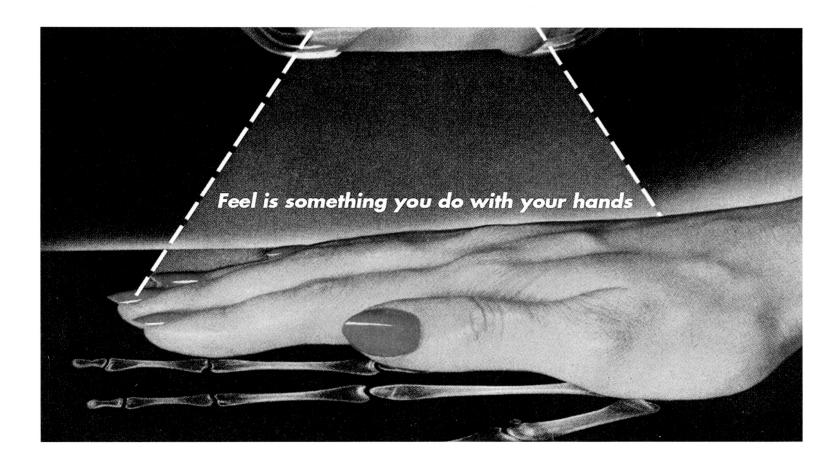

Untitled (Feel is something you do with your hands), 2020

FATUOUS FOOLS, BLOATED EGOS, LOV
PROFESSORS, POSERS, THINKERS, F
BRUTAL SCHEMERS, KIND SOULS, BE
COMEDIANS, DIVAS, INTELLECTUALS,
LOSERS, JERKS, HATERS, PLAYER

Untitled (Cast of characters), 2016/2020

SINGERS, SPEAKERS, SYCOPHANTS, ERS, DOERS ARTISTS AIR KISSERS, ERS, DOUBTERS CREEPS, ASSHOLES, UTIES, BEASTS, BIG SHOTS, WINNERS, ACOLYTES, SUICIDES, SURVIVORS.

Another artist • Another exhibition • Another gallery • Another magazine • Another review • Another career • Another life

136 *Untitled (Another)*, **2003**

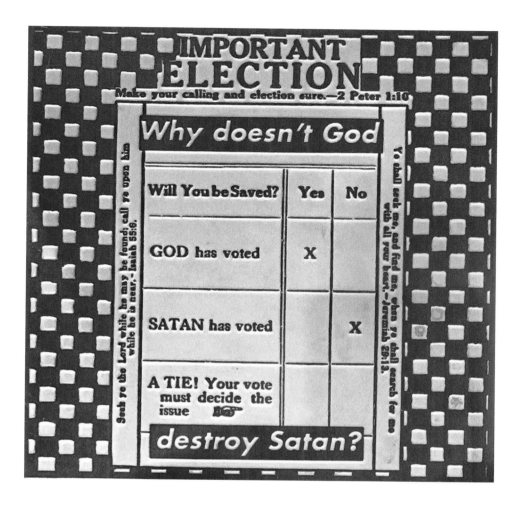

Untitled (Why doesn't God destroy Satan), 1994

138 *The Globe Shrinks*, 2010, installation views, Sprüth Magers, Berlin, 2010

Don't leave. Please. Stay. It's nice to be in the dark, right? You can relax a little. No brittle smiles. No air kisses. No sarcasm. Forget the stress. The worry. The petty skirmishes. Life is too short. Too short for cruelty. Close your eyes.

The Globe Shrinks, 2010, installation views, Sprüth Magers, London, 2011

GREEDY SCHMUCK

Untitled (Greedy schmuck), 2012

Untitled (Too big to fail), 2012

143

I HATE MYSELF AND YOU LOVE ME FOR IT

I LOVE MYSELF

AND YOU HATE ME FOR IT

pp. 142–43: *Untitled (Money is like shit)*, 2012

pp. 144–45: *Untitled (Selfie)*, 2020

Opposite: *Justice*, 1997

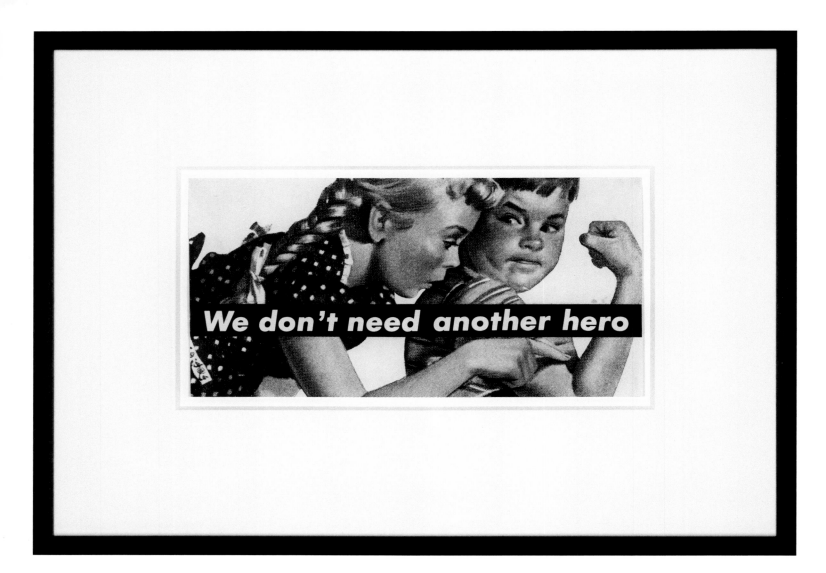

Pasteup of *Untitled (We don't need another hero)*, 1987

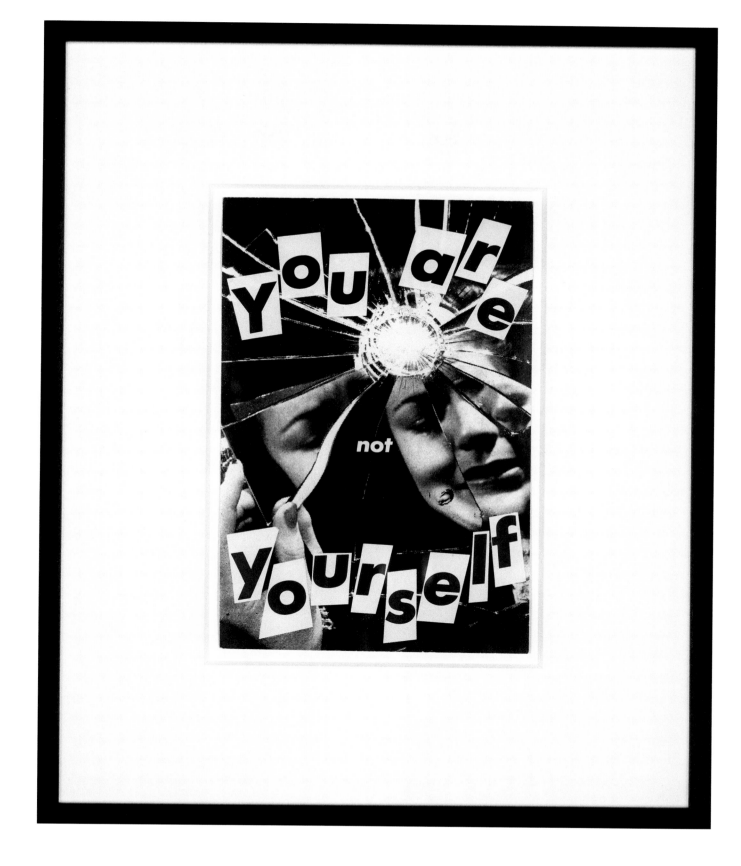

Pasteup of *Untitled (You are not yourself)*, **1982**

150 **Pasteup of *Untitled (Your gaze hits the side of my face)*, 1981**

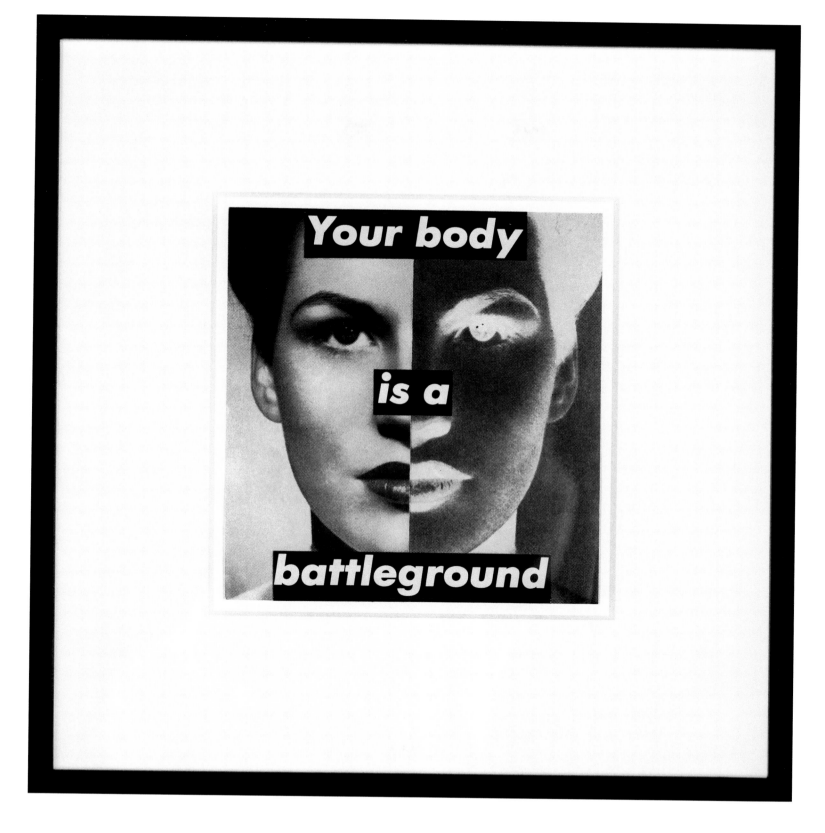

Pasteup of *Untitled (Your body is a battleground)*, 1989

Selected Texts

INTRODUCTION TO SELECTED TEXTS

Rebecca Morse

In the world of academia, a syllabus offers the student guidance about the course and serves as a method of communication between teacher and student, detailing the teacher's expectations and the student's responsibilities. Most often it includes a list of readings that flesh out the precise pedagogical approach and suggest the range of perspectives that will be considered on any given subject. But what might it mean for such a reading list to be included in a monographic exhibition catalogue? Could it serve a similarly calibrating function—without being didactic? Could the texts instead create a discursive space within which we might open up our thinking about the works of art reproduced in these pages? And what might it mean to invite readers to consider the impact of an artist's pedagogical activities on the broader discourse of contemporary art?

The following selection of readings, while not reflective of any particular syllabus, has been assembled and sequenced by Barbara Kruger to be read in relation to the other contents of this book but also to be absorbed through the filter of engaged citizenship and conscious cultural participation. That filter aptly describes Kruger's manner of teaching. Since 2005, she has been a full-time faculty member at the University of California, Los Angeles (UCLA), in the Department of Art, and, more specifically, since 2013, in the New Genres (film, video, installation, performance, audio, digital) area. Nestled within a public institution and serving both undergraduate and graduate students, the art department at UCLA is among the most rigorous, dynamic, and respected in the country. It has a history of experimentation and a faculty that includes some of the most highly esteemed and internationally well-recognized artists working today. Since the 1960s in Los Angeles, artists have actively, and with much due respect, held teaching positions at local institutions— public universities, private colleges, art schools, and community colleges. Rather than being viewed as a distraction from one's art career, as it sometimes is elsewhere, teaching is seen in California as part of the generalized job description of being a visual artist, offering both a supportive intellectual community and financial stability.

Kruger's work as a designer and picture editor through the 1970s at *Mademoiselle*, *House & Garden*, and *Aperture* is often cited as the natural prelude to her iconic style, formed in the late 1970s, which features large-scale black-and-white photographic images, sourced from midcentury manuals, punctuated with Futura Bold Oblique texts that openly address the viewer. Equally generative is her activity as a researcher, thinker, and reader of titles that span fiction and theory, art criticism and sociology. Kruger also has a voracious appetite for the news, reading everything from print newspapers to aggregate websites to blogs to social media, all across the political spectrum. Although her formal schooling includes only one year at the School of Art at Syracuse University and a handful of classes at New York's Parsons School of Design in the mid-1960s, she has continued to find her way back to academia, which nourishes her inquisitive mind.

During the mid-1970s Kruger taught in the art department of renowned public universities in the Midwest, including Ohio State University in Columbus (1975–76) and Wright State University in Fairborn, Ohio, where she was a visiting artist for one quarter in the winter of 1978 and taught beginning, intermediate, and advanced drawing. After two semesters teaching at the School of the Art Institute of Chicago, in 1977, she began teaching at the University of California, Berkeley. Not only did the experience offer an education in California culture, but the Berkeley Art Museum and Pacific Film Archive were a rich source of inspiration for Kruger. In 1979, at the invitation of artist Douglas Huebler, she accepted a position as visiting professor at the California Institute of the Arts (CalArts) in Valencia. Traversing the city by car—a 1967 Plymouth Valiant—Kruger came to understand the sheer breadth and diversity of Los Angeles. CalArts was an oasis of experimentation, with Michael Asher and John Baldessari heading up the School of Art, and a robust faculty that included Jo Ann Callis, Vija Celmins, John Divola, Judy Fiskin, and a steady stream of visiting artists. Being closer in age to the students than to many of the other professors, she became lifelong friends with students Stephen Prina and Christopher Williams. Kruger taught three courses in post-studio art, including a seminar titled "Spectacles and Secret Operators." Although her experience at CalArts was rich and rewarding, she did not teach for the next twenty years.

In 2001 Kruger was a well-known artist just coming off her first large-scale museum show at the Museum of Contemporary Art, Los Angeles, and the Whitney Museum of American Art in New York, yet she was drawn to the possibility of full-time employment that was not contingent on the whims of the art market. She took a full-time job at the University of California, San Diego, and for four years she commuted south from Los Angeles to teach various undergraduate and graduate courses. In the art department there she taught alongside Amy Adler, Babette Mangolte, Lev Manovich, Ruben Ortiz, and Jennifer Pastor, as well as Lesley Stern in art history.

When a position opened at the University of California, Los Angeles, in

2005 she took it and for fifteen years has been a full-time professor at UCLA, now holding the title of distinguished professor. This is a rigorous and demanding position that includes reviewing portfolios for undergraduate admission, eight hours of undergraduate teaching per week, and weekly graduate group critiques. Many of her students take her courses as electives, while a few have gone on to be professional artists. Over the years at UCLA, Kruger has taught Beginning New Genre, Senior Studio, Advanced Drawing, Special Topics in Studio, Graduate Group Critique, Graduate Photography, Graduate New Genres, Open Area Studio, and Graduate Interdisciplinary Studio. She has taught alongside Monika Baer, Jennifer Bolande, Russell Ferguson, Andrea Fraser, Roger Herman, Vishal Jugdeo, Mary Kelly, Candice Lin, Rodney McMillian, Catherine Opie, Silke Otto-Knapp, Hirsch Perlman, Lari Pittman, Charles Ray, Nancy Rubins, Anna Sew Hoy, Rodrigo Valenzuela, James Welling, and Patty Wickman, among many others. Kruger's decision to teach at a *public* university, which supports an incredibly diverse student body, is significant and echoes the commitment to accessibility in her art practice. Her courses are known for being very conversational, and on the syllabus she informs her students that their contribution to class discussions, as well as their considerations and suggestions regarding the work of their peers, is central to their grades.

The selections included here offer a glimpse into Kruger's thinking about cultural practices, including her own, and suggest how we might begin to connect ideas from the rarefied world of theory to contemporary art, the built environment, the circulation of capital, the body, and the pain and powers of the everyday. The writings span over one hundred years, from 1916 to 2017, and the authors range from public intellectuals to political activists, creative writers to artists, as well as architects and filmmakers. They follow an organic sequence, with one text flowing easily into the next to create a larger syntax of interrelated ideas.

The first text, by artist, filmmaker, and critic Hito Steyerl, suggests a trend toward empowering the self through "withdrawal from representation." In contrast to Andy Warhol's prediction of fifteen minutes of fame, she outlines an alternative scenario, one in which people wish to be invisible for fifteen minutes, particularly given "the countless acts of aggression and invasion performed against them in mainstream media." Steyerl is in part responding to the persistent surveillance each of us undergoes when occupying public spaces like streets and when interacting with our personal, seemingly private devices. Architect and writer Keller Easterling unpacks the "zone," which is not exactly a city, state, or country, but a "permanent version of an Olympic opening ceremony," in which the market is the ruler. Zones are terrifyingly lawless, lack bureaucracy, and compete for the cheapest labor within the most deregulated conditions in an ongoing "race to the bottom." Satirist Gary Shteyngart holds a mirror up to the zone in his 2007 book *Absurdistan*, in which the protagonist Misha Vainberg becomes trapped in a small fictional country—a Western parody of commercial glut—where, without any expertise, he is made the minister of multicultural affairs. Georges Perec's imaginative text continues to reflect on the ways in which a place might be decoded, describing the particulars that make up an unnamed street and prompting students to engage in their own studied observations.

These reflections on various social spaces give way to a landmark essay by French sociologist Pierre Bourdieu. Introducing his 1984 book *Distinction: A Social Critique of the Judgement of Taste*, he outlines the way upbringing and formal schooling inform one's perception of art. According to Bourdieu, the development of one's individual taste, and the subsequent appreciation of art and culture, serves a larger function in society, which is to legitimate social differences. Immediately following his text is a tribute by artist Andrea Fraser—who, incidentally, is Kruger's colleague at UCLA, where she is department head and professor of interdisciplinary studio. Fraser's 2002 essay is titled "'To Quote,' Say the Kabyles, 'Is to Bring Back to Life.'" As a high school dropout and relative autodidact prior to her art school training, Fraser credits Bourdieu with helping her to free herself "from the sense of illegitimacy—what he later called symbolic violence—imposed by legitimate culture" that she once felt in French art galleries and museums. The British visual artist and writer Hannah Black then unpacks identity politics by examining the discord between the identity artist who is used to "absolve the social and collective history of race" and the identity critics who "suspect the identity artist of being opportunistic." According to Black, the formation of a nonhierarchical collective against the powerful and violent capitalistic class is problematic yet necessary.

Trauma is at the heart of the discussion by literature and Black studies scholar Christina Sharpe, who explores the relationship between the empowered and the powerless. In 2016's *In the Wake*, she surveys the history of American slavery and in particular its aftermath, in which the brutality toward and criminalization of Black individuals amounts to a "denial of Black humanity." British Israeli intellectual and architect Eyal Weizman recounts how the action of investigating trauma and violence—as evidenced in buildings, territories, photographs, and people—does not numb us to the pain of others, but instead makes us more sensitive. The infliction of pain without consent—otherwise known as torture—is the topic of an excerpt from Elaine Scarry's best-known book, *The Body in Pain: The Making and Unmaking of the World* (1985). She examines the absence of language to describe physical pain and suggests that our inability to express our feelings surrounding it is at the root of human

expression and creation, setting up a call-and-response type of dynamic between torturer and victim. With a cadence reminiscent of a Kruger work, Scarry discusses the process that enables "one person's physical pain to be understood as another person's power." As a counterpoint to the overwhelming magnitude of suffering described by Scarry, novelist and critic Lynne Tillman subsequently catalogues the personal indignities associated with various bodily imperfections, which she describes as small threats upon the self. She religiously has them removed from her own body by her dermatologist, who keeps a large file documenting the removals because such "failures and mishaps are worth recording."

The final selections suggest the control that institutions such as the state and the education system have in determining the fates of individual bodies and lives. In her 1916 essay "Again the Birth Control Agitation," political activist and anarchist Emma Goldman considers the power of the state during a time when information about birth control was lawfully withheld and the distribution of it a convictable criminal act. Poet and critic Fred Moten and interdisciplinary theorist Stefano Harney tackle the toxic yet inextricable relationship between debt and credit within American educational institutions: "So long as debt and credit are paired in the monogamous violence of the home, the pension, the government, or the university, debt can only feed credit, debt can only desire credit." Turning to one of the most powerful figures of state, the American president, Gary Indiana writes a compelling review of *The Haldeman Diaries* by Nixon's chief of staff and loyalist Harry Robbins "Bob" Haldeman. Excerpts from his daily journals and subsequent commentary offer a glimpse into the authority of the presidency and how "the sudden intoxications of power put P [President Nixon] into scary overdrive." Taken altogether, these texts can be seen as acts of resistance,

empowering generations of readers, thinkers, and makers.

THE SPAM OF THE EARTH: WITHDRAWAL FROM REPRESENTATION

Hito Steyerl

Dense clusters of radio waves leave our planet every second. Our letters and snapshots, intimate and official communications, TV broadcasts and text messages drift away from earth in rings, a tectonic architecture of the desires and fears of our times.[1] In a few hundred thousand years, extraterrestrial forms of intelligence may incredulously sift through our wireless communications. But imagine the perplexity of those creatures when they actually look at the material. Because a huge percentage of the pictures inadvertently sent off into deep space is actually spam. Any archaeologist, forensic, or historian—in this world or another—will look at it as our legacy and our likeness, a true portrait of our times and ourselves. Imagine a human reconstruction somehow made from this digital rubble. Chances are, it would look like image spam.

Image spam is one of the many dark matters of the digital world; spam tries to avoid detection by filters by presenting its message as an image file. An inordinate amount of these images floats around the globe, desperately vying for human attention.[2] They advertise pharmaceuticals, replica items, body enhancements, penny stocks, and degrees. According to

the pictures dispersed via image spam, humanity consists of scantily dressed degree-holders with jolly smiles enhanced by orthodontic braces.

Image spam is our message to the future. Instead of a modernist space capsule showing a woman and man on the outside—a family of "man"—our contemporary dispatch to the universe is image spam showing enhanced advertisement mannequins.[3] And this is how the universe will see us; it is perhaps even how it sees us now.

In terms of sheer quantity, image spam outnumbers the human population by far. It's formed a silent majority, indeed. But of what? Who are the people portrayed in this type of accelerated advertisement? And what could their images tell potential extraterrestrial recipients about contemporary humanity?

From the perspective of image spam, people are improvable, or, as Hegel put it, perfectible. They are imagined to be potentially "flawless," which in this

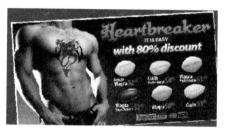

Medical spam images retrieved from corporation Symantec Intelligence's blog.

context means horny, super skinny, armed with recession-proof college degrees, and always on time for their service jobs, courtesy of their replica watches. This is the contemporary family of men and women: a bunch of people on knockoff antidepressants, fitted with enhanced body parts. They are the dream team of hyper-capitalism.

But is this how we really look? Well, no. Image spam might tell us a lot about "ideal" humans, but not by showing actual humans: quite the contrary. The models in image spam are photochopped replicas, too improved to be true. A reserve army

of digitally enhanced creatures who resemble the minor demons and angels of mystic speculation, luring, pushing and blackmailing people into the profane rapture of consumption.

Image spam is addressed to people who do not look like those in the ads: they neither are skinny nor have recession-proof degrees. They are those whose organic substance is far from perfect from a neoliberal point of view. People who might open their inboxes every day waiting for a miracle, or just a tiny sign, a rainbow at the other end of permanent crisis and hardship. Image spam is addressed to the vast majority of human-kind, but it does not show them. It does not represent those who are considered expendable and superfluous—just like spam itself; it speaks to them.

The image of humanity articulated in image spam thus has actually nothing to do with it. On the contrary, it is an accurate portrayal of what humanity is actually not. It is a negative image.

MIMICRY AND ENCHANTMENT

Why is this? There is an obvious reason, which is too well known to elaborate on here: images trigger mimetic desires and make people want to become like the products represented in them. In this view, hegemony infiltrates everyday culture and spreads its values by way of mundane representation.[4] Image spam is thus interpreted as a tool for the produc-tion of bodies, and ultimately ends up creating a culture stretched between bulimia, steroid overdose, and personal bankruptcy. This perspective—one of more traditional Cultural Studies—views image spam as an instrument of coercive persuasion as well as of insidious seduc-tion, and leads to the oblivious pleasures of surrendering to both.[5]

But what if image spam were actually much more than a tool of ideological and affective indoctrination? What if actual people—the imperfect and nonhorny ones—were not excluded from spam advertisements because of their assumed

Ed Ruscha, *SPAM* (detail), 1961. From the series *Product Still Lifes*, 1961/1999.

deficiencies but had actually chosen to desert this kind of portrayal? What if image spam thus became a record of a widespread refusal, a withdrawal of people from representation?

What do I mean by this? For a certain time already I have noted that many people have started actively avoiding photographic or moving-image represen-tations, surreptitiously taking their distance from the lenses of cameras. Whether it's camera-free zones in gated communities or elitist techno clubs, someone's declining interviews, Greek anarchists smashing cameras, or looters destroying LCD TVs, people have started to actively, and passively, refuse con-stantly being monitored, recorded, identified, photographed, scanned, and taped. Within a fully immersive media landscape, pictorial representation— which was seen as a prerogative and a political privilege for a long time[6]— feels more like a threat.

There are many reasons for this. The numbing presence of trash talk and game shows has led to a situation in which TV has become a medium inextricably linked to the parading and ridiculing of lower classes. Protagonists are violently made over and subjected to countless invasive ordeals, confessions, inquiries, and assessments. Morning TV is the contem-porary equivalent to a torture chamber— including the guilty pleasures of torturers, spectators, and, in many cases, also the tortured themselves.

Additionally, in mainstream media people are often caught in the act of

vanishing, whether it be in life-threatening situations, extreme emergency and peril, warfare and disaster, or in the constant stream of live broadcasts from zones of conflict around the world. If people aren't trapped within natural or man-made disasters, they seem to physically vanish, as anorexic beauty standards imply. People are emaciated or made to shrink or downsize. Dieting is obviously the metonymic equivalent to an eco-nomic recession, which has become a permanent reality and caused substantial material losses. This recession is coupled with an intellectual regression, which has become a dogma within all but a very few mainstream media outlets. As intel-ligence doesn't simply melt away via starvation, derision and rancor largely manage to keep it away from the grounds of mainstream representation.[7]

Thus the zone of corporate represen-tation is largely one of exception, which seems dangerous to enter: you may be derided, tested, stressed, or even starved or killed. Rather than representing people it exemplifies the vanishing of the people: it's gradual disappearance. And why wouldn't the people be vanishing, given the countless acts of aggression and invasion performed against them in mainstream media, but also in reality?[8] Who could actually withstand such an onslaught without the desire to escape this visual territory of threat and constant exposure?

Additionally, social media and cell-phone cameras have created a zone of mutual mass-surveillance, which adds to the ubiquitous urban networks of control, such as CCTV, cell-phone GPS tracking and face-recognition software. On top of institutional surveillance, people are now also routinely surveilling each other by taking countless pictures and publishing them in almost real time. The social control associated with these practices of horizontal representation has become quite influential. Employers google reputations of job candidates; social media and blogs become halls of shame and malevolent gossip. The

top-down cultural hegemony exercised by advertisement and corporate media is supplemented by a down-down regime of (mutual) self-control and visual self-disciplining, which is even harder to dislocate than earlier regimes of representation. This goes along with substantial shifts in modes of self-production. Hegemony is increasingly internalized, along with the pressure to conform and perform, as is the pressure to represent and be represented.

Warhol's prediction that everybody would be world-famous for fifteen minutes had become true long ago. Now many people want the contrary: to be invisible, if only for fifteen minutes. Even fifteen seconds would be great. We entered an era of mass-paparazzi, of the peak-o-sphere and exhibitionist voyeurism. The flare of photographic flashlights turns people into victims, celebrities, or both. As we register at cash tills, ATMs, and other checkpoints—as our cell phones reveal our slightest movements and our snapshots are tagged with GPS coordinates—we end up not exactly amused to death but represented to pieces.

WALKOUT
This is why many people by now walk away from visual representation. Their instincts (and their intelligence) tell them that photographic or moving images are dangerous devices of capture: of time, affect, productive forces, and subjectivity. They can jail you or shame you forever; they can trap you in hardware monopolies and conversion conundrums, and, moreover, once these images are online they will never be deleted again. Ever been photographed naked? Congratulations—you're immortal. This image will survive you and your offspring, prove more resilient than even the sturdiest of mummies, and is already traveling into deep space, waiting to greet the aliens.

The old magic fear of cameras is thus reincarnated in the world of digital

Example of spam advertising schooling.

natives. But in this environment, cameras do not take away your soul (digital natives replaced this with iPhones) but drain away your life. They actively make you disappear, shrink, and render you naked, in desperate need of orthodontic surgery. In fact, it is a misunderstanding that cameras are tools of representation; they are at present tools of disappearance.[10] The more people are represented the less is left of them in reality.

To return to the example of image spam I used before; it is a negative image of its constituency, but how? It is not—as a traditional Cultural Studies approach would argue—because ideology tries to impose a forced mimicry on people, thus making them invest in their own oppression and correction in trying to reach unattainable standards of efficiency, attractiveness, and fitness. No. Let's boldly assume that image spam is a negative image of its constituency because people are *also* actively walking away from this kind of representation, leaving behind only enhanced crash-test dummies. Thus image spam becomes an involuntary record of a subtle strike, a walkout of the people from photographic and moving-image representation. It is a document of an almost imperceptible exodus from a field of power relations that are too extreme to be survived without major reduction and downsizing. Rather than a document of domination, image spam is the people's monument of resistance to being represented *like this*. They are leaving the *given* frame of representation.

POLITICAL AND CULTURAL REPRESENTATION
This shatters many dogmas about the relation between political and pictorial representation. For a long time my generation has been trained to think that representation was the primary site of contestation for both politics and aesthetics. The site of culture became a popular field of investigation into the "soft" politics inherent in everyday environments. It was hoped that changes in the field of culture would hark back to the field of politics. A more nuanced realm of representation was seen to lead to more political and economical equality.

But gradually it became clear that both were less linked than originally anticipated, and that the partition of goods and rights and the partition of the senses were not necessarily running parallel to each other. Ariella Azoulay's concept of photography as a form of civil contract provides a rich background to think through these ideas. If photography was a civil contract between the people who participated in it, then the current withdrawal from representation is the breaking of a social contract, having promised participation but delivered gossip, surveillance, evidence, serial narcissism, as well as occasional uprisings.[11]

While visual representation shifted into overdrive and was popularized through digital technologies, political representation of the people slipped into a deep crisis and was overshadowed by economic interest. While every possible minority was acknowledged as a potential consumer and visually represented (to a certain extent), people's participation in the political and economic realms became more uneven. The social contract of contemporary visual representation thus somewhat resembles the ponzi schemes of the early twenty-first century, or, more precisely, participation in a game show with unpredictable consequences.

And if there ever was a link between the two, it has become very unstable in

an era in which relations between signs and their referents have been further destabilized by systemic speculation and deregulation.

Both terms do not only apply to financialization and privatization; they also refer to loosened standards of public information. Professional standards of truth production in journalism have been overwhelmed by mass media production, by the cloning of rumor and its amplification on Wikipedia discussion boards. Speculation is not only a financial operation but also a process that takes place in between a sign and its referent, a sudden miraculous enhancement, or spin, that snaps apart any remaining indexical relation.

Visual representation matters, indeed, but not exactly in unison with other forms of representation. There is a serious imbalance between both. On the one hand, there is a huge number of images without referents; on the other, many people without representation. To phrase it more dramatically: A growing number of unmoored and floating images corresponds to a growing number of disenfranchised, invisible, or even disappeared and missing people.[12]

CRISIS OF REPRESENTATION
This creates a situation that is very different from how we used to look at images: as more or less accurate representations of something or someone in public. In an age of unrepresentable people and an overpopulation of images, this relation is irrevocably altered.

Cover of *Voyager*'s golden record with playing instructions and sound diagrams, launched in 1977.

Image spam is an interesting symptom of the current situation because it is a representation that remains, for the most part, invisible.

Image spam circulates endlessly without ever being seen by a human eye. It is made by machines, sent by bots, and caught by spam filters, which are slowly becoming as potent as anti-immigration walls, barriers, and fences. The plastic people shown in it thus remain, to a large extent, unseen. They are treated like digital scum, and thus paradoxically end up on a similar level to that of the low-res people they appeal to. This is how it is different from any other kind of representational dummies, which inhabit the world of visibility and high-end representation. Creatures of image spam

Rendition of iSee Manhattan, a web-based application charting the locations of CCTV surveillance cameras in urban environments. Users are able to locate routes that avoid being filmed by unregulated security monitors.

get treated as lumpen data, avatars of the conmen who are indeed behind their creation. If Jean Genet were still alive, he would have sung praise to the gorgeous hoodlums, tricksters, prostitutes, and fake dentists of image spam.

They are still not a representation of the people, because, in any case, the people are not a representation. They are an event, which might happen one day, or maybe later, in that sudden blink of an eye that is not covered by anything.

By now, however, people might have learned this, and accepted that any people can only be represented visually in negative form. This negative cannot be developed under any circumstance, since a magical process will ensure that all you are ever going to see in the positive is a bunch of populist substitutes and impostors, enhanced crash-test dummies trying

to claim legitimacy. The image of the people as a nation, or culture, is precisely that: a compressed stereotype for ideological gain. Image Spam is the true avatar of the people. A negative image with absolutely no pretense to originality? An image of what the people are not as their only possible representation?

And as people are increasingly makers of images—and not their objects or subjects—they are perhaps also increasingly aware that the people might happen by jointly making an image and not by being represented in one. Any image is a shared ground for action and passion, a zone of traffic between things and intensities. As their production has become mass production, images are now increasingly *res publicae*, or public things. Or even pubic things, as the languages of spam fabulously romance.[13]

This doesn't mean that who or what is being shown in images doesn't matter. This relation is far from being one-dimensional. Image spam's generic cast is not the people, and the better for it. Rather, the subjects of image spam stand in for the people as negative substitutes and absorb the flak of the limelight on their behalf. On the one hand, they embody all the vices and virtues (or, more precisely, vices-as-virtues) of the present economic paradigm. On the other, they remain more often than not invisible, because hardly anybody actually looks at them.

Who knows what the people in image spam are up to, if nobody is actually looking? Their public appearance may be just a silly face they put on to make sure we continue to not pay attention. They might carry important messages for the aliens in the meantime, about those who we stopped caring for, those excluded from shambolic "social contracts," or any form of participation other than morning TV; that is, the spam of the earth, the stars of CCTV and aerial infrared surveillance. Or they might temporarily share in the realm of the disappeared and invisible, made up of those who, more often than not,

inhabit a shameful silence and whose relatives have to lower their eyes to their killers every day.

The image-spam people are double agents. They inhabit both the realms of over- and invisibility. This may be the reason why they are continuously smiling but not saying anything. They know that their frozen poses and vanishing features are actually providing cover for the people to go off the record in the meantime. To perhaps take a break and slowly regroup. "Go off screen," they seem to whisper. "We'll substitute for you. Let them tag and scan us in the meantime. You go off the radar and do what you have to." Whatever this is, they will not give us away, ever. And for this, they deserve our love and admiration.

* Text first published in "The Wretched of the Screen," *e-flux Journal*, no. 32 (February 2012): 161–73, https://www.e-flux.com/journal/32/68260/the-spam -of-the-earth-withdrawal-from-representation/.

Notes
1. Douglas Phillips, "Can Desire Go On Without a Body?," in *The Spam Book: On Viruses, Porn, and Other Anomalies from the Dark Side of Digital Culture*, ed. Jussi Parikka and Tony D. Sampson (Cresskill, NJ: Hampton Press, 2009), 199f.
2. The number of spam emails sent per day is at roughly 250 billion (as per 2010). The total amount of image-spam has varied considerably over the years, but in 2007, image spam accounted for 35 percent of all spam messages and took up 70 percent of bandwidth bulge. "Image spam could bring the internet to a standstill," *London Evening Standard,* October 2007, 1. All the pictures of image spam accompanying this text have been borrowed from the invaluable source "Image Spam," by Mathew Nisbet. To avoid misunderstandings, most image spam shows text, not pictures.
3. This is similar to the golden plaques on the *Pioneer* space capsules launched in 1972 and 1973, which depicted a white woman and a white man, with the woman's genitals omitted. Because of the criticism directed at the relative nudity of the human figures, subsequent plaques showed only the human silhouettes. It will be at least forty thousand years until the capsule could potentially deliver this message.
4. This is a sloppy, fast-forward rehash of a classical Gramscian perspective, from early Cultural Studies.
5. Or it may more likely be analyzed as partially self-defeating and contradictory.
6. I have discussed the failed promise of cultural representation in "The Institution of Critique," in *Institutional Critique: An Anthology of Artists' Writings*, ed. Alex Alberro and Blake Stimson (Cambridge, MA: MIT Press, 2009), 486f.
7. This applies unevenly around the world.
8. In the 1990s, people from former Yugoslavia would say that the former anti-fascist slogan of the Second World War had been turned upside down: "Death to fascism, freedom to the people" had been transformed by nationalists from all sides into "Death to the people, freedom to fascism."
9. See Brian Massumi, *Parables for the Virtual* (Durham, NC: Duke University Press, 2002).
10. I remember my former teacher Wim Wenders elaborating on the photographing of things that will disappear. It is more likely, though, that things will disappear if (or even because) they are photographed.
11. I cannot expand on this appropriately here. It might be necessary to think through recent Facebook riots from the perspective of breaking intolerable social contracts, and not from entering or sustaining them.
12. The era of the digital revolution corresponds to that of enforced mass disappearance and murder in former Yugoslavia, Rwanda, Chechnya, Algeria, Iraq, Turkey, and parts of Guatemala, to list just a few. In the Democratic Republic of the Congo, which saw roughly 2.5 million war casualties between 1998 and 2008, it is agreed on by researchers that demand for raw materials for the IT industries (such as coltane) played a direct role in the country's conflict. The number of migrants who died while trying to reach Europe since 1990 is estimated to be eighteen thousand.
13. This derives from a pirated DVD cover of the movie *In the Line of Fire* (Wolfgang Peterson, 1993), which states, in no uncertain terms, that pubic performance of the disc is strictly prohibited.

EXTRASTATE-CRAFT: THE POWER OF INFRASTRUC-TURE SPACE

Keller Easterling

Shenzhen is a double of Hong Kong. Pudong doubles Shanghai. CIDCO, the City and Industrial Development Company of Maharashtra, operating under the motto "We make cities," is making Navi Mumbai the double of Mumbai.[1] Not only has the zone become a city, but major cities and even national capitals are now engineering their own zone doppelgängers—their own non-national territories in which to create newer, cleaner alter-egos, free of any incumbent bureaucracy. The zone embodies what political scientist Stephen D. Krasner calls "hypocritical sovereignty"—where nations operate between multiple jurisdictions with potentially conflicting allegiances and laws—or what international relations professor Ronen Palan calls "sovereign bifurcation," where "states intentionally divide their sovereign space into heavily and lightly regulated realms."[2] The world capital and national capital can now shadow each other, alternately exhibiting a regional cultural ethos, national pride, or global ambition. State and non-state actors use each other as proxy or camouflage as they juggle and decouple from the law in order to create the most advantageous political or economic climate.[3]

Hong Kong and Shenzhen are like twins who can trick the world or trick each other. Hong Kong uses its sister city as a source of cheap labor and rent; Shenzhen competes with Hong Kong while accepting investment from its businessmen. Shenzhen also smothers its island sibling with symbiotic over-achievement. *China Daily* projects the mainland's ambitions when it chirps that, given Shenzhen's spectacular success, Hong Kong will surely want to form a single metropolitan region.[4]

Conforming to a global standard, the promotional video for New Songdo City in South Korea flies in from outer space and through a digital model, accompanied by a new-age soundtrack from the Icelandic band Sigur Rós. A complete international city designed by Kohn Pedersen Fox, Songdo is a double of Seoul in an expansion of the Incheon free-trade territories. It is the "city in a box" that developer Stanley Gale plans to reproduce elsewhere in the world. Aspiring to the cosmopolitan urbanity of New York, Venice, and Sydney, the city has a Central Park, a World Trade Center, and a Canal Street, as well as commercial, residential, cultural, and educational programs including an

international convention center, a hospital, a Jack Nicklaus golf course, office buildings, luxury hotels, and shopping malls. There are also additional free-trade zone areas like a "Techno-park" and a "Bio Complex."[5] Songdo will eventually cover only 15,000 acres and house a projected population of a quarter of a million.[6] Yet it already claims to be a major world city, a "smart city," a "green city," an "aerotropolis," and "a commercial epicenter of Northeast Asia" that provides access to one-third of the world's population in three-and-a-half hours.[7] The video's emotional soundtrack targets international business families looking for a home in the "world community."[8]

In some cases, surpassing all irony, the national capital and the zone have become the same entity, making the zone itself the seat of governance from which it is selectively exempt.[9] In 1997, the capital of Kazakhstan was simply moved from the old city of Almaty to the more strategic Astana, forming a central SEZ called "Astana-New City."[10] Even though Astana has a population of a little more than 600,000, it calls itself a "megacity."[11] President Nursultan Nazarbayev unabashedly created a twenty-three-square-mile (5,900 ha) area in which the nation could advertise its market enticements and display urban buildings saturated with national pride and regional imagery.[12] Astana is, in many ways, part of a campaign to position Central Asia as a paleo-Genghis corridor ready to compete with Dubai.

In 1997, Kisho Kurokawa, the late Japanese Metabolist architect, designed an axial master plan for Astana-New City anchored by Norman Foster's pyramidal Palace of Peace and Reconciliation. The religiously neutral icon offers, at the top of the pyramid, a place of retreat and summit for world leaders—the zone as a permanent version of an Olympic opening ceremony. Joining Foster's pyramid was the Khan Shatyr (roughly translated as the "tent of the Khan"), a 500-foot-tall,

140,000-square-meter ETFE tent creating an interior microclimate for recreation, shopping, restaurants, and green space.[13] Colored lights illuminate the buildings, the graphic flower beds, and the expressive Bayterek observation tower. Multicolored fountains and water shows, like those in Las Vegas or Macau, are also recognized as necessary accoutrements of the new zone.[14] In 2010, three days of celebrations—coinciding with Nazarbayev's seventieth birthday—marked the opening of the indoor park with its monorail, tropical zone, wave machine, and beach. A performance by Andrea Bocelli, together with a circus and other spectacles, entertained the world leaders who gathered for the event.[15]

*Excerpted from *EXTRASTATECRAFT: The Power of Infrastructure Space* (London: Verso Books, 2016), 48–53.

Notes

1. CIDCO is to deliver infrastructure that is the zone standard: an airport, mass rapid transit, railway stations, industrial compounds, a harbor, a central park, a golf course, and residential areas. A similar company, SKIL Infrastructure Ltd., will contract for some portion of the infrastructure as a private-sector endeavor. Navi Mumbai will be equipped with infrastructural and legal environments like those in Shenzhen and Pudong—city-states with not only commercial areas but also a full array of programs. See cidco.maharashtra.gov.in and skilgroup.co.in.
2. Krasner describes several forms of sovereignty that the nation must juggle: Westphalian, Interdependence, Domestic, and Legal. The zone sometimes eliminates conflicts between these different jurisdictions to streamline relations with foreign investment even as it creates yet another independent jurisdiction. Stephen Krasner, *Sovereignty: Organized Hypocrisy* (Princeton: Princeton University Press, 1999), 3–25; Ronen Palan, *The Offshore World: Sovereign Markets, Virtual Places, and Nomad Millionaires* (Ithaca, NY: Cornell University Press, 2003), 8, 182. See also Roy E. H. Mellor, *Nation, State, and Territory: A Political Geography* (London: Routledge, 1989), 59.
3. This argument joins those of other scholars who note that new incarnations of statehood, like those the zone sponsors, strengthen rather than diminish the power of the state. As professor of urban theory Neil Brenner writes, "the notion of state rescaling is intended to characterize the transformed form of (national) statehood under contemporary capitalism, not to imply its erosion, withering, or demise." Neil Brenner, *New State Spaces: Urban Governance and the Rescaling of Statehood* (New York: Oxford University Press, 2004), 4.
4. "Shenzhen SEZ Aims to Be 5 Times Bigger," *China Daily*, May 22, 2009.
5. See songdo.com.
6. Chungjin Kim, "A Study on the Development Plan of Incheon Free Economic Zone, Korea: Based on a Comparison to a Free Economic Zone in Pudong, China" (master's thesis, University of Oregon, 2007), 13. Korea's four main Free Economic Zones are Incheon, Busan, Jinhae, and Gwangyang.
7. For a discussion of the Airport City see John D. Kasarda and Greg Lindsay, *Aerotropolis: The Way We'll Live Next* (New York: Farrar, Straus and Giroux, 2011).
8. "A Brand New City," at songdo.com.
9. In Hong Kong, Macau, Singapore, Mauritius, Fiji, Gibraltar, and Thailand, zone laws are permitted throughout the entire territory. See Diamond and Diamond, *Tax-Free Trade Zones of the World,* Far East, iii.
10. "Privileges for Participants in Special Economic Zones," at http://invest.gov.kz.
11. "Industrial Zones," at jordaninvestment.com.
12. In line with other world powers, Kazakhstan develops conurbations in business park units called "cities." Alatau IT City, one example outside of Almaty, follows the familiar template and features mirror-tiled buildings and towers with monumental but indeterminate reference.
13. See fosterandpartners.com.
14. See astana.gov.kz/en/.
15. "Giant Indoor Park Opened for Kazakh President's Birthday," at telegraph.co.uk.

ABSURDISTAN

Gary Shteyngart

Svanï City clung wearily to a small mountain range. We took an ascending road away from the gray curve of the Caspian Sea until we reached something called the Boulevard of National Unity. We found ourselves, in a manner of speaking, on the primary thoroughfare of Portland, Oregon, U.S.A., where I had once misspent a couple of weeks in my youth. We passed shops of unmistakable wealth, if somewhat curious provenance—an outlet that sold the nightmare products of the American conglomerate Disney, an espresso emporium named Caspian Joe's (a bright green rip-off of a famous American chain), a side-by-side presentation of the popular American stores the Gap and the Banana Republic, the above-mentioned 718 Perfumery, rife

with the odors of the Bronx, and an Irish theme pub named Molly Malloy's crouching drunkenly behind imported ivy and a giant shamrock.

After Molly's, the boulevard turned into a canyon of recently built glass skyscrapers bearing the corporate logos of ExxonMobil, BP, ChevronTexaco, Kellogg, Brown & Root, Bechtel, and Daewoo Heavy Industries (Timofey grunted happily at the makers of his beloved steam iron), and finally the identical Radisson and Hyatt skyscrapers staring each other down from the opposite ends of a windswept plaza.

The Hyatt lobby was an endless skylit atrium where multinational men buzzed from one corner to another with the hungry, last-ditch exasperation of late-summer flies. Everywhere I looked, there seemed to be little corners of ad hoc commerce, plastic tables and chairs clumped together under signs with strange legends such as HAIL, HAIL BRITANNIA—THE PUB. One of these hives was a golden-lit affair called RECEPTION. There a smiling boy of seemingly Scandinavian origin spoke to us in smooth business-school English. "Welcome to the Park Hyatt Svanï City," he said, beaming. "My name is Aburkharkhar. How can I help you gentlemen today?"

Alyosha-Bob ordered a penthouse suite for the two of us and a little shed behind the pool for Timofey. A glassed-in elevator hoisted us forty stories through the sunny atrium, so the next thing I knew, I was looking at a happy Western parody of a modern home, with marble countertop on everything from the desks to the nightstand to the bathroom sink to the coffee table. For a second I thought I had actually arrived in Europe, so I muttered the word "Belgium," fell to my knees, doubled over, enjoyed immensely the feeling of plush carpeting enveloping my breasts and cradling my stomach, and bade the waking world goodbye.

* Excerpted from Chapter 14, "The Norway of the Caspian," in *Absurdistan: A Novel* (New York: Random House, 2007), 119–20.

THE STREET

Georges Perec

I

The buildings stand one beside the other. They form a straight line. They are expected to form a line, and it's a serious defect in them when they don't do so. They are then said to be "subject to alignment," meaning that they can by rights be demolished, so as to be rebuilt in a straight line with the others. The parallel alignment of two series of buildings defines what is known as a street.

The street is a space bordered, generally on its two longest sides, by houses; the street is what separates houses from each other, and also what enables us to get from one house to another, by going either along or across the street. In addition, the street is what enables us to identify the houses. Various systems of identification exist. The most widespread, in our own day and our part of the world, consists in giving a name to the street and numbers to the houses. The naming of streets is an extremely complex, often even thorny, topic, about which several books might be written. And numbering isn't that much simpler. It was decided, first, that even numbers would be put on one side and odd numbers on the other (but, as a character in Raymond Queneau's *The Flight of Icarus* very rightly asks himself, "Is 13A an even or an odd number?"); secondly, that the even numbers would be on the right (and odd numbers on the left) relative to the direction of the street; and thirdly, that the said direction of the street would be determined generally (but we know of many exceptions) by the position of the said street in relation to a fixed axis, in the event the River Seine. Streets parallel with the Seine are numbered starting upstream, perpendicular streets starting from the Seine and going away from it (these explanations apply to Paris obviously; one might reasonably suppose that analogous solutions have been thought up for other towns).

Contrary to the buildings, which almost always belong to someone, the streets in principle belong to no one. They are divided up, fairly equitably, into a zone reserved for motor vehicles, known as the roadway, and two zones, narrower obviously, reserved for pedestrians, which are called pavements. A certain number of streets are reserved exclusively for pedestrians, either permanently, or else on particular occasions. The zones of contact between the roadway and the pavements enable motorists who don't wish to go on driving to park. The number of motor vehicles not wishing to go on driving being much greater than the number of spaces available, the possibilities of parking have been restricted, either, within certain perimeters known as "blue zones," by limiting the amount of parking time, or else, more generally, by installing paid parking.

Only infrequently are there trees in the streets. When there are, they have railings round them. On the other hand, most streets are equipped with specific amenities corresponding to various services. Thus there are street-lights which go on automatically as soon as the daylight begins to decline to any significant degree; stopping places at which passengers can wait for buses or taxis; telephone kiosks, public benches; boxes into which citizens may put letters which the postal services will come to collect at set times; clockwork mechanisms intended to receive the money necessary for a limited amount of parking time; baskets reserved for waste paper and other detritus, into which numbers of people compulsively cast a furtive glance as they pass; traffic lights. There are likewise traffic signs indicating, for example, that it is appropriate to park on this side of the street or that according to whether we are in the first or second fortnight of the month (what is known as "alternate side parking"), or that silence

is to be observed in the vicinity of a hospital, or, finally and especially, that the street is one-way. Such is the density of motor traffic indeed that movement would be almost impossible if it had not become customary, in the last few years, in a majority of built-up areas, to force motorists to circulate in one direction only, which, obviously, sometimes obliges them to make long detours.

At certain road junctions deemed especially dangerous, communication between the pavements and the roadway, normally free, has been prevented by means of metal posts linked by chains. Identical posts, set into the pavement themselves, serve sometimes to stop motor vehicles from coming and parking on the pavements, which they would frequently tend to do if they weren't prevented. In certain circumstances, finally—military parades, Heads of State driving past, etc.—entire sections of the roadway may be put out of bounds by means of light metal barriers that fit one inside the other.

At certain points in the pavement, curved indentations, familiarly known as "*bateaux*"[1] indicate that there may be motor vehicles parked inside the buildings themselves which should always be able to get out. At other points, small earthenware tiles set into the edge of the pavement indicate that this section of the pavement is reserved for the parking of hire vehicles.

The junction of the roadway and the pavements is known as the gutter. This area has a very slight incline, thanks to which rain water can flow off into the drainage system underneath the street, instead of spreading right across the roadway, which would be a considerable impediment to the traffic. For several centuries, there was only one gutter, to be found in the middle of the roadway, but the current system is thought to be better suited. Should there be a shortage of rainwater, the upkeep of the roadway and pavements can be effected thanks to hydrants installed at almost every intersection; these can be opened with the help of the T-shaped keys with which the council employees responsible for cleaning the streets are provided.

In principle, it is always possible to pass from one side of the street to the other by using the pedestrian crossings that motor vehicles must only drive over with extreme caution. These crossings are signalled, either by two parallel rows of metal studs, perpendicular to the axis of the street, whose heads have a diameter of about twelve centimetres, or else by broad bands of white paint running at an angle across the whole width of the street. This system of studded or painted crossings no longer seems as effective as it no doubt was in the old days, and it is often necessary to duplicate it by a system of traffic lights of three colours (red, amber and green) which, as they have multiplied, have ended up causing extraordinarily complex problems of synchronization that certain of the world's largest computers and certain of what are held to be the age's most brilliant mathematical brains are working tirelessly to resolve.

At various points, remote-controlled cameras keep an eye on what is going on. There is one on top of the Chambre des Deputes, just underneath the big tricolour; another in the Place Edmond-Rostand, in continuation of the Boulevard Saint-Michel; others still at Alesia, the Place Clichy, the Chatelet, the Place de la Bastille, etc.

II

I saw two blind people in the Rue Linne. They were walking holding one another by the arm. They both had long, exceedingly flexible sticks. One of the two was a woman of about fifty, the other quite a young man. The woman was feeling all the vertical obstacles that stood along the pavement with the tip of her stick, and guiding the young man's stick so that he, too, touched them, indicating to him, very quickly and without ever being mistaken, what the obstacles consisted of: a street light, a bus stop, a telephone kiosk, a waste-paper bin, a post box, a road sign (she wasn't able to specify what the sign said obviously), a red light…

III
PRACTICAL EXERCISES
Observe the street, from time to time, with some concern for system perhaps.

Apply yourself. Take your time.

Note down the place: the terrace of a cafe near the junction of

the Rue de Bae and the Boulevard Saint-Germain

the time: seven o'clock in the evening

the date: 15 May 1975

the weather: set fair

Note down what you can see. Anything worthy of note going on.

Do you know how to see what's worthy of note?

Is there anything that strikes you?

Nothing strikes you. You don't know how to see.

You must set about it more slowly, almost stupidly.

Force yourself to write down what is of no interest, what is most obvious, most common, most colourless.

The street: try to describe the street, what it's made of, what it's used for. The people in the street. The cars. What sort of cars? The buildings: note that they're on the comfortable, well-heeled side. Distinguish residential from official buildings. The shops. What do they sell in the shops? There are no food shops. Oh yes, there's a baker's. Ask yourself where the locals do their shopping.

The cafes. How many cafes are there? One, two, three, four. Why did you choose this one? Because you know it, because it's in the sun, because it sells cigarettes. The other shops: antique shops, clothes, hi-fi, etc. Don't say, don't write "etc." Make an effort to exhaust the subject, even if that seems grotesque, or pointless, or stupid. You still haven't looked at anything, you've merely picked out what you've long ago picked out.

Detect a rhythm: the passing of cars. The cars arrive in clumps because they've been stopped by a red light further up or down the street.

Count the cars.

Look at the number plates. Distinguish between the cars registered in Paris and the rest.

Note the absence of taxis precisely when there seem to be a lot of people waiting for them.

Read what's written in the street: Morris columns,[2] newspaper kiosks, posters, traffic signs, graffiti, discarded handouts, shop signs.

Beauty of the women.

The fashion is for heels that are too high.

Decipher a bit of the town, deduce the obvious facts: the obsession with ownership, for example. Describe the number of operations the driver of a vehicle is subjected to when he parks merely in order to go and buy a hundred grams of fruit jelly:

– parks by means of a certain amount of toing and froing

– switches off the engine

– withdraws the key, setting off a first anti-theft device

– extricates himself from the vehicle

– winds up the left-hand front window

– locks it

– checks that the left-hand rear door is locked;

if not:

– opens it

– raises the handle inside

– slams the door

– checks it's locked securely

– circles the car; if need be, checks that the boot is locked properly

– checks that the right-hand rear door is locked; if not, recommences the sequence of operations already carried out on the left-hand rear door

– winds up the right-hand front window

– shuts the right-hand front door

– locks it

– before walking away, looks all around him as if to make sure the car is still there and that no one will come and take it away.

Decipher a bit of the town. Its circuits: why do the buses go from this place to that? Who chooses the routes, and by what criteria? Remember that the trajectory of a Paris bus *intra muros* is defined by a two-figure number the first figure of which describes the central and the second the peripheral terminus. Find examples, find exceptions: all the buses whose number begins with a 2 start from the Gare St-Lazare, with a 3 from the Gare de l'Est. All the buses whose number ends in a 2 terminate roughly speaking in the sixteenth arrondissement or in Boulogne.

(Before, they used letters: the S, which was Queneau's favourite, has become the 84. Wax sentimental over the memory of buses that had a platform at the back, the shape of the tickets, the ticket collector with his little machine hooked on to his belt.)

The people in the streets: where are they coming from? Where are they going to? Who are they?

People in a hurry. People going slowly. Parcels. Prudent people who've taken their macs. Dogs: they're the only animals to be seen. You can't see any birds—yet you know there are birds—and can't hear them either. You might see a cat slip underneath a car, but it doesn't happen.

Nothing is happening, in fact.

Try to classify the people: those who live locally and those who don't live locally. There don't seem to be any tourists. The season doesn't lend itself to it, and anyway the area isn't especially touristy. What are the local attractions? Salomon Bernard's house? The church of St Thomas Aquinas? No 5, Rue Sebastien-Bottin?[3]

Time passes. Drink your beer. Wait.

Note that the trees are a long way off (on the Boulevard Saint-Germain and the Boulevard Raspail), that there are no cinemas or theatres, that there are no building sites to be seen, that most of the houses seem to have obeyed the regulations so far as renovation is concerned.

A dog, of an uncommon breed (Afghan hound? saluki?).

A Land Rover that seems to be equipped for crossing the Sahara (in spite of yourself, you're only noting the untoward, the peculiar, the wretched exceptions; the opposite is what you should be doing).

Carry on

Until the scene becomes improbable, until you have the impression, for the briefest of moments, that you are in a strange town or, better still, until you can no longer understand what is happening or is not happening, until the whole place becomes strange, and you no longer even know that this is what is called a town, a street, buildings, pavements…

Make torrential rain fall, smash everything, make grass grow, replace the people by cows and, where the Rue de Bae meets the Boulevard Saint-Germain, make King Kong appear, or Tex Avery's herculean mouse, towering a hundred metres above the roofs of the buildings!

Or again: strive to picture to yourself, with the greatest possible precision, beneath the network of streets, the tangle of sewers, the lines of the Metro, the invisible underground proliferation of conduits (electricity, gas, telephone lines, water mains, express letter tubes), without which no life would be possible on the surface.

Underneath, just underneath, resuscitate the eocene: the limestone, the marl and the soft chalk, the gypsum, the lacustrian Saint-Ouen limestone, the Beauchamp sands, the rough limestone, the Soissons sands and lignites, the plastic clay, the hard chalk.

* Excerpted from "La rue," in *Espèces d'espaces* (Paris: Galilee, 1974); trans. John Sturrock, *Species of Spaces and Other Pieces* (London and New York: Penguin, 1997), 46–56.

Notes
1. Called *boats* because of their shape.
2. The sturdy columns that carry posters advertising theatrical and other entertainments.
3. The address of the largest and most glamorous of French publishing houses, Editions Gallimard, by whom Perec would like to have been published, though he never was.

DISTINCTION: A SOCIAL CRITIQUE OF THE JUDGE-MENT OF TASTE

Pierre Bourdieu

There is an economy of cultural goods, but it has a specific logic. Sociology endeavours to establish the conditions in which the consumers of cultural goods, and their taste for them, are produced, and at the same time to describe the different ways of appropriating such of these objects as are regarded at a particular moment as works of art, and the social conditions of the constitution of the mode of appropriation that is considered legitimate. But one cannot fully understand cultural practices unless "culture," in the restricted, normative sense of ordinary usage, is brought back into "culture" in the anthropological sense, and the elaborated taste for the most refined objects is reconnected with the elementary taste for the flavours of food.

Whereas the ideology of charisma regards taste in legitimate culture as a gift of nature, scientific observation shows that cultural needs are the product of upbringing and education: surveys establish that all cultural practices (museum visits, concert-going, reading etc.), and preferences in literature, painting or music, are closely linked to educational level (measured by qualifications or length of schooling) and secondarily to social origin.[1] The relative weight of home background and of formal education (the effectiveness and duration of which are closely dependent on social origin) varies according to the extent to which the different cultural practices are recognized and taught by the educational system, and the influence of social origin is strongest—other things being equal—in "extra-curricular" and avant-garde culture. To the socially recognized hierarchy of the arts, and within each of them, of genres, schools or periods, corresponds a social hierarchy of the consumers. This predisposes tastes to function as markers of "class." The manner in which culture has been acquired lives on in the manner of using it: the importance attached to manners can be understood once it is seen that it is these imponderables of practice which distinguish the different—and ranked—modes of culture acquisition, early or late, domestic or scholastic, and the classes of individuals which they characterize (such as "pedants" and *mondains*). Culture also has its titles of nobility—awarded by the educational system—and its pedigrees, measured by seniority in admission to the nobility.

The definition of cultural nobility is the stake in a struggle which has gone on unceasingly, from the seventeenth century to the present day, between groups differing in their ideas of culture and of the legitimate relation to culture and to works of art, and therefore differing in the conditions of acquisition of which these dispositions are the product.[2] Even in the classroom, the dominant definition of the legitimate way of appropriating culture and works of art favours those who have had early access to legitimate culture, in a cultured household, outside of scholastic disciplines, since even within the educational system it devalues scholarly knowledge and interpretation as "scholastic" or even "pedantic" in favour of direct experience and simple delight.

The logic of what is sometimes called, in typically "pedantic" language, the "reading" of a work of art, offers an objective basis for this opposition. Consumption is, in this case, a stage in a process of communication, that is, an act of deciphering, decoding, which presupposes practical or explicit mastery of a cipher or code. In a sense, one can say that the capacity to see (*voir*) is a function of the knowledge (*savoir*), or concepts, that is, the words, that are available to name visible things, and which are, as it were, programmes for perception. A work of art has meaning and interest only for someone who possesses the cultural competence, that is, the code, into which it is encoded. The conscious or unconscious implementation of explicit or implicit schemes of perception and appreciation which constitutes pictorial or musical culture is the hidden condition for recognizing the styles characteristic of a period, a school or an author, and, more generally, for the familiarity with the internal logic of works that aesthetic enjoyment presupposes. A beholder who lacks the specific code feels lost in a chaos of sounds and rhythms, colours and lines, without rhyme or reason. Not having learnt to adopt the adequate disposition, he stops short at what Erwin Panofsky calls the "sensible properties," perceiving a skin as downy or lace-work as delicate, or at the emotional resonances aroused by these properties, referring to "austere" colours or a "joyful" melody. He cannot move from the "primary stratum of the meaning we can grasp on the basis of our ordinary experience" to the "stratum of secondary meanings," i.e., the "level of the meaning of what is signified," unless he possesses the concepts which go beyond the sensible properties and which identify the specifically stylistic properties of the work.[3] Thus the encounter with a work of art is not "love at first sight" as is generally supposed, and the act of empathy, *Einfühlung*, which is the art-lover's pleasure, presupposes an act of cognition, a decoding operation, which implies the

implementation of a cognitive acquirement, a cultural code.[4]

This typically intellectualist theory of artistic perception directly contradicts the experience of the art-lovers closest to the legitimate definition; acquisition of legitimate culture by insensible familiarization within the family circle tends to favour an enchanted experience of culture which implies forgetting the acquisition.[5] The "eye" is a product of history reproduced by education. This is true of the mode of artistic perception now accepted as legitimate, that is, the aesthetic disposition, the capacity to consider in and for themselves, as form rather than function, not only the works designated for such apprehension, i.e., legitimate works of art, but everything in the world, including cultural objects which are not yet consecrated—such as, at one time, primitive arts, or, nowadays, popular photography or kitsch—and natural objects. The "pure" gaze is a historical invention linked to the emergence of an autonomous field of artistic production, that is, a field capable of imposing its own norms on both the production and the consumption of its products.[6] An art which, like all Post-Impressionist painting, is the product of an artistic intention which asserts the primacy of the mode of representation over the object of representation demands categorically an attention to form which previous art only demanded conditionally.

The pure intention of the artist is that of a producer who aims to be autonomous, that is, entirely the master of his product, who tends to reject not only the "programmes" imposed a priori by scholars and scribes, but also—following the old hierarchy of doing and saying—the interpretations superimposed a posteriori on his work. The production of an "open work," intrinsically and deliberately polysemic, can thus be understood as the final stage in the conquest of artistic autonomy by poets and, following in their footsteps, by painters, who had long been reliant on writers and their

work of "showing" and "illustrating." To assert the autonomy of production is to give primacy to that of which the artist is master, i.e., form, manner, style, rather than the "subject," the external referent, which involves subordination to functions—even if only the most elementary one, that of representing, signifying, saying something. It also means a refusal to recognize any necessity other than that inscribed in the specific tradition of the artistic discipline in question: the shift from an art which imitates nature to an art which imitates art, deriving from its own history the exclusive source of its experiments and even of its breaks with tradition. An art which ever increasingly contains reference to its own history demands to be perceived historically; it asks to be referred not to an external referent, the represented or designated "reality," but to the universe of past and present works of art. Like artistic production, in that it is generated in a field, aesthetic perception is necessarily historical, inasmuch as it is differential, relational, attentive to the deviations (écarts) which make styles. Like the so-called naive painter who, operating outside the field and its specific traditions, remains external to the history of the art, the "naive" spectator cannot attain a specific grasp of works of art which only have meaning—or value—in relation to the specific history of an artistic tradition. The aesthetic disposition demanded by the products of a highly autonomous field of production is inseparable from a specific cultural competence. This historical culture functions as a principle of pertinence which enables one to identify, among the elements offered to the gaze, all the distinctive features and only these, by referring them, consciously or unconsciously, to the universe of possible alternatives. This mastery is, for the most part, acquired simply by contact with works of art—that is, through an implicit learning analogous to that which makes it possible to recognize familiar faces without explicit rules or criteria—and it generally remains at a practical

level; it is what makes it possible to identify styles, i.e., modes of expression characteristic of a period, a civilization or a school, without having to distinguish clearly, or state explicitly, the features which constitute their originality. Everything seems to suggest that even among professional valuers, the criteria which define the stylistic properties of the "typical works" on which all their judgements are based usually remain implicit.

The pure gaze implies a break with the ordinary attitude towards the world, which, given the conditions in which it is performed, is also a social separation. Ortega y Gasset can be believed when he attributes to modern art a systematic refusal of all that is "human," i.e., generic, common—as opposed to distinctive, or distinguished—namely, the passions, emotions and feelings which "ordinary" people invest in their "ordinary" lives. It is as if the "popular aesthetic" (the quotation marks are there to indicate that this is an aesthetic "in itself" and not "for itself") were based on the affirmation of the continuity between art and life, which implies the subordination of form to function. This is seen clearly in the case of the novel and especially the theatre, where the working-class audience refuses any sort of formal experimentation and all the effects which, by introducing a distance from the accepted conventions (as regards scenery, plot etc.), tend to distance the spectator, preventing him from getting involved and fully identifying with the characters (I am thinking of Brechtian "alienation" or the disruption of plot in the nouveau roman). In contrast to the detachment and disinterestedness which aesthetic theory regards as the only way of recognizing the work of art for what it is, i.e., autonomous, selbständig, the "popular aesthetic" ignores or refuses the refusal of "facile" involvement and "vulgar" enjoyment, a refusal which is the basis of the taste for formal experiment. And popular judgements of paintings or photographs spring from an "aesthetic" (in fact it is an ethos) which is the

exact opposite of the Kantian aesthetic. Whereas, in order to grasp the specificity of the aesthetic judgement, Kant strove to distinguish that which pleases from that which gratifies and, more generally, to distinguish disinterestedness, the sole guarantor of the specifically aesthetic quality of contemplation, from the interest of reason which defines the Good, working-class people expect every image to explicitly perform a function, if only that of a sign, and their judgements make reference, often explicitly, to the norms of morality or agreeableness. Whether rejecting or praising, their appreciation always has an ethical basis.

Popular taste applies the schemes of the ethos, which pertain in the ordinary circumstances of life, to legitimate works of art, and so performs a systematic reduction of the things of art to the things of life. The very seriousness (or naivety) which this taste invests in fictions and representations demonstrates a contrario that pure taste performs a suspension of "naive" involvement which is one dimension of a "quasi-ludic" relationship with the necessities of the world. Intellectuals could be said to believe in the representation—literature, theatre, painting—more than in the things represented, whereas the people chiefly expect representations and the conventions which govern them to allow them to believe "naively" in the things represented. The pure aesthetic is rooted in an ethic, or rather, an ethos of elective distance from the necessities of the natural and social world, which may take the form of moral agnosticism (visible when ethical transgression becomes an artistic *parti pris*) or of an aestheticism which presents the aesthetic disposition as a universally valid principle and takes the bourgeois denial of the social world to its limit. The detachment of the pure gaze cannot be dissociated from a general disposition towards the world which is the paradoxical product of conditioning by negative economic necessities—a life of ease—that tends to induce an active distance from necessity.

Although art obviously offers the greatest scope to the aesthetic disposition, there is no area of practice in which the aim of purifying, refining and sublimating primary needs and impulses cannot assert itself, no area in which the stylization of life, that is, the primacy of forms over function, of manner over matter, does not produce the same effects. And nothing is more distinctive, more distinguished, than the capacity to confer aesthetic status on objects that are banal or even "common" (because the "common" people make them their own, especially for aesthetic purposes), or the ability to apply the principles of a "pure" aesthetic to the most everyday choices of everyday life, e.g., in cooking, clothing or decoration, completely reversing the popular disposition which annexes aesthetics to ethics.

In fact, through the economic and social conditions which they presuppose, the different ways of relating to realities and fictions, of believing in fictions and the realities they simulate, with more or less distance and detachment, are very closely linked to the different possible positions in social space and, consequently, bound up with the systems of dispositions (habitus) characteristic of the different classes and class fractions. Taste classifies, and it classifies the classifier. Social subjects, classified by their classifications, distinguish themselves by the distinctions they make, between the beautiful and the ugly, the distinguished and the vulgar, in which their position in the objective classifications is expressed or betrayed. And statistical analysis does indeed show that oppositions similar in structure to those found in cultural practices also appear in eating habits. The antithesis between quantity and quality, substance and form, corresponds to the opposition—linked to different distances from necessity— between the taste of necessity, which favours the most "filling" and most economical foods, and the taste of liberty— or luxury—which shifts the emphasis to the manner (of presenting, serving, eating

etc.) and tends to use stylized forms to deny function.

The science of taste and of cultural consumption begins with a transgression that is in no way aesthetic: it has to abolish the sacred frontier which makes legitimate culture a separate universe, in order to discover the intelligible relations which unite apparently incommensurable "choices," such as preferences in music and food, painting and sport, literature and hairstyle. This barbarous reintegration of aesthetic consumption into the world of ordinary consumption abolishes the opposition, which has been the basis of high aesthetics since Kant, between the "taste of sense" and the "taste of reflection," and between facile pleasure, pleasure reduced to a pleasure of the senses, and pure pleasure, pleasure purified of pleasure, which is predisposed to become a symbol of moral excellence and a measure of the capacity for sublimation which defines the truly human man. The culture which results from this magical division is sacred. Cultural consecration does indeed confer on the objects, persons and situations it touches, a sort of ontological promotion akin to a transubstantiation. Proof enough of this is found in the two following quotations, which might almost have been written for the delight of the sociologist:

"What struck me most is this: nothing could be obscene on the stage of our premier theatre, and the ballerinas of the Opera, even as naked dancers, sylphs, sprites or Bacchae, retain an inviolable purity."[7]

"There are obscene postures: the simulated intercourse which offends the eye. Clearly, it is impossible to approve, although the interpolation of such gestures in dance routines does give them a symbolic and aesthetic quality which is absent from the intimate scenes the cinema daily flaunts before its spectators' eyes… As for the nude scene, what can one say, except that it is brief and theatrically not very effective? I will not say it is chaste or innocent, for

nothing commercial can be so described. Let us say it is not shocking, and that the chief objection is that it serves as a box-office gimmick…. In *Hair*, the nakedness fails to be symbolic."[8]

The denial of lower, coarse, vulgar, venal, servile—in a word, natural—enjoyment, which constitutes the sacred sphere of culture, implies an affirmation of the superiority of those who can be satisfied with the sublimated, refined, disinterested, gratuitous, distinguished pleasures forever closed to the profane. That is why art and cultural consumption are predisposed, consciously and deliberately or not, to fulfil a social function of legitimating social differences.

*Excerpted from the introduction to the first edition of *Distinction: A Social Critique of the Judgement of Taste*, trans. Richard Nice (Cambridge, MA: Harvard University Press, 1984), 1–7. Originally published by Les Éditions de Minuit, Paris, as *La Distinction: Critique sociale du jugement*, 1979.

Notes
1. Bourdieu et al., *Un art moyen: essai sur les usages sociaux de la photographie* (Paris: Ed. de Minuit, 1965); P. Bourdieu and A. Darbel, *L'Amour de l'art: les musées et leur public* (Paris: Ed. de Minuit, 1966).
2. The word *disposition* seems particularly suited to express what is covered by the concept of habitus (defined as a system of dispositions)—used later in this chapter. It expresses first the *result of an organizing action*, with a meaning close to that of words such as structure; it also designates a way of being, a habitual state (especially of the body) and, in particular, a *predisposition, tendency, propensity* or *inclination*. [The semantic cluster of "disposition" is rather wider in French than in English, but as this note—translated literally—shows, the equivalence is adequate. Translator.] P. Bourdieu, *Outline of a Theory of Practice* (Cambridge: Cambridge University Press, 1977), 214n1.
3. E. Panofsky, "Iconography and Iconology: An Introduction to the Study of Renaissance Art," *Meaning in the Visual Arts* (New York: Doubleday, 1955), 28.
4. It will be seen that this internalized code called culture functions as cultural capital owing to the fact that, being unequally distributed, it secures profits of distinction.
5. The sense of familiarity in no way excludes the ethnocentric misunderstanding which results from applying the wrong code. Thus, Michael Baxandall's work in historical ethnology enables us to measure all that separates the perceptual schemes that now tend to be applied to Quattrocento paintings and those which their immediate addressees applied. The "moral and spiritual eye" of Quattrocento man, that is, the set of cognitive and evaluative dispositions which were the basis of his perception of the world and his perception

of pictorial representation of the world, differs radically from the "pure" gaze (purified, first of all, of reference to economic value) with which the modern cultivated spectator looks at works of art. As the contracts show, the clients of Filippo Lippi, Dominico Ghirlandaio or Piero della Francesca were concerned to get "value for money." They approached works of art with the mercantile dispositions of a businessman who can calculate quantities and prices at a glance, and they applied some surprising criteria of appreciation, such as the expense of the colours, which sets gold and ultramarine at the top of the hierarchy. The artists, who shared this world view, were led to include arithmetical and geometrical devices in their compositions so as to flatter this taste for measurement and calculation; and they tended to exhibit the technical virtuosity which, in this context, is the most visible evidence of the quantity and quality of the labour provided; M. Baxandall, *Painting and Experience in Fifteenth-Century Italy: A Primer in the Social History of Pictorial Style* (Oxford: Oxford University Press, 1972).
6. See P. Bourdieu, "Le marché des biens symboliques," *L'Année Sociologique* 22 (1973): 49–126; and "Outline of a Sociological Theory of Art Perception," *International Social Science Journal* 20 (Winter 1968): 589–612.
7. O. Merlin, "Mlle. Thibon dans la vision de Marguerite," *Le Monde*, 9 December 1965.
8. F. Chenique, "*Hair* est-il immoral?," *Le Monde*, 28 January 1970.

"TO QUOTE," SAY THE KABYLES, "IS TO BRING BACK TO LIFE"

Andrea Fraser

Doomed to death, that end which cannot be taken as an end, man is a being without a reason for being. It is society, and society alone, which dispenses, to different degrees, the justifications and reasons for existing; it is society which, by producing the affairs or positions that are said to be "important," produces the acts and agents that are judged to be "important," for themselves and for the others—characters objectively and subjectively assured of their value and thus liberated from indifference and insignificance.
—Pierre Bourdieu, "A Lecture on the Lecture," 1982

I am sitting at a desk at the Collège de France, in an office a few doors down from the office Pierre Bourdieu occupied until a few months ago. I found my way here through the intervention of Inès Champey, who often played the role of mediating my contact with Bourdieu when he was alive. (Bourdieu was the only person to whom I ever sent unsolicited work, but even after we met I remained too shy to call him directly.) Marie-Christine Rivière, Bourdieu's secretary of many decades, graciously responded to my need to consult English translations of his writings. Inès thought this would be the easiest place to find them.

I've been trying to write this short text for over six weeks now. I want to attribute my difficulty to the fact that I'm traveling and don't have access to my library. But the painful irony is that the task of writing a memorial essay about Bourdieu has become a test, not only of my understanding of his work, but of my success in internalizing it.

I haven't been able to find copies of tributes Bourdieu himself wrote. I'm looking through the essays collected in *Language and Symbolic Power*. I wonder if he would have counted the tribute as one of the "rites of institution" he described as serving to consecrate arbitrary differences—the difference, for example, between a significant and an insignificant life.[1] But there is nothing arbitrary to me about Bourdieu's significance in my own life. I'm looking through *Outline of a Theory of Practice*. I wonder if he would have analyzed the tribute as an exchange within a symbolic economy where debt is repaid as recognition.[2] The language of honor and the achievements of great men are foreclosed to me. I'm looking through the essays collected in *Practical Reason*. I wonder if he would have considered the tribute a form of production of symbolic capital that serves to structure the perception of particular properties according to modes of classification generated by the field in which those

properties are constituted as legitimate stakes. Or would he have considered the tribute an occasion to practice a "*realpolitik* of reason," pressing the symbolic capital accumulated in the cultural field into the service of struggles against symbolic domination?[3]

Perhaps he simply would have said, as he did when accepting the Ernst Block Prize, that the many eulogies written about him are "really too generous," attributing to "my individual personality alone a number of properties or qualities which are also the product of social conditions."[4]

No, I won't betray him now, by honoring him. No, I won't betray him now, by failing to honor him.

Having come to Paris, where Inès has shown me dozens of tributes published in France, and to the Collège de France, where a meeting of Bourdieu's colleagues and collaborators happens to be taking place in the next room, I'm acutely aware of the arbitrariness of being delegated to write this essay, as well as the arbitrariness of my knowledge of Bourdieu's work itself. I have only a secondhand sense of the impact of his activism of the past decade. I'm not a sociologist or an ethnographer or a philosopher. I can't evaluate his research or theory in its intellectual context. Sitting here, I find myself retreating to the first-person narrative (running the risk of individualizing an experience that is only, as Bourdieu liked to say, after Bachelard, "a particular instance of the possible").[5] Theoretical overviews and artistic applications will have to wait. The tools of universalization are lost to me. Sitting here, I find myself reduced once again in my own mind to the high school dropout whose desperate efforts to compensate for educational failure led me to scour bookshops obsessively, without order, without syllabi. As Bourdieu described the autodidact's knowledge—I'm searching through my borrowed copy of *Distinction* for the passage—what I know of his work is no more than "a collection of unstrung pearls, accumulated in the

course of an uncharted exploration" with no other connection than a "sequence of biographical accidents."[6]

My encounter with Bourdieu was just such an accident. Had I syllabi I might never have bought *Distinction,* as Bourdieu was on no reading list I ever received in my mid-1980s art education, despite its infusion with postwar French theory. I was very young. His work became my second language.

He writes: the "autodidact's relations to culture, and the autodidact himself"—in later works Bourdieu took to using feminine pronouns—is a negative product of the educational system as "the sole agency empowered to transmit the hierarchical body of aptitudes and knowledge which constitutes legitimate culture, and to consecrate arrival at a given level of initiation."[7] Above all, he continues, "the autodidact, a victim by default of the effects of educational entitlement, is ignorant of the right to be ignorant that is conferred by certificates of knowledge."[8]

Sitting here in the Collège de France brings back the memory of the acute anxiety I once felt when confronted with legitimate culture—in academic contexts, in France generally, in museums and galleries. I credit Bourdieu with freeing me, or helping me free myself, from the sense of illegitimacy—what he later called symbolic violence—imposed by legitimate culture, "a product of domination predisposed to express or legitimate domination."[9] Against a legitimacy Bourdieu described so simply as "the fact of feeling justified in being (what one is), being what it is right to be,"[10] *Distinction* exposed the paralyzing experience of illegitimacy with liberating clarity: the muting and mutilating violence of cultural judgments, the crushing authority of consecrated competence, the anguish that filled the gap between knowledge and recognition, the sense of imposture, the disfiguring force of aspirations structured according to socially and materially foreclosed possibilities.

But *Distinction,* as a product of Bourdieu's relational, reflexive sociology, also made it impossible for me to imagine symbolic domination as a force that exists somewhere out there, in particular, substantive, institutions or individuals or cultural forms or practices, external to me as a social agent or as an artist—however young and disempowered I may have felt.

"Reflexive analysis," Bourdieu says in *An Invitation to Reflexive Sociology,* "teaches that we are the ones who endow the situation with part of the potency it has over us." It allows us to step back and monitor "the determinisms that operate through the relation of immediate complicity between position and dispositions," between the social fields in which we exist and the internalized schemes of perception and appreciation, classification and hierarchization, interest and practice produced in those very fields, which he called habitus.[11]

Bourdieu was explicit in describing one of the aims of his work as producing a habitus disposed, "as a matter of practical logic," to act reflexively. If reflexivity, for Bourdieu, was the condition of the possibility of liberation from symbolic domination, he also saw it as the condition of social science, as what stands between scientific truth and theoretical distortions which, more often than not, result in the reproduction of conservative doxa.[12]

Bourdieu defined reflexive methodology as the full objectification, not only of an object, but of one's relation to an object—including not only the schemes of perception and classification one employs in one's objectifications, and not only one's interest in objectifying, but the social conditions of their possibility.[13] The principle of reflexivity seemed to orient every turn of Bourdieu's practice, from choosing to do ethnographic fieldwork in Algeria during the Algerian war—where he already questioned the "practical privilege" of the observer;[14] to pursuing ethnographic study first of his hometown in France and then, in *Distinction,* of

France itself; to his study of the production and exploitation of the very forms of capital that he himself held as a consecrated intellectual, in *Homo Academicus* and *The State Nobility;* to his work on *Masculine Domination;* and finally, to challenging in his activism the profound if often unconscious complicity that exists between increasingly heteronomous intellectuals and neoliberalism's "theodicy" of competence, which they share.[15]

One of the most important elements of Bourdieu's analysis of the cultural field (including such subfields as the arts, the humanities, and the sciences) is that it occupies a dominated position in the dominant field—or what he also called the field of power. He described this condition as one of the foundations of the ambivalence of artists and intellectuals. In our own experiences as a "dominated faction of the dominant faction," as well as in the homology between our condition and the condition of dominated classes, we may find our politics. But in our own interests in maintaining and improving our relative position, invested even in our struggles against the dominant, we also tend to reproduce the conditions of domination—our own and that of others.[16] As Bourdieu wrote in *Distinction,* "one may choose to emphasize either the complicities which unite them in hostility or the hostilities which separate them in complicity";[17] but the structural homologies that exist within the field of power between the holders of cultural capital and the holders of economic and political capital consign artists and intellectuals to their place within "divisions of the labor of domination" material and symbolic. They are homologies that political self-proclamations tend most often only to mask.

It is, above all, from the structural ambivalence of the cultural field that the necessity of reflexive cultural practice arises. According to our position "as dominated among the dominant," reflexive analysis does not only demand of cultural practice a politics. It also—to evoke a term Bourdieu used only rarely and with caution—demands an ethics: a limit on the exploitation of a form of power we may or may not subjectively experience but nevertheless objectively manifest as holders of a relative monopoly on forms of socially and institutionally recognized competence.

It was Bourdieu's reflexivity, even more than the explanatory power of his account of the cultural field (and my experiences in it) that turned me into an adherent. As an artist, I perceived an immediate sympathy between his reflexive sociology and site-specific institutional critique—they are practices I now see as differing only in the different tools they employ and the different fields in which they function. While I have never been in the position to evaluate the scientific truth claims of Bourdieu's work, I do see reflexivity as the condition of the truth of any critical practice. It may be the only thing that stands between critique, intervention, even possible transformation, and the reproduction of the relations of domination expressed and legitimized in the cultural field. If we, as artists and intellectuals, are to exercise our historically won freedoms by speaking truth to power, then it is first of all to the truth of our own power that we must speak. Any other critical practice, or critical theory, is simply bad faith. Bourdieu provided not only the tools for understanding that truth, but an exemplary performance of its practice. Cultural fields confer an extraordinary autonomy, he wrote somewhere, especially when you use that autonomy not as a weapon against others or an instrument of defense, but as a weapon against yourself, an instrument of vigilance.

I'm reaching for "A Lecture on the Lecture," which Bourdieu delivered in 1982 on his induction into the Collège de France. It begins: "One ought to be able to deliver a lecture, even an inaugural lecture, without wondering what right one has to do so: the institution is there to protect one from that question and the anguish inseparable from the arbitrariness of all new beginnings."[18] With that question Bourdieu stepped away from the protection, the consecration, the justification, provided by the institutions of cultural legitimacy. And in that distance he created the only opening through which I can imagine being able to enter them.

* This tribute to Pierre Bourdieu was first published in *October* and *Texte zur Kunst* in their Summer 2002 issues. This version, including additional notes, is excerpted from the collection *Museum Highlights: The Writings of Andrea Fraser* (Cambridge, MA: MIT Press, 2005), 81–87.

Notes
1. Pierre Bourdieu, "Rites of Institution," in *Language and Symbolic Power*, ed. John B. Thompson, trans. Gino Raymond and Matthew Adamson (Cambridge, MA: Harvard University Press, 1994), 118.
2. See Pierre Bourdieu, "Structures, Habitus, Power: Basis for a Theory of Symbolic Power,' in *Outline of a Theory of Practice*, trans. Richard Nice (Cambridge, UK: Cambridge University Press, 1977).
3. See Pierre Bourdieu, "The Economy of Symbolic Goods" and "The Scholastic Point of View," in *Practical Reason* (Stanford: Stanford University Press, 1998).
4. Pierre Bourdieu, "A Reasoned Utopia and Economic Fatalism," *New Left Review* 227 (January/February 1998): 125.
5. See, for example, "The Practice of Reflexive Sociology (The Paris Workshop)," in Pierre Bourdieu and Lok Wacquant, *An Invitation to Reflexive Sociology* (Chicago: University of Chicago Press, 1992), 233–34.
6. Pierre Bourdieu, *Distinction: A Social Critique of the Judgment of Taste*, trans. Richard Nice (Cambridge, MA: Harvard University Press, 1984), 328.
7. Ibid.
8. Ibid., 329.
9. Ibid., 228.
10. Ibid.
11. Bourdieu and Wacquant, *An Invitation to Reflexive Sociology*, 136.
12. For a good introduction to Bourdieu's notion of reflexive sociology, see Lok Wacquant, "Epistemic Reflexivity," in Bourdieu and Wacquant, *An Invitation to Reflexive Sociology*, 36–46.
13. See also Bourdieu's discussion of "participant objectivation" in *An Invitation to Reflexive Sociology*, 68, 253–60.
14. Bourdieu, *Outline of a Theory of Practice*, 1.
15. Pierre Bourdieu, "The 'Globalization' Myth and the Welfare State," in *Acts of Resistance*, trans. Richard Nice (New York: New Press, 1998), 42–44.
16. See Pierre Bourdieu, "The Field of Cultural Production, or: The Economic World Reversed," in *The Field of Cultural Production* (New York: Columbia University Press, 1993).
17. Bourdieu, *Distinction*, 316. See also the section on "The Correspondence between Goods Production and Taste Production;" 230–44.

18. Pierre Bourdieu, "A Lecture on the Lecture," in *In Other Words*, trans. Matthew Adamson (Stanford: Stanford University Press, 1990), 177. The title of this tribute, as well as the epigraph, can be found in the same text on page 196.

THE IDENTITY ARTIST AND THE IDENTITY CRITIC

Hannah Black

The phrase *identity politics* is hard to approach directly because it is often put to use in contradictory ways. One is the really existing identity politics of, for example, the Hillary Clinton campaign. We are encouraged to vote for Clinton simply because she is a woman, as the writer Sydette Harry described in a 2015 essay for the *New Inquiry*: "The prospect of a woman presidential candidate is depoliticized into an overdue payment…something seen in 2008 as a sign of moral weakness in Black voters [i.e., voting for Obama because he is black] is considered a feminist rallying cry in white women voters for 2016."

The tokenism of white cultural and political organizations is characteristic of this mode of identity politics. People who are not white men are seen as individualized carriers of a biopolitical surplus that has to be constantly washed away in the form of an inclusion that might as well be a disavowal. To perform as evidence of the institution's purity, the identity artist has to exemplify a race/gender category, but as soon as she steps into the institution's embrace, she becomes an example of universality. She is artificially cleansed of race/gender even as she is called on to represent it.

Tokens are currency, and currency only exists insofar as it's exchanged.

The limits of inclusion are clear, sometimes brutally so. At the University of Chicago, which, like many prestigious US institutions, produces world-renowned politically radical critical theory alongside other research, victims of violence in the city are unable to receive treatment at the university's medical center: Wounded people die near medical help because the university until recently refused to reopen an adult trauma center that could save their lives. Intellectualized or aestheticized trauma is displayed for institutional, artistic, or academic validation, but physical and emotional trauma goes untreated, because it falls outside the bounds of institutional relevance. The pseudopolitics of art and academia are the pseudopolitics of identity, where exceptional individuals are supposed to magically carry or absolve the social and collective history of race.

The assumption seems to be that theories of race/gender are always autobiographical and drawn from singular experiences, while theories of class/labor can be abstract and universal, when not reduced to a fully reactionary bootstrap narrative of individual striving. There is an identity politics of class, too, which interprets it as a flatly individual and experiential category, a set of affects, vague anomies. This form of identity politics affords no materiality to history (which is a word for collective experience) beyond the narrow boundaries of the self.

This kind of identity politics is a really existing mechanism through which institutions attempt to publicly exonerate themselves of their role in the reproduction of domination.

Yet the phrase *identity politics* is also often an accusation leveled against the political or social-interpretative activities of racialized people. This criticism maintains the pseudopolitics outlined above—racialized individuals are still the magical bearers of race—but race

is understood to be a private delusion lacking political meaning. For these critics, it is impossible for race/gender to be directly political, because both belong to a private sphere of bodies, which lies either outside the public sphere of capital or within a sticky interior.

Though identity critics are not exactly *against* policies that diversify labor or representation, neither are they likely to work to make their organizations, meetings, desires, lives, or theories inclusive of nonwhiteness, because they think of the problems of race/gender as qualitatively different from the problems of labor. They are *obviously not racist*, but not because they have listened to, thought about, or ever expected to be surprised by or to learn something from a person of color's perception of what race is or how it works. If the identity critic is a man, he is *obviously not sexist*, not because he has thought about it, but because he has not thought about it at all. The identity critic can miraculously transcend the operations of misogyny and whiteness without considering race/gender, which has always just stopped being real: Some new civic gain (freedom, the vote, a movie) has always just obliterated history.

The identity critics are mad at the identity artists because they think the identity artists are only ever capable of pseudopolitics. Ironically, it is the identity critics who maintain this pseudopolitics, with their weird mix of disbelief and blame. The identity critics suspect the identity artist of being opportunistic, of leveraging identity; meanwhile, many of them rest high on the plumped psychic pillow of being white, being cis, being a man. The identity critics complain that they are sad, too; that they have suffered, too; that they experience pain, too. Liberation is not (only) about freedom from personal pain, but they are incapable of understanding this, because all they see when they look at you is the open wound of their guilt, or fear.

Of course, no one seriously believes that the limp corporate strategy of

diversity is a blow to the heart of capitalism. People demand to be included in existing institutions because they want to live well now, and not in a revolutionary afterlife. Similarly, struggles for higher wages are important without being automatically revolutionary: They are not aimed at a radical rupture, but form part of the continuing face-off between capital and labor. The huge questions of how we might wish to live together are always falling under the shadow of the questions of how to live now; the identity artist is not the only one whose attempts at survival collude with violence.

For the identity critics, reformist desires (such as demands for better pay) are acceptable as part of a radical struggle against capitalism when they occur among white men, but not when they are expressed by white women or racialized people in relation to race/gender. For these identity critics, the operation of whiteness (or racial equivalence — "We're all exactly the same") is not an object of critique but a baseline or default. They seem, in fact, to see the uninterrogated dominance of whiteness/masculinity as an important aspect of political struggle, because it offers an image of universality. In their condemnatory use of the phrase *identity politics*, *identity* is just a euphemism for not white, not cis, not male, not belonging here.

It is difficult to live the multiple valences projected onto you by identity champions and identity critics: both to be a miraculous body, capable of absolving white and misogynist institutions just by your presence, and to have this miraculous power ascribed to a narcissistic desire for difference. Although the identity artist is often praised or accused of being "very personal," the material of race/gender is not personal at all.

The evocation of the dismal histories and current realities of race/gender in an art context, like evocations of labor, is not often directly aimed at producing actual political effects. Art is a place to think, even if it's also a place where that thought gets repackaged and commodified. Although some institutions are worse than others, I suspect that effective radical struggles have to be far more antagonistic and communal than is possible within the realm of contemporary art. Art is not conducive to collective struggle, although activists and political theorists are often invoked in the name of art, for reasons to do with its historical function as a space of permissible critique.

Equally, art is not a space of pure self-expression. It is a place where we can treat the self as historical and social material. The universality of race/gender does not lie in whiteness/masculinity as its apex or negation but in a universally shared entanglement in race/gender's problematics. Art can come close to the real structure of "identity," which also entails a kind of nonidentity with the self. The peculiarities of race/gender produce all sorts of doubling or layering effects: A woman is a person who consents to be troubled by her failures to be a woman, and blackness is something that I can't be and can't be without.

What the contemporary politics of identity makes painfully visible is the problem of establishing meaningful collectivity — without elision, domination, or uninflected hierarchy — against a capitalist class capable of extreme acts of violence and mass control. Collectivity might be the necessary first step toward making life bearable, but the production of that collectivity may be less cozy than strategies of inclusion, diversity, and universality suggest.

* Text first published in *Artforum* 54, no. 10 (Summer 2016), https://www.artforum.com/print/201606/the-identity-artist-and-the-identity-critic-60105.

IN THE WAKE: ON BLACKNESS AND BEING

Christina Sharpe

I teach a course called Memory for Forgetting. The title came from my misremembering the title of a book that Judith Butler mentioned in an MLA talk on activism and the academy in San Diego in 2004. The book was Mahmoud Darwish's *Memory for Forgetfulness*, and the course looks at two traumatic histories (the Holocaust and largely US/North American slavery) and the film, memoir, narrative, literature, and art that take up these traumas. I have found that I have had to work very hard with students when it comes to thinking through slavery and its afterlives. When I taught the course chronologically, I found that many, certainly well-meaning, students held onto whatever empathy they might have for reading about the Holocaust but not for North American slavery. After two semesters of this, I started teaching the Holocaust first and then North American chattel slavery. But even after I made the change, students would say things about the formerly enslaved like, "Well, they were *given* food and clothing; there was a kind of care there. And what would the enslaved have done otherwise?" The "otherwise" here means: What lives would Black people have had outside of slavery? How would they have survived independent of those who enslaved them? In order for the students in the class to confront their inability to think blackness otherwise and to think slavery as state violence, at a certain moment in the course I replay a scene from Claude Lanzmann's *Shoah*. The scene is in the section of *Shoah* where we meet Simon Srebnik (one

of three survivors of the massacre at Chelmno then living in Israel) on his return to Chelmno, Poland. In this scene Srebnik is surrounded by the townspeople who remember him as the young boy with the beautiful voice who was forced by the Germans to sing on the river every morning. At first the townspeople are glad to see him, glad to know that he is alive. Soon, though, and with ease, their relief and astonishment turn into something else, and they begin to speak about how they helped the Jewish residents of Chelmno, and then they begin to blame the Jews of Chelmno for their own murder. The camera stays on Srebnik's face, as it becomes more and more frozen into a kind of smile as these people surround him. Some of these people who are brought out of their homes by his singing on the river — as if he is a revenant — are the very people who by apathy or more directly abetted the murder of thousands of the town's Jewish residents. The students are appalled by all of this. They feel for him. I ask them if they can imagine if, after the war's end, Simon Srebnik had no place to go other than to return to this country and this town; to these people who would have also seen him dead; who had, in fact, tried to kill him and every other Jewish person in Chelmno. That is, I say, the condition in the post–Civil War United States of the formerly enslaved and their descendants; still on the plantation, still surrounded by those who claimed ownership over them and who fought, and fight still, to extend that state of capture and subjection in as many legal and extralegal ways as possible, into the present. The means and modes of Black subjection may have changed, but the fact and structure of that subjection remain. Those of us who teach, write, and think about slavery and its afterlives encounter myriad silences and ruptures in time, space, history, ethics, research, and method as we do our work. Again and again scholars of slavery face absences in the archives as we attempt to find "the agents buried beneath" (Spillers 2003) the accumulated erasures,

projections, fabulations, and misnamings. There are, I think, specific ways that Black scholars of slavery get wedged in the partial truths of the archives while trying to make sense of their silences, absences, and modes of dis/appearance. The methods most readily available to us sometimes, oftentimes, force us into positions that run counter to what we know. That is, our knowledge, of slavery and Black being in slavery, is gained from our studies, yes, but also in excess of those studies;[1] it is gained through the kinds of knowledge from and of the everyday, from what Dionne Brand calls "sitting in the room with history."[2] We are expected to discard, discount, disregard, jettison, abandon, and measure those ways of knowing and to enact epistemic violence that we know to be violence against others and ourselves. In other words, for Black academics to produce legible work in the academy often means adhering to research methods that are "drafted into the service of a larger destructive force" (Saunders 2008, 67), thereby doing violence to our own capacities to read, think, and imagine otherwise. Despite knowing otherwise, we are often disciplined into thinking through and along lines that reinscribe our own annihilation, reinforcing and reproducing what Sylvia Wynter (1994, 70) has called our "narratively condemned status." We must become undisciplined. The work we do requires new modes and methods of research and teaching; new ways of entering and leaving the archives of slavery, of undoing the "racial calculus and…political arithmetic that were entrenched centuries ago" (Hartman 2008, 6) and that live into the present. I think this is what Brand describes in *A Map to the Door of No Return* as a kind of blackened knowledge, an unscientific method, that comes from observing that where one stands is relative to the door of no return and that moment of historical and ongoing rupture. With this as the ground, I've been trying to articulate a method of encountering a past that is not past. A

method along the lines of a sitting with, a gathering, and a tracking of phenomena that disproportionately and devastatingly affect Black peoples any and everywhere we are. I've been thinking of this gathering, this collecting and reading toward a new analytic, as the wake and wake work, and I am interested in plotting, mapping, and collecting the archives of the everyday of Black immanent and imminent death, and in tracking the ways we resist, rupture, and disrupt that immanence and imminence aesthetically and materially. I am interested in how we imagine ways of knowing that past, in excess of the fictions of the archive, but not only that. I am interested, too, in the ways we recognize the many manifestations of that fiction and that excess, that past not yet past, in the present.

*Excerpted from Chapter 1, "The Wake," in *In the Wake: On Blackness and Being* (Durham, NC: Duke University Press, 2016), 11–13.

Notes
1. That is, study within the university and graduate classroom and not Black Study as [Fred] Moten and [Stefano] Harney take it up in *The Undercommons: Fugitive Planning and Black Study*.
2. Brand writes: "One enters a room and history follows; one enters a room and history precedes. History is already seated in the chair in the empty room when one arrives. Where one stands in a society seems always related to this historical experience. Where one can be observed is relative to that history. All human effort seems to emanate from this door. How do I know this? Only by self-observation, only by looking. Only by feeling. Only by being a part, sitting in the room with history" (Brand 2001, 29).

Works Cited
Brand, Dionne. *A Map to the Door of No Return*. Toronto: Doubleday Canada, 2001.

Hartman, Saidiaya. *Lose Your Mother: A Journey Along the Atlantic Slave Route*. New York: Macmillan, 2008.

Saunders, Patricia. "Defending the Dead, Confronting the Archive: A Conversation with M. NourbeSe Philip." *Small Axe* 12, no. 2 (June 2008): 63–79.

Spillers, Hortense J. *Black, White, and in Color: Essays on American Literature and Culture*. Chicago: University of Chicago Press, 2003.

Wynter, Sylvia. "No Humans Involved: An Open Letter to My Colleagues." *Knowledge on Trial* 1, no. 1 (1994): 42–73.

FORENSIC ARCHITECTURE: VIOLENCE AT THE THRESHOLD OF DETECTABILITY

Eyal Weizman

We cannot know the past as a conclusive, transparent fact mechanically etched into matter or memory or perfectly captured in an image. Histories of violence will always have their lacunas and discontinuities. They are inherent in violence and trauma and to a certain extent evidence of them. When undertaking our investigations, we must take into account the difficulties and complexities of memory, just as we do with photography and other forms of material investigation. No evidence ever speaks for itself. It must always be presented and face cross-interrogation. In trying to interpret and present the evidence before us, we must continually try to steer between the two opposing tendencies into which all discussions of truth gravitate—a totalizing view of a single, privileged position such as the state's, and a relativist, anti-universalist perspective that regards all truths as multiple, relative, or nonexistent.

The starting point for each of our investigations is the inherent contradiction in all accounts—not only between the claims of the state and its military and the accounts of its civilian victims, but also within each of these groups and sometimes within a single testimony or a single bit of material or media evidence. Sometimes from that great, messy flood of testimonies and pixels, from the contradictions and unknowables, it is possible to assemble, with some effort, a more or less coherent narrative (or a counternarrative) that is cognizant of the problem of truth-telling, and claim, "This is what happened here." But even in such cases, we record the situated perspectives and divergences and regard them as information in their own right.

We do not have at our disposal the same access to technologies and information that rich states, corporations, and their militaries might be able to muster. We sometimes have only weak signals at the threshold of detectability with which to disrupt the flood of obfuscating messages and attempts at denial—a faint and blurry streak, identified in a single frame of a video shot by a videographer-activist, a few pixels, lighter than their surroundings, that indicate, in the absence of other photographic documentation, the likely place of impact of a drone-fired missile, changes in the vigor of vegetation that demonstrate the loss of biomass in the cloud forest and thus the displacement of the indigenous peoples who lived there.

The potentially fragile nature of such evidence makes political mobilization necessary. Unlike law, politics does not seek to render judgment on past events from the vantage point of the present and its institutions. Rather, it is driven by a desire to change the way things are.

One of the most important insights from time spent in forensic work together with activist and human rights groups is that rather than numbing our perceptions of the pain of others, work on sensing, detecting, calculating, processing, and presenting the facts of violence and destruction has, in fact, further sensitized us to the world around us.

In achieving a heightened state of sensitivity to the actuality and material consequences of politics, we realized that we had grown to have something in common with the objects of our investigation. No matter if you are a building, a territory, a photograph, a pixel, or a person, to sense is to be imprinted by the world around you, to internalize its force fields, and to transform. And to transform is to feel pain.

*Excerpted from *Forensic Architecture: Violence at the Threshold of Detectability* (Brooklyn: Zone Books, 2017), 129.

THE BODY IN PAIN: THE MAKING AND UNMAKING OF THE WORLD

Elaine Scarry

Physical pain is able to obliterate psychological pain because it obliterates all psychological content, painful, pleasurable, and neutral. Our recognition of its power to end madness is one of the ways in which, knowingly or unknowingly, we acknowledge its power to end all aspects of self and world.

Another manifestation of this power—is its continual reappearance in religious experience. The self-flagellation of the religious ascetic, for example, is not (as is often asserted) an act of denying the body, eliminating its claims from attention, but a way of so emphasizing the body that the contents of the world are cancelled and the path is clear for the entry of an unworldly, contentless force. It is in part this world-ridding, path-clearing logic that explains the obsessive presence of pain in the rituals of large, widely shared religions as well as in the imagery of intensely private visions, that partly explains why the crucifixion of Christ is at the center of Christianity, why so many primitive forms of worship climax in pain ceremonies, why Brontë's *Wuthering Heights* is built on the principle

first announced in Lockwood's dream that the pilgrim's staff is also a cudgel, why even Huysmans's famous dandy recognizes in his sieges of great pain a susceptibility to religious conversion, why in the brilliant ravings of Artaud some ultimate and essential principle of reality can be compelled down from the heavens onto a theatre stage by the mime of cruelty, why, though it occurs in widely different contexts and cultures, the metaphysical is insistently coupled with the physical with the equally insistent exclusion of the middle term, world.

The position of the person who is tortured is in many ways, of course, radically different from that of the person who experiences pain in a religious context, or that of an old person facing death, or that of the person who is hurt in a dentist's office. One simple and essential difference is duration: although a dentist's drill may in fact be the torturer's instrument, it will not land on a nerve for the eternity of a few seconds but for the eternity of the uncountable number of seconds that make up the period of torture, a period that may be seventeen hours on a single day or four hours a day on each of twenty-nine days. A second difference is control: the person tortured does not will his entry into and withdrawal out of the pain as the religious communicant enters and leaves the pain of a Good Friday meditation, or as the patient enters and leaves the pain of the healing therapy. A third difference is purpose: the path of worldly objects is swept clean not, as in religion, to make room for the approach of some divinely intuited force nor, as in medicine and dentistry, to repair the ground for the return of the world itself; there is in torture not even a fragment of a benign explanation as there is in old age where the absence of the world from oneself can be understood as an experienceable inversion of the eventual but unexperienceable absence of oneself from the world. Perhaps only in the prolonged and searing pain caused by accident or by disease or by the breakdown of the pain pathway itself is

there the same brutal senselessness as in torture. But these other nonpolitical contexts are called upon because they make immediately self-evident a central fact about, pain that, although emphatically present in torture, is also obscured there by the idiom of "betrayal." It is the intense pain that destroys a person's self and world, a destruction experienced spatially as either the contraction of the universe down to the immediate vicinity of the body or as the body swelling to fill the entire universe. Intense pain is also language-destroying: as the content of one's world disintegrates, so the content of one's language disintegrates, as the self disintegrates, so that which would express and project the self is robbed of its source and its subject.

World, self, and voice are lost, or nearly lost, through the intense pain of torture and not through the confession as is wrongly suggested by its connotations of betrayal. The prisoner's confession merely objectifies the fact of their being almost lost, makes their invisible absence, or nearby absence, visible to the torturers. To assent to words that through the thick agony of the body can be only dimly heard, or to reach aimlessly for the name of a person or a place that has barely enough cohesion to hold its shape as a word and none to bond it to its worldly referent, is a way of saying, yes, all is almost gone now, there is almost nothing left now, even this voice, the sounds I am making, no longer form my words but the words of another.

Torture, then, to return for a moment to the starting point, consists of a primary physical act, the infliction of pain, and a primary verbal act, the interrogation. The verbal act, in turn, consists of two parts, "the question" and "the answer," each with conventional connotations that wholly falsify it. "The question" is mistakenly understood to be "the motive"; "the answer" is mistakenly understood to be "the betrayal." The first mistake credits the torturer, providing him with a justification, his cruelty with an explanation. The second discredits the prisoner,

making him rather than the torturer, his voice rather than his pain, the cause of his loss of self and world. These two misinterpretations are obviously neither accidental nor unrelated. The one is an absolution of responsibility; the other is a conferring of responsibility; the two together turn the moral reality of torture upside down. Almost anyone looking at the *physical* act of torture would be immediately appalled and repulsed by the torturers. It is difficult to think of a human situation in which the lines of moral responsibility are more starkly or simply drawn, in which there is a more compelling reason to ally one's sympathies with the one person and to repel the claims of the other. Yet as soon as the focus of attention shifts to the *verbal* aspect of torture, those lines have begun to waver and change their shape in the direction of accommodating and crediting the torturers.[1] This inversion, this interruption and redirecting of a basic moral reflex, is indicative of the kind of interactions occurring between body and voice in torture and suggests why the infliction of acute physical pain is inevitably accompanied by the interrogation.

However near the prisoner the torturer stands, the distance between their physical realities is colossal, for the prisoner is in overwhelming physical pain while the torturer is utterly without pain; he is free of any pain originating in his own body; he is also free of the pain originating in the agonized body so near him. He is so without any human recognition of or identification with the pain that he is not only able to bear its presence but able to bring it continually into the present, inflict it, sustain it, minute after minute, hour after hour. Although the distance separating the two is probably the greatest distance that can separate two human beings, it is an invisible distance since the physical realities it lies between are each invisible. The prisoner experiences an annihilating negation so hugely felt throughout his own body that it overflows into the spaces before his eyes and in his ears and mouth; yet one which is unfelt, unsensed by anybody else. The torturer

experiences the absence of this annihilating negation. These physical realities, an annihilating negation and an absence of negation, are therefore translated into verbal realities in order to make the invisible distance visible, in order to make what is taking place in terms of pain take place in terms of power, in order to shift what is occurring exclusively in the mode of sentience into the mode of self-extension and world. The torturer's questions—asked, shouted, insisted upon, pleaded for—objectify the fact that he has a world, announce in their feigned urgency the critical importance of that world, a world whose asserted magnitude is confirmed by the cruelty it is able to motivate and justify. Part of what makes his world so huge is its continual juxtaposition with the small and shredded world objectified in the prisoner's answers, answers that articulate and comment on the disintegration of all objects to which he might have been bonded in loyalty or love or good sense or long familiarity. It is only the prisoner's steadily shrinking ground that wins for the torturer his swelling sense of territory. The question and the answer are a prolonged comparative display, an unfurling of world maps.

This display of worlds can alternatively be understood as a display of selves or a display of voices, for the three are close to being a single phenomenon. The vocabulary of "motive" and "betrayal," for example, is itself an indication of a perceived difference in selfhood: to credit the torturer with having a motive is, among other things, to credit him with having psychic content, the very thing the prisoner's confession acknowledges the absence of and which the idiom of "betrayal" accuses him of willfully abandoning. The question and answer also objectify the fact that while the prisoner has almost no voice—his confession is a halfway point in the disintegration of language, an audible objectification of the proximity of silence—the torturer and the regime have doubled their voice since the prisoner is now speaking their words.

The interrogation is, therefore, crucial to a regime. Within the physical events of torture, the torturer "has" nothing: he has only an absence, the absence of pain. In order to experience his distance from the prisoner in terms of "having," their physical difference is translated into a verbal difference: the absence of pain is a presence of world; the presence of pain is the absence of world. Across this set of inversions pain becomes power. The direct equation, "the larger the prisoner's pain, the larger the torturer's world" is mediated by the middle term, "the prisoner's absence of world": the larger the prisoner's pain (the smaller the prisoner's world and therefore, by comparison) the larger the torturer's world. This set of inversions at once objectifies and falsifies the pain, objectifies one crucial aspect of pain in order to falsify all other aspects. The obliteration of the contents of consciousness, the elimination of world ground, which is a condition brought about by the pain and therefore one that once objectified (as it is in confession) should act as a sign of the pain, a call for help, an announcement of a radical occasion for attention and assistance, instead acts to discredit the claims of pain, to repel attention, to ensure that the pain will be unseen and unattended to. That not only the torturers but the world at large should tend to identify the confession as a "betrayal" makes very overt the fact that his absence of world earns the person in pain not compassion but contempt. This phenomenon in which the claims of pain are eclipsed by the very loss of world it has brought about is a crucial step in the overall process of perception that allows one person's physical pain to be understood as another person's power.

When one human being "recognizes" the incontestable legitimacy of another human being's existence, he or she is locating the other's essential reality in one of two places—either in the complex fact of sentience or in the objects of sentience, in the fact of consciousness or in the objects of consciousness.

*Excerpted from Chapter 1, "The Structure of Torture: The Conversion of Real Pain to the Fiction of Power," in *The Body in Pain: The Making and Unmaking of the World* (New York: Oxford University Press, 1985), 34–37.

Note
1. This is not to say that our sympathies are primarily with the torturer, for they are of course still with the prisoner; but to have moved even a small amount in the direction of the torturer in this most clear-cut of moral situations is a remarkable and appalling sign of the seductiveness of even the most debased forms of power, and indicates how wrong our moral responses might be in situations that have more complexity.

AMERICAN GENIUS: A COMEDY

Lynne Tillman

The English built a society around and against embarrassment, since they fear it, no one of them wants to be embarrassed or to embarrass others, but it's more than not wanting, it's a potent, silent anxiety, so subtlety condemns them to understatement, but when at parties they drink heavily, rage, make false or true accusations, or behave licentiously, they forget embarrassment, and their bad acts are usually forgotten the next day when no one mentions the other's objectionable behavior, since they aren't Puritans. Persecuted Puritans fled England for America, where they thrived, and in America conversations and news about crimes, sinful nights, or a sinner's bad acts are received with a thrill, since the wickedness of others invigorates Puritans, and many go West, young men and others, to be lawless, since outlaws are Puritan Antichrists. As a consequence

of their sins, sinners—Methodists believe everyone is a sinner—who bring shame to themselves and their families will just work harder, supposedly, to overcome their weaknesses. The English upper classes especially don't want to appear to work hard or to be called intellectuals, and they despise Puritans. Here, in this place for serenity and repose, not a day goes by when I'm not privy to some small shameful or shameless episode, loose talk, or am established even briefly as a subject of conversation, of which I am mostly unaware, happily. One resident or guest, who prefers "guest" as she insists she makes her own decisions, complains incessantly about her closest friends, who are not here, and I am glad not to be one of them, and in her complaints, like most sensitive people, she is blameless. But I am a Puritan who also has ignoble and disgraced thoughts. Separatists chose to be Congregationalists rather than Presbyterians, whose church had a hierarchy; the Separatists formed individual congregations with as few as four members, on the basis that sainthood could be divined from those who desired to be members, a tautological wish. The Separatists wanted a holy kingdom, and probably most English people thought theirs was holy enough and felt bothered, since another's righteousness is a nuisance and insulting. In the New World, the Puritans strove for salvation, unimpeded by Parliament, the king, and venerable and rigid traditions, though they knew sin was inevitable, that no matter how hard they worked, they would never have certainty of God's love or if they were good, which was anyway preordained. Still, they had to prove their virtue in this life to achieve a place in heaven, and so they praised rectitude and accumulated, and the more they had, the more they decided God had demonstrated his love to them. They saved and prayed they were saved and followed their God's law, and, far away from the landed gentry they once feared or honored, they took possession and claimed the land, directing a furious

violence against its brown- and red-skinned possessors, the earlier claimants, whom they smote with the vindictiveness and passion they felt toward the English and other Europeans who'd persecuted them. The Puritans slaughtered without compunction, because they would not be stopped in the creation of their heaven on earth. Manifest Destiny is also a Puritan's idea, and the history of civilization is dominated by the missions of righteous conquerors.

Acceptance is American love, shunning is a Puritan's punishment, animals do it regularly, mother cats shun their three-month-old kittens from one day to the next—I have witnessed this ordinary cruelty—turning away from or hissing at them, but human mothers shouldn't, though some do in other ways, and mammals such as humans are both obvious and subtle, like people at parties who turn toward and away abruptly, who search crowds for a partner, for sex, friendship, advancement, or to while away time, and there is an imposingly tall woman here, the acerbic one who now leads the women's table, occasionally there is one, who peers intently over the tops of people's heads, seeking a better connection, since love and acceptance, like fame, are also pursued in this secluded place where residents hope to make themselves into something, or to escape something or themselves, or to realize themselves in a novel guise, and where some seek renown, goodness, or worthiness, while others seek calm, peace, and quiet. The Count may just want peace, he's had the other. His Calvinist relatives speak ill of him, or don't speak to him, his wife may have abandoned him, his Parisian gang deserted him, all of which is etched in deep creases on his skin, in the deep lines on his high forehead, around his mouth, and on his chin, but time is his constant friend, even if it passes and is ambivalent.

Puritanism successfully infiltrated America, nowhere else so completely, and in this country fame is a visible proof of God's love, it sits beside material

wealth, intangible but a form of temporary approval, and may be gained and lost, possibly the devil's work, whose business easily fools sinners, and so the famous, whose celebrity rests on the effervescent fascination and mood of non-famous others, must maintain that goodwill through incessant appearance and reappearance, to fix their stars in a worldly firmament and also in limited imaginations. The famous become paranoid. Celebrity is coruscating and fleeting, since its value isn't attached to anything, there is no logic to fame and no use to it, except for exciting suffocated imaginations that consume hope. Dante's paradise became tiresome, blandly beautiful, because in it there was nothing left to hope for, while hell was vivid and detailed. I'm an American Calvinist who rebukes herself, also with other lives, a desperate convict on death row or an escaped slave, Harriet Jacobs, caged for years in an attic hardly bigger than her body, whose authorship was disputed because she was black, but I still can't discount all lesser anguish, and I also don't believe I should, though others' pain overwhelms or even shames mine, but relativity is also historical, so my ethical compass wobbles. It must be why a dark night is endless, when I often remind myself that I must unmake everything, but the best I can achieve is a temporary, furtive indifference to myself, the others around me, and my projects on the floor.

The transvestite frequently sat on the stoop of her tenement building with two of her friends, a woman who might be a dwarf, another in mismatched clothes, with no teeth, and I've watched them from across the street, never joining their conversations, but drawn, in a ghoulish way, to their irregular animations. The imperfections I notice and remember include skin tags, achrochordons, the excess skin or flaps that form on the human body in response to the skin's irritation in areas of friction, heat, and moisture, where a bra strap or a waistband might rub the flesh. I notice

moles at the corners of lips, bristly hair shooting from them, or large, flat hairy moles that patch upper arms and backs of necks, which can be removed, but when they aren't, invariably catch my eye. There are some discolorations that can't be removed, some moles or sebaceous cysts also that, if removed, would leave small craters in legs and arms, since they run beneath the epidermis like underground rivers and more than what was apparent and visible on the skin would require removal. A cyst on the upper arm that is nearly flat on the surface of skin may have deep roots beneath and connect to another cyst farther down the arm that may be larger, and it would be a mistake, my dermatologist told me, to have it removed, because the excision's scar would be more unsightly than the cyst or mole. But I don't like moles. Also I notice stooped shoulders, wandering eyes, palsies of every sort, harelips, limps, because, for one thing, I am interested in defective bodies that function anyway. Over the years, my dermatologist has treated me for a variety of nevus, or nevi, birthmarks or moles, which he excised; seborrheic dermatitis; dilated blood vessels or telangiciectasias; benign growths, or seborrheic keratoses; solarkerotses, or sun damage; skin tags; acne rosacea; xeroderma, or dry skin; tinea, or a fungal infection of the feet or skin pads; and nummular eczema, or coin-shaped, blistery, and encrusted skin, and none of these was life threatening. I didn't ever mention the pressure or weight on my heart, since he wasn't a cardiologist, and since my internist insisted, after she ordered an EKG and echocardiogram, that there was no physical cause for the pressure, that it might be stress-related, which should have been reassuring but wasn't. Each mark, redness, or patch has its characteristics, which my dermatologist recognized immediately, and when he did, he said aloud the name of the malformation or minor disease with an intellectual's satisfaction, and I always asked him to repeat

and spell it, so I could see its design and remember it. Every imperfection and unsightliness of my flesh, since failures and mishaps are worth recording, he noted, and I watched him write up, in his neat script, each defect, chronic or acute skin condition, dutifully, even lovingly, in his increasingly thick file on me.

After the removal of a nevus, my dermatologist presses cotton soaked in an antiseptic lotion or salve on the fresh wound, then he asks me to continue to press the ointment-soaked cotton against it until the blood stops flowing, and, without looking, only feeling the slight burn of medication against the skin, I do so, even though I easily become nauseated at the sight of blood and on occasion have fainted. I regret fainting at the sight of blood, a revulsion I can't control which begins as revolutions in my stomach, the second heart, and I have often envied my dermatologist's job, which involves blood spurting, but affords him the right to stare with childlike attention, professional concentration, and intense pleasure at the deformities and growths, ugly moles, with hairs shooting from them, on the bodies and faces of his patients, numbering into the thousands, and then his expertise in knowing how to burn or cut them off complements his desire to rid the body, or the world, of its abnormalities and threats. When he performs a procedure, I look, if I can, without dizziness, or follow the procedure's reflection on his glasses, though sometimes he takes them off, as the blood rises to the surface of the skin and spills onto the cotton square he holds in one hand, when he appears to trust his naked eye only, and with the knowledge that he has removed some imperfection, some excess that has, in some way, gracelessly defined me, one of his patients, he confidently sprays antiseptic on the wound and covers it with a Band-Aid.

* Excerpted from *American Genius, A Comedy* (New York: Soft Skull Press, 2006), 171–75.

AGAIN THE BIRTH CONTROL AGITATION

Emma Goldman

If any one is in doubt about the tremendous growth of the Birth Control movement, two recent happenings in New York City should dispel this doubt.

One is the opinion of Judge Wadhams of General Sessions, and the other is the desperate methods employed by the New York Police Department in dealing with the Birth Control advocates. Not only do the police arrest everyone who openly discusses or distributes Birth Control information, but they frame up charges against innocent victims. Of course, perjury is nothing new with the Police Department, so it may not surprise you to learn that the old staid method is again being used in the most flagrant manner,

First as to Judge Wadhams. A woman was brought before him for burglary. Mrs. Schnur declared that she was compelled to steal to obtain bread for her six children, the youngest of whom was ten months old.

Up until five years ago Samuel Schnur was able to support his family with his earnings as an operator on childrens' coats in an east side shop. The close confinement ultimately had its effect on the man, and he developed tuberculosis. He kept at his work, despite his illness until discovered by an inspector of the Health Department, who refused to permit him to remain in the shop as long as he had the disease. Since that time he has been unable to obtain employment.

The burden of support fell on Mrs. Schnur, who has partially earned a living for the family by doing odd jobs. Recently she was unfortunate in obtaining employment, and quickly used up what little

money she had on hand. Last month she entered the home of Morris Moskowitz, at 203 East Seventh Street, and stole a small sum of money and a watch, which resulted in her arrest.

In his opinion Judge Wadhams said that Mrs. Schnur had been found guilty on a previous occasion of theft, arising out of the same conditions, but sentence was suspended. Although the woman could be sentenced for a long term in prison, the Court said that the unusual circumstances were such as to warrant a further extension of clemency.

After discussing the condition of the husband and his inability to care for his family, Judge Wadhams made the following statement:

> Nevertheless he goes on becoming the father of children who have very little chance under the conditions to be anything else but tubercular, and, themselves growing up, to repeat the process with society. There is no law against that.
>
> But we have not only no birth regulation in such cases, but if information is given with respect to birth regulation people are brought to the bar of justice for it. There is a law they violate.

Judge Wadhams pointed out that many nations of Europe had adopted birth regulation with seemingly excellent results. He queried whether Americans had taken as common sense a view of the subject as we might.

"I believe," the Opinion continued, "that we are living in an age of ignorance which at some future time will be looked upon aghast as we look back upon conditions which we now permit to exist. So before us we have here a family increasing in number, with a tubercular husband, with a woman with a child at her breast, with other small children at her skirts, and no money."

It was certainly worth going to jail to teach a Judge the importance of Birth Control for the masses of people.

However, even going to jail will never teach the police anything.

Friday, October 20th, I was subpoenaed to appear as a witness for Mr. Bolton Hall, in his trial before Special Sessions, Department Six, for having distributed Birth Control circulars at the Union Square meeting on May 20th. Mr. Hall was acquitted. Together with a number of friends, I left the court house about 5 P.M., and had barely gotten to the sidewalk when I was arrested by detective Price. When he was asked to show a warrant he said it was unnecessary, that I was in his charge and would have to come along. Knowing from the past that a detective, even like the Russian Black Hundred, is absolute, I went along to the Elizabeth Street station house, and was there placed under $1,000 bail for having distributed Birth Control leaflets at the Union Square meeting May 20th. Evidently the detectives took no heed to the overwhelming testimony brought to bear in behalf of Mr. Bolton Hall, a testimony which, of course, will also be brought to bear in my behalf, i.e., that neither Mr. Hall nor myself distributed Birth Control leaflets. The detectives had decided to engage in a frame-up and they straightway proceeded to carry out their decision.

You will recollect that last April, I was arrested for *having given out birth control information;* that I was tried and found guilty and that I preferred going to the Queen's County Jail rather than pay a fine of $100.00. With that in view it is hardly necessary for me to emphasize that I believe in the birth control issue, and that I believe in the necessity of giving people information. In other words, I am willing to take the consequences if I have been guilty of what the law pleases to call an offence. But, as it is, I have not given out the circulars and, of course, do not intend to be arrested and thrown into jail simply because the New York detectives want to crown themselves with laurels of stemming the tide of the Birth Control agitation.

Friday, October 27th, I appeared before Judge Barlow, a type out of Dickens or Victor Hugo. Hard, pompous and dull. I waived examination, and was held for trial. I cannot say at present when the trial will come up, but I expect to get a postponement and probably secure a jury trial.

Meanwhile I am out on $1,000 bail.

On October 30th three cases were tried in the Court of Special Sessions: Jesse Ashley and two I.W.W. boys, Kerr and Marman. Of course they were all found guilty. Jesse Ashley was sentenced to pay $50.00 fine or serve 10 days in jail. She would have preferred the jail sentence but was urged to make a test case. Therefore she paid the fine under protest and will appeal.

Kerr and Marman will probably fare worse, inasmuch as the detective testified that while speaking on Madison Square, the boys offered a Birth Control pamphlet for sale at 10 cents and gave away with it—Oh, horrors!—"Preparedness: The Road to Universal Slaughter," by E. G. Little did we dream, when we published the pamphlet what an important part it would play in a New York court.

The two boys insisted that what they did do was to sell the "preparedness" pamphlet and give the Birth Control leaflet gratis. But though judges know that detectives never hesitate to perjure themselves, Kerr and Marman were found guilty.

However, it was evident that the judges are being educated. Thus one of them was very emphatic in saying that he means to distinguish between those that give Birth Control information free, out of conviction, and those that sell it. No such instruction was made in either Bill Sanger's, Ben Reitman's, or my case, although none of us sold information.

The opinion of the judge, then, proves that direct action is the only action that counts. But for those of us who have defied the law, Birth Control would still be a parlor proposition, as it continues to be to this day with nearly all of the Birth Control leagues in this country.

*Excerpted from *Anarchy and the Sex Question* (Oakland: PM Press, 2016), 109–12.

DEBT AND CREDIT

Fred Moten and Stefano Harney

They say we have too much debt. We need better credit, more credit, less spending. They offer us credit repair, credit counseling, microcredit, personal financial planning. They promise to match credit and debt again, debt and credit. But our debts stay bad. We keep buying another song, another round. It is not credit that we seek, nor even debt, but bad debt—which is to say real debt, the debt that cannot be repaid, the debt at a distance, the debt without creditor, the black debt, the queer debt, the criminal debt. Excessive debt, incalculable debt, debt for no reason, debt broken from credit, debt as its own principle.

Credit is a means of privatization and debt a means of socialization. So long as debt and credit are paired in the monogamous violence of the home, the pension, the government, or the university, debt can only feed credit, debt can only desire credit. And credit can only expand by means of debt. But debt is social and credit is asocial. Debt is mutual. Credit runs only one way. Debt runs in every direction, scattering, escaping, seeking refuge. The debtor seeks refuge among other debtors, acquires debt from them, offers debt to them. The place of refuge is the place to which you can only owe more, because there is no creditor, no payment possible.

This refuge, this place of bad debt, is what we would call the fugitive public.

Running through the public and the private, the state and the economy, the fugitive public can be identified by its bad debt—but only by its debtors. To creditors, it is just a place where something is wrong, though that something—the invaluable thing that has no value—is desired. Creditors seek to demolish that place, that project, in order to save those who live there from themselves and from their lives.

They research it, gather information on it, try to calculate it. They want to save it. They want to break its concentration and store the fragments in the bank. All of a sudden, the thing credit cannot know—the fugitive thing for which it gets no credit—is inescapable.

Once you start to see bad debt, you start to see it everywhere, hear it everywhere, feel it everywhere. This is the real crisis for credit, its real crisis of accumulation. Now debt begins to accumulate without it. That's what makes it so bad. We saw it yesterday in the way someone stepped, in the hips, a smile, the way the hand moved. We heard it in a break, a cut, a lilt, the way the words leapt. We felt it in the way someone saves the best part just for you, and then it's gone, given, a debt. They don't want nothing. You got to accept it, you got to accept that. You're in debt but you can't give credit because they won't hold it. Then the phone rings. It's the creditors. Credit keeps track. Debt forgets. You're not home, you're not you, you moved without leaving a forwarding address called refuge.

The student is not home, out of time, out of place, without credit, in bad debt. The student is a bad debtor threatened with credit. The student runs from credit. Credit pursues the student, offering to match credit for debt until enough debts and enough credits have piled up. But the student has a habit, a bad habit. She studies. She studies but she does not learn. If she learned, they could measure her progress, confirm her attributes, give her credit. But the student keeps studying, keeps planning to study, keeps running to study, keeps studying a plan, keeps building a debt. The student does not intend to pay.

DEBT AND FORGETTING

Debt cannot be forgiven, it can only be forgotten and remembered. To forgive debt is to restore credit. It is restorative justice. Debt can be abandoned for bad debt, it can be forgotten, but it cannot be forgiven. Only creditors can forgive, and only debtors, bad debtors, can offer justice. Creditors forgive debt by offering credit, by offering more from the very source of the pain of debt, a pain for which there is only one source of justice: bad debt, forgetting, remembering again, remembering it cannot be paid, cannot be credited, stamped "received." There will be a celebration when the North spends its own money and is left with nothing, and spends again, on credit, on stolen cards, on account of a friend who knows he will never again see what he lent. There will be a celebration when the Global South does not get credit for discounted contributions to world civilization and commerce, but keeps its debts, changes them only for the debts of others, a swap between those who never intend to pay, who will never be allowed to pay, in a bar in Penang, in Port of Spain, in Bandung, where your credit is no good.

Credit can be restored, restructured, rehabilitated, but debt forgiven is always unjust, always unforgiven. Restored credit is restored justice and restorative justice is always the renewed reign of credit, a reign of terror, a hail of obligations to be met, measured, dispensed, endured. Justice is only possible where debt never obliges, never demands, never equals credit, payment, payback. Justice is possible only where it is never expected, in the refuge of bad debt, in the fugitive public of strangers and not of communities, of undercommons and not neighborhoods, among those who have been there all along from somewhere. To seek justice through restoration is to return debt to the balance sheet and the

balance sheet never balances. It plunges toward risk, volatility, uncertainty, more credit chasing more debt, more debt shackled to more credit. To restore is to not conserve again. There is no refuge in restoration. Conservation is always new. It comes from the place we stopped on the run. It's made from the people who took us in. It's the space they say is wrong, the practice they say needs fixing, the homeless aneconomics of visiting.

Communities do not need to be restored. They need to be conserved, which is to say they need to be moved, hidden, restarted with the same joke, the same story, always somewhere other than where the long arm of the creditor seeks them—conserved from restoration, beyond justice, beyond law, in bad country, in bad debt. Communities are planned when they are least expected, planned when they don't follow the process, when they escape policy, evade governance, forget themselves, remember themselves, have no need of forgiveness. They are never wrong. They are not actually communities, but debtors at a distance—bad debtors, forgotten but never forgiven. Give credit where credit is due, and render unto bad debtors only debt, only that mutuality that tells you what you can't do. You can't pay me back, give me credit, get free of me, and I can't let you go when you're gone. If you want to do something, then forget this debt, and remember it later.

Debt at a distance is forgotten, and remembered again. Think of autonomia, its debt at a distance to the black radical tradition. In autonomia, in the militancy of post-workerism, there is no outside, refusal takes place inside and makes its break, its flight, its exodus from the inside. There is biopolitical production and there is empire. There is even what Franco "Bifo" Berardi calls "soul trouble." In other words, there is this debt at a distance to a global politics of blackness emerging out of slavery and colonialism, a black radical politics, a politics of debt without payment, without credit, without limit. This debt was built in a struggle with empire before empire, when power was not held by institutions or governments alone, where any owner or colonizer had the violent power of a ubiquitous state. This debt attached to those who, through dumb insolence or nocturnal planning, ran away without leaving, left without getting out. This debt was shared with anyone whose soul was sought for labor power, whose spirit was born marked with a price. And it is still shared, never credited and never abiding credit, a debt you play, a debt you walk, a debt you love. And without credit, this debt is infinitely complex. It does not resolve into profit, seized assets, or a balance in payment. The black radical tradition is a movement that works through this debt. The black radical tradition is debt work. It works in the bad debt of those in bad debt. It works intimately and at a distance until autonomia, for instance, remembers, and then forgets. The black radical tradition is debt unconsolidated.

DEBT AND REFUGE

We went to the public hospital but it was private, and we went through the door marked "private" to the nurses' coffee room, and it was public. We went to the public university but it was private, and we went to the campus barbershop, and it was public. We went into the hospital, into the university, into the library, into the park. We were offered credit for our debt. We were granted citizenship. We were given the credit of the state, the right to render private any public gone bad. Good citizens can match credit and debt. They get credit for knowing the difference, for knowing their place. Bad debt leads to bad publics, publics unmatched, unconsolidated, unprofitable. We were made honorary citizens. We honored our debt to the nation. We rated the service, assessed the cleanliness, paid our fees.

Then we went to the barbershop and they gave us a Christmas breakfast, and we went to the coffee room and got coffee and red pills. We were going to run away but we didn't have to. They ran. They ran across the state and across the economy, like a secret cut, a public outbreak, a fugitive fold. They ran but they didn't go anywhere. They stayed so we could stay. They saw our bad debt coming from a mile away. They showed us that this was the public, the real public, the fugitive public, and where to look for it. Look for it where they say the state doesn't work. Look for it where they say there is something wrong with that street. Look for it where new policies are to be introduced. Look for it where tougher measures are to be taken, belts are to be tightened, papers are to be served, neighborhoods are to be swept—anywhere bad debt elaborates itself. Anywhere you can sit still, conserve yourself, plan, spend a few minutes, a few days without hearing them say there is something wrong with you.

DEBT AND GOVERNANCE

We hear them say that what's wrong with you is your bad debt. You're not working. You fail to pay your debt to society. You have no credit, but that is to be expected. You have bad credit, and that is fine. But bad debt is a problem—debt seeking only other debt, detached from creditors, fugitive from restructuring. Destructuring debt, now that's wrong. But even still, what's wrong with you can be fixed. First we give you a chance—that's called governance, a chance to be interested, or even disinterested. That's policy. Or if you are still wrong, still bad, we give you policy. Bad debt is senseless, which is to say it cannot be perceived by the senses of capital. But therapy is available. Governance wants to reconnect your debt to the outside world. You are on the spectrum, the capitalist spectrum of interests. You are the wrong end. Your bad debt looks unconnected, autistic, in its own world. But you can be developed. You can get credit after all. The key is to have interests. Tell us what you want. Tell us what you want and we can help you get it, on credit. We can lower the rate so you can take interest. We can raise the rate so you will

pay attention. But we can't do it alone. Governance only works when you work, when you tell us what you want, when you invest your interests back in debt and credit. Governance is the therapy of your interests, and your interests will bring your credit back. You will have an investment, even in debt. And governance will gain new senses, new perceptions, new advances into the world of bad debt, new victories in the war on those without interests, those who will not speak for themselves, participate, identify their interests, invest, inform, demand credit.

Governance does not seek credit. It does not seek citizenship, although it is often understood to do so. Governance seeks debt, debt that will seek credit. Governance cannot not know what might be shared, what might be mutual, what might be common. Why award credit, why award citizenship? Only debt is productive, only debt makes credit possible, only debt allows credit to rule. Productivity always precedes rule, even if the students of governance do not understand this, and even if governance itself barely does. But rule does come, and today it is called policy, the reign of precarity. And who knows where it will hit you, some creditor walking by you on the street. You keep your eyes down but he makes policy anyway, smashes anything you have conserved, any bad debt you are smuggling. Your life reverts to vicious chance, to arbitrary violence, a new credit card, a new car loan, torn from those who hid you, ripped from those with whom you shared bad debt. They don't hear from you again.

STUDY AND PLANNING

The student has no interests. The student's interests must be identified, declared, pursued, assessed, counseled, and credited. Debt produces interests. The student will be indebted. The student will be interested. Interest the students! The student can be calculated by her debts, can calculate her debts by her interests. She has credit in her sights, has graduation in her sights, has being a creditor, being

invested in education, being a citizen in her sights. The student with interests can demand policies, can formulate policy, give herself credit, pursue bad debtors with good policy, sound policy, evidence-based policy. The student with credit can privatize her own university. The student can start her own NGO, invite others to identify their interests, put them on the table, join the global conversation, speak for themselves, get credit, manage debt. Governance is interest-bearing. Credit and debt. There is no other definition of good governance, no other interest. The public and private in harmony, in policy, in pursuit of bad debt, on the trail of fugitive publics, chasing evidence of refuge. The student graduates.

But not all of them. Some stay, committed to black study in the university's undercommon rooms. They study without end, plan without pause, rebel without policy, conserve without patrimony. They study in the university and the university forces them under, relegates them to the state of those without interests, without credit, without debt that bears interest, debt that earns credits. They never graduate. They just ain't ready. They're building something in there, something down there, a different kind of speculation, a speculation called "study," a debt speculation, a speculative mutuality. Mutual debt, unpayable debt, unbounded debt, unconsolidated debt, debt to each other in a study group, to others in a nurses' room, to others in barbershops, to others in a squat, a dump, the woods, a bed, an embrace.

And in the undercommons of the university they meet to elaborate their debt without credit, their debt without number, without interest, without repayment. Here they meet those others who dwell in a different compulsion, in the same debt, a distance, forgetting, remembered again but only after. These other ones carry bags of newspaper clippings, or sit at the end of the bar, or stand at the stove cooking, or sit on a box at the newsstand, or speak through bars, or in tongues. These other ones have a passion

for telling you what they have found, and they are surprised that you want to listen, even though they've been expecting you. Sometimes the story is not clear, or it starts in a whisper. It goes around again and again but listening—it is funny every time. This knowledge has been degraded, the research rejected. They can't get access to books, and no one will publish them. Policy has concluded they are conspiratorial, heretical, criminal, amateur. Policy says they can't handle debt and will never get credit. But if you listen to them, they will tell you: we will not handle credit, and we cannot handle debt, debt flows through us, and there's no time to tell you everything, so much bad debt, so much to forget and remember again. But if we listen to them, they will say, "Come, let's plan something together." And that's what we're going to do. We're telling all of you, but we're not telling anyone else.

*Text first published in *e-flux Journal*, no. 14 (March 2010), https://www.e-flux.com/journal/14/61305/debt-and-study/.

THE P AND I

Gary Indiana

The Haldeman Diaries:
Inside the Nixon White House
by H. R. Haldeman

The publication of *The Haldeman Diaries* immediately after Nixon's funeral is the kind of prosaic justice our cooling 37th president most enjoyed: a coincidence that looks like a vendetta.

Unrecognizable in the somber eulogies to the architect of detente, the canny elder statesman, and the man of peace, our Nixon—the mad Christmas bomber, scourge of Alger Hiss and Helen Gahagan Douglas, a loser in victory as well as defeat—has been restored to us in all his daft and whimsical glory: unlovable, paranoid, congenitally dishonest, and, like Richard III, entirely aware of his own wretched nature. "P was fascinated this morning to get a report on the Kennedy Center opening of the [Bernstein] Mass last night…he paused a minute, this was over the phone, and then said, 'I just want to ask you one favor. If I'm assassinated, I want you to have them play "Dante's Inferno" and have Lawrence Welk produce it,' which was really pretty funny."

And so it is. H. R. Haldeman's genius at playing straight man to Nixon's japes has been underappreciated in early reviews. Haldeman owes a little to James Boswell, a bit to Cosima Wagner, and quite a lot to Joseph Goebbels. Swirling in decaying orbit around a black hole, he too mixes the sublime with the tawdry, the monumental with the petty, the public gesture with the private tic. As diarist, however, Haldeman's perfected absence from his own narrative most resembles Andy Warhol's. Warhol said that he stopped having emotions when he bought his first television; for Haldeman this apparently happened

when he became Nixon's chief of staff, if not earlier. There is hardly a trace of personality in Haldeman's day-by-day account—except, at the very end, a touch of asperity and disappointment. There is only the P, the P's lofty musings and valiant deeds, and the P's wacky collection of allies and adversaries.

This slightly posthumous work (Haldeman cooled shortly before P) is a comic masterpiece to place alongside Keynes's *The Economic Consequences of the Peace*. Yet the media, unable to wrench itself out of the somber/elegiac thing, has so far treated it with a leaden austerity. The *Wall Street Journal* notes "shocking anti-Semitic and anti-black bigotry" along with "fascinating glimpses of Mr. Nixon as a leader," as if they were different, reserving most of its contempt for Henry Kissinger—a/k/a K—"an incredibly petty and insecure man." Jonathan Schell, in *Newsday,* sees Nixon's career, per Haldeman, as "a titanic struggle between concealment and revelation," though Haldeman renders it as an effortless manic-depressive segue. In the *Daily News,* William F. Buckley, Jr. sniffs that the "supposed" "racial and ethnic prejudices" of Nixon were not "lethal," and were therefore not "the kind of racism we properly worry about." Ted Koppel, in a two-part *Nightline* program, plucked some of the juicier bits, e.g., "[Billy] Graham has the strong feeling that the Bible says that there are satanic Jews, and that—that's where our problem arises," but trod very lightly upon K, the book's second largest character and Koppel's favorite talking head. Michiko Kakutani, in the daily *Times,* does note "moments of out-and-out farce," but concludes that the diaries "can only depress and perturb the reader." Oh, please.

Such tidings reflect a nervous discomfort with the obvious fidelity of Haldeman's portrait. Kakutani, for one, seems to believe that most Americans actually swallowed the funereal makeover of Nixon as "a visionary foreign-policy maker," etc. and recites his major crimes

as if disclosing them for the first time. It is rather jejune to find anything shocking, or for that matter arguable, about Nixon's ethnic phobias, his inexhaustible resentment, his compulsive lying, or the fact that he was, in the only sense of the word, a crook. Haldeman's ideal reader takes all that for granted and basks in the author's hilarious, total identification with P.

Nixon's zesty drollery and hijinks are there from the beginning. Within a month of inauguration, he and K are cooking up the secret bombing of Cambodia, giving it the festive code name "Operation Menu." The sudden intoxications of power put P into scary overdrive. "Fascinated by Tkach report of people who need no sleep at all. Hates to waste the time.… Thinks you have to be 'up,' not relaxed, to function best." Even the White House staff's gift Irish setter, King Timahoe, feels edgy around P. "Had Tim in the office, both of them pretty nervous." K, like P, "swings from very tense to very funny."

Haldeman strikes the note of farce with recurring comic minor characters. "Poor Agnew slipped on the icy runway during troop review and smashed his nose. Then went on TV to introduce P with huge cut on nose bleeding profusely." "Almost unbelievable conversation at dinner as J. Edgar went on and on about his friends…and his enemies.… A real character out of days of yore.… P seems fascinated by him and ordered me to have lunch with him twice a month to keep up a close contact." A theme of omnipresent enemies is also sounded with Warholian deadpan. "Interesting to watch Eunice Shriver last night and tonight, she obviously hates seeing Nixon as President. She talked to herself and winced all through the toasts, both nights, and must have been thinking back to JFK." "Big flap about proposed Ambassador to Canada. Turned out to be a guy P had met in '67 in Argentina. He was Ambassador there, and Nixon stayed at the residence, he left anti-Nixon literature and Herblock cartoons on bedstand. So now P has

blocked this appointment, or any, for this guy."

The gang around P—an ever-shifting cavalcade of poltroons, buffoons, and sleazy opportunists, with a boorish core of constant retainers like Ehrlichman, Mitchell, Buchanan, Moynihan, Haig and Connally, along with the largely irrelevant cabinet, the almost invisible Pat Nixon, and the spectral Bebe Rebozo—is soon swept up in the charade of rulership. Like the court of the Medici everyone harbors little secrets, everyone "leaks" this and that to the press, and all important decisions take place in an atmosphere of psychotic secrecy. "P issued strict orders that Ziegler and White House staff are to say nothing about Vietnam until further orders. Has to keep complete control and not let an inadvertent comment play into their hands." "Later called over, all upset because K making an issue out of State reluctance to bomb Laos. Rogers wanted a meeting, to argue P's decision. P told me to tell K to go ahead and bomb, don't make announcement or notify State just do it and skip the argument."

Even in an actual crisis, Haldeman's tongue-in-cheek rescues his pen from excessive melodrama. As South Vietnamese troops entered Cambodia, P "reviewed DDE's Lebanon decision and JFK's Cuban missile crisis. Decided this was tougher than either of those…" Minutes later, "Called again to discuss problem of locating his new pool table. Decided it won't fit in solarium, so wants a room in EOB."

After a few unsatisfying meetings with civil rights leaders and anti-war groups, P and his team decide to ignore the demonstrations and other unpleasantness occurring outside the White House. "Need to reexamine our appointments and start to play to our group, without shame or concern or apology. Should feel our way, appear to be listening to critics, but we have now learned we have gained nothing by turning to the other side." From Haldeman's

marginalia, however, the reader gradually surmises that just below the immediate circle of P subluminous worker ants with names like Liddy, Hunt, Krogh, and Ulasciewicz are scurrying around the troubled countryside, planting spooks at leftist get-togethers, burglarizing offices, forging letters on other people's stationery, and delivering large amounts of cash in brown paper bags.

Meanwhile, the inner circle serenely goes about its imperial business. "The Apollo shot was this morning; the P slept through it, but we put out an announcement that he had watched it with great interest." The P is preoccupied with keeping the kooks, hippies, niggers, and yids at bay, holding the line on school desegregation, nominating ghastly judges for the Supreme Court, and planning nasty shocks for an ever-growing list of enemies. Despite his ingenuity in these domestic areas, the P feels unappreciated. "K, at Congress, didn't make the point regarding the character of the man, how he toughed it through…. Why not say that without the P's courage we couldn't have had this? The basic line here is the character, the lonely man in the White House, with little support from government,…overwhelming opposition from media and opinion leaders, including religious, education, and business, but strong support from labor. P alone held on and pulled it out."

We will never know exactly how long the Vietnam War was protracted by K's on-again, off-again Paris Peace Talks, which in Haldeman's account seem mainly hobbled by K and P's capricious habit of following up each session with massive bombing raids. "The mad bomber" was Nixon's own term; he thought if the Communists believed he was really insane, they would be desperate to negotiate. K apparently agreed when it suited his mood, squabbled when it didn't. Haldeman's K is a Molierean figure of fun, an incessantly grumbling, pompous, infantile worrywart

who demands constant stroking from the P, threatens to resign every other day, and spends much of his time upstaging Secretary of State William Rogers, who he's convinced is "out to get him." What K and P share, aside from a child's love of secrecy, is the delusion that they function best in crises, which they frequently manufacture to rouse themselves from the torpor of omnipotence. They detect Soviet influence in various affairs the Soviets have little interest in—the India-Pakistan conflict, for example—issue blustery ultimatums, and work themselves into a prenuclear lather; when the bewildered Soviets acquiesce, K and P congratulate themselves on having forced the enemy to "back down."

They're equally gifted at spawning tensions within their own circle. "So I asked Henry to come in and join us. E then jumped on him pretty hard, on not only that, but also the intelligence thing, and the international drug problem…. At this point Henry blew and said as long as he's here, nobody's going to go around him… E got a little more rough on him, and that resulted in Henry saying E couldn't talk to him that way, and getting up and stalking out of the meeting." Squalid internecine rivalries and craven favor mongering permeate every small and large issue, conference, meeting, state visit, and memorandum. From Haldeman's micromanaging perspective, the epochal Nixon visit to China and the Moscow signing of SALT I are slapstick, almost accidental triumphs of business over venality and pettiness. And after Moscow it's all downhill.

Haldeman first notes the Watergate break-in on Sunday, June 18, 1972. "It turns out there was a direct connection (with CRP), and Ehrlichman was very concerned about the whole thing. I talked to Magruder this morning, at Ehrlichman's suggestion, because he was afraid the statement that Mitchell was about to release was not a good one from our viewpoint." At first the little tapping of Plumbers is muted by the roar of P's landslide election victory.

For a time, the gang is confident that the problem can be "contained," even turned to advantage. "He wants to get our people to put out that foreign or Communist money came in in support of the demonstrations in the campaign, tie all the '72 demonstrations to McGovern and thus the Democrats…. Broaden the investigation to include the peace movement and its leaders, McGovern and Teddy Kennedy." In fact, freshly mandated P feels nearly invincible. "He wants Ziegler to put a total embargo on *Times* and *Newsweek,* there's to be no background to Sidey regarding election night or anything else at any time. He wants total discipline on the press, they're to be used as enemies, not played for help."

As late as February 1973, the P still had other things on his mind. "He said, 'Don't discuss this with anyone else, but we've got to cover the question of how to handle the Nobel Peace Prize. It's a bad situation to be nominated and not get it.' Maybe there should be a letter to Miller, who is nominating him, saying the P feels he should not be honored for doing his duty… He wants a report on the Nobel Prize—who's on the committee, what's the process, can the P withdraw his name, and so on." By April, however, even the P's unflagging prankishness has waned. "The P had me in at 8:00 this morning. Said that if this thing goes the way it might, and I have to leave, he wants me to take all the office material from his—ah—machinery there and hold it for the library."

With impeccable comic timing, Watergate begins to unravel the P at the very moment that K secures a negotiated settlement in Vietnam, snatching defeat from the jaws of defeat. Just when K and P should be preening in the funhouse mirror of world history, unsavory drones surface from the netherworld for urgent nocturnal covens, scrambling to get their stories straight. Each story is quickly shredded by someone else's story. No one can recall exactly when and where who told who to do what to whom. "Talked to Dean on the phone this morning…. He's back to his cancer theory, that we've got to cut the thing out. Cut out the cancer now and deal with it." "…Jeb said that he and Mitchell were afraid Colson was going to take over the intelligence apparatus, so they went ahead, and Dean feels it was probably with Mitchell's OK." "Caulfield gave this letter to Dean, Dean told Mitchell about it, Mitchell told Dean to have Caulfield see McCord and take his pulse." "…some evidence that Colson had put Hunt into the Plumbers operation to spy on Krogh, and so on."

As all the P's men are hauled before the grand jury, P recalls—too late!— the trap he set for Alger Hiss, involving the question of perjury. P realizes with horror that he's walked into the same trap! Here, Haldeman's narrative brilliantly captures the lunar panic of the final days, when one by one, sometimes two by two, the White House gang is thrown to the wolves by P. Frankly unable to recall his own lies, prevarications, secret meetings and the like, Haldeman starts to report other people's accounts of "Haldeman," as if he and the author were two different people.

Happily for us, Haldeman, along with Ehrlichman, is pretty much the last to go, unless you count the interim staff, special prosecutors, defense attorneys, and of course K, who surrounded the P when he was, at long last, forced to climb aboard his final presidential helicopter. Only a day before Haldeman's departure, P "shook hands with me, which is the first time he's ever done that." After announcing H's and E's resignations on TV, the P "asked me if I thought I could do some checking around on reaction to the speech as I had done in the past, and I said no, I didn't think I could. He realized that was the case." But the P just wouldn't be Nixon if he didn't ask.

And there Haldeman's delightful account closes, with the Vampire of Yorba Linda still clutching the frayed reins of power as he gallops toward… a full presidential pardon, his pension, and the mulch of historical relativism, shameless and saucy as the lounge comedian and used car dealer we, the people, always knew him to be.

*Text published in *Let It Bleed: Essays, 1985–1995* (London: Serpent's Tale Books, 1996), 132–39.

Acknowledgments

Thinking of ~~You~~. I Mean ~~Me~~. I Mean You. was a deeply collaborative project. Reconsidering Barbara Kruger's remarkable oeuvre while upending the conventions of the typical retrospective, the exhibition features the artist presenting her own history and reconceptualizing her earlier work anew. The largest and most comprehensive presentation of Kruger's work in twenty years, it offers an unprecedented opportunity to reexamine the work of this groundbreaking artist whose cultural influence is vital and indelible, and whose voice remains relevant, courageous, and crucial.

This undertaking has been made possible by the coordinated efforts of the three institutions and numerous individuals. This project would not have been possible without the visionary leadership and sustaining support of the directors of our institutions—namely, James Rondeau, President and Eloise W. Martin Director, the Art Institute of Chicago; Michael Govan, CEO and Wallis Annenberg Director, Los Angeles County Museum of Art; and Glenn D. Lowry, The David Rockefeller Director, The Museum of Modern Art, New York. Our gratitude goes to all of them.

This remarkable volume, the first major publication on Kruger's work in over a decade, was inspired by her unique vision for a different type of retrospective, one that not only reconsiders her work through distinctly different manifestations at each of our institutions, but also amplifies the voices of others. The artist thoughtfully selected a number of critical and fictional texts addressing subjects both personally crucial and collectively urgent. We thank those authors—Hannah Black, Pierre Bourdieu, Keller Easterling, Andrea Fraser, Emma Goldman, Gary Indiana, Fred Moten and Stefano Harney, Georges Perec, Elaine Scarry, Gary Shteyngart, Christina Sharpe, Hito Steyerl, Lynne Tillman, and Eyal Weizman—as well as the publishers who granted permission to reprint their texts. Our sincere appreciation goes to fellow catalogue contributors James Rondeau and Michael Govan for their texts, as well as to Zoé Whitley, whose important essay was initially planned when the Hayward Gallery in London was still a partner in this project.

The striking design of this book is also the product of a generative collaboration, between the artist and designers Adam Michaels and Marina Kitchen of IN-FO.CO, who worked closely with Kruger on a mutual vision for this volume. We are grateful to LACMA Publisher Lisa Gabrielle Mark, whose creativity and diplomacy have yielded a distinctive and stunning catalogue. In LACMA's Rights and Reproductions department, Dawson Weber systematically tracked down and secured the artist's images from varied sources. Wondrous editor Polly Watson meticulously and sensitively refined the texts and brought her exacting standards to fact-checking and proofreading, the latter of which was supported by LACMA Editor Claire Crighton's efforts. Indexer Kathleen Preciado shrewdly interpreted both the texts and Kruger's work to produce a valuable and comprehensive index. At the Art Institute of

186

Chicago, Executive Director of Publishing Gregory Nosan provided crucial support and early editorial input for the Rondeau and Farrell essays. We also thank our dedicated copublisher, Mary DelMonico of DelMonico Books/D.A.P., along with Karen Farquhar, who oversaw production.

Our sincere gratitude goes to Monika Sprüth and Philomene Magers of Sprüth Magers, who generously shared key insights from their longstanding relationship with Kruger and extensive experience with the work, as did their colleagues Anja Trudel, Simone Manwarring, and Marie Dorsch. Special appreciation goes to Mary Boone, Ron Warren, and Anna Zorina of Mary Boone Gallery, who provided key assistance, drawing from their early and long history of working with the artist. Warm thanks go to David Zwirner and Bellatrix Hubert of David Zwirner for their unwavering support of the artist's work. We were also fortunate to have benefitted from the support and key insights of Rhona Hoffman and Ben Gill of Rhona Hoffman Gallery.

We would also like to express our gratitude to the institutions and private individuals who generously supported the exhibition with crucial loans, including Amorepacific Museum of Art, Barasch Carmel Family, Denver Art Museum, Everson Art Museum, FWA-Foundation for Woman Artists, Glenstone Museum, Emily Fisher Landau, Liz and Eric Lefkofsky, Margaret and Daniel Loeb, S.E.A. family, Billur and Atilla Tacir, and other private collections.

The presentation at the Art Institute of Chicago involved nearly every department. We warmly thank James Rondeau, who initiated this project with the artist in 2015, and whose profound commitment to Kruger's work is at its core. The wise counsel of Sarah Guernsey, Deputy Director and Senior Vice President, Curatorial Affairs, as well as the support of the staff of the office of the President and Director, including Amanda Block, Claire Burdulis, Kate Tierney Powell, and Maureen Ryan, were essential throughout the course of this project. Special thanks goes to Alexander Jen for his invaluable research support to James Rondeau.

In Modern and Contemporary Art, the guidance of Ann Goldstein, Deputy Director and Chair and Curator of Modern and Contemporary Art, was instrumental. The exhibition benefited greatly from her curatorial acumen and longstanding relationship with the artist, including organizing Kruger's 1999 retrospective at the Museum of Contemporary Art, Los Angeles. We also wish to thank current and former colleagues Makayla May, Mary Coyne, Molly Brandt, Lekha Hileman Waitoller, and Suzie Oppenheimer for their valued contributions throughout the exhibition's organization. Nicholas Barron supervised the installation with his trademark attention to detail and was assisted by Thomas Huston and Kit Rosenberg, who worked with extraordinary skill. Thea Liberty Nichols provided exemplary exhibition support. Further thanks must be extended to Solveig Nelson for her support of time-based media. Our colleagues Hendrik Folkerts, Caitlin Haskell, Jordan Carter, and Jay Dandy buoy us with their enthusiasm. We are grateful to colleagues in other curatorial departments who enthusiastically supported the project and opened their gallery spaces and collections for the duration of the exhibition: Alison Fisher and Maite Borjabad of Architecture and Design; Sarah Kelly Oehler of Arts of the Americas; Tao Wang and Madhuvanti Ghose of Arts of Asia; and Matthew S. Witkovsky of Photography and Media.

In Exhibitions, Megan Rader and Courtney Smith supervised complex logistics in an expert fashion. Led by Michael Neault, Experience Design provided expert talent and insight across multiple areas of the exhibition. Leticia Pardo and Jason Stec thoughtfully crafted the elegant exhibition design and site-specific installations throughout the museum. Joe Vatinno guided impeccable production with every aspect of the exhibition plan and Margaret Skimina provided helpful insight for the physically distanced design and safety guidelines. Kirsten Southwell and her team lent keen insight into content across platforms. Salvador Cruz produced exhibition graphics that meld seamlessly with the artist's vision for the Chicago presentation. Kristine Scott Schultz, Tom Riley, Chris Wood, and Dan Van Duerm of AV Solutions lent their technical expertise and insight to the time-based work within the galleries.

In Learning and Public Engagement, Sarah Alvarez, Nancy Chen, and Michael Green helped make research accessible to visitors; we are especially grateful to Emily Lew Fry and Sheila Majumdar in Publishing. External Affairs, led by Eve Coffee Jeffers and including Nora Gainer, Stephanie Henderson, Kati Murphy, Kathryn Rahn, Lauren Schultz, and Robert Sexton, enthusiastically fostered the exhibition at the Art Institute. In Institutional Relations, the good-humored efforts of Jennifer Oatess, as well as those of George

Martin, Sam White, and wonderful colleagues Jonathan Kinkley, Anna Maria Carvallo VanMeter, and Erika Lowe in Philanthropy, helped secure the funding that made this project possible in Chicago. Troy Klyber offered valuable legal counsel. In Retail and Exhibition Product Services, Heather L. Reinholtz and Jennifer Evanoff supported the artist's vision for exhibition merchandise.

In Collections and Loans, Cayetana Castillo, Sara Patrello, Leslie Carlson, and their colleagues expertly coordinated numerous loans and exhibition schedules. The staff of Conservation and Science, led by Francesca Casadio, ensured the safety of the work on view at the Art Institute; special thanks go to Kristin MacDonough, Emily Heye, Allison Langley, Sylvie Penichon, and Mary Broadway. Autumn Mather and colleagues in the Ryerson and Burnham Libraries in the Research Center were a true brain trust for the curators in Chicago. Lucio Ventura, Corey Burrage, and our colleagues in Protection Services supervised visitor experience with the utmost professionalism.

At LACMA, CEO and Wallis Annenberg Director Michael Govan, a longtime admirer of Kruger's work, eagerly welcomed the opportunity to co-organize this exhibition in her adopted hometown of Los Angeles, while Eve Schillo, Dhyandra Lawson, and Britt Salvesen lent a tremendous amount of curatorial expertise and energy to its presentation there. In the Director's Office, Liz Andrews managed to keep things on track with grace. Early research was conducted by Danielle Pesqueira, Mellon Undergraduate Curatorial Fellow at LACMA (2018–20), and Zoe Weingarten, both of whom we thank for their precision and enthusiasm. Senior Assistant Registrar Elspeth Patient expertly arranged for the safe travel and arrival of the artworks with care. Further appreciation goes out to Janice Schopfer and Soko Furuhata in the Conservation Department. Martin Sztyk took on the challenge of designing a unique, site-specific installation with calm and proficiency, while Victoria Behner provided steady guidance throughout. We worked closely with Patrick Heilman on the time-based media installations, and Kirsten Opstad brought her expertise to the lighting of the exhibition. Thank you to Michael Pourmohsen and David Karwan for overseeing the vinyl production and installation, as well as the environmental graphics, and to Julia Latane and her team in Art Preparation and Installation for their unparalleled capability in creating a stunning installation in Los Angeles. Digital Content Specialist Nandi Dill Jordan and Creative Director of Digital Media Agnes Stauber brought their expertise and creativity to the digital programming around this exhibition.

Deputy Director of Curatorial and Planning Zoe Kahr, together with Carolyn Oakes and Iris Jang in Exhibition Coordination, organized and budgeted for the many components of this show with dedication and steadfast attention to detail. In Development, Senior Vice President Melissa Bomes and Katie Kennedy, Lauren Bergman Siegel, and Catherine Massey were instrumental in the fundraising efforts. Interim Director of Communications Jessica Youn and Interim Director of Executive Communications Chi-Young Kim, together with Director of Marketing John Rice and his team, brought tremendous enthusiasm and vision to promoting Barbara Kruger's work. Associate Vice President of Retail and Merchandising Grant Breding together with Retail and Merchandising Manager Zandra Van Batenburg worked closely with the artist to create original merchandise for the show specific to LACMA. Thanks are also owed to Vice President of Education and Public Programs Naima Keith and Education and Public Programs Curatorial Assistant Elizabeth Gerber for conceiving of a creative schedule of programs to complement the exhibition.

At MoMA, Glenn D. Lowry, The David Rockefeller Director, recognized the enduring significance of Kruger's art and the unique opportunity this project offered to share her work with a broad audience in New York. Alongside the presentation of the exhibition at MoMA PS1, he extended the invitation for Kruger to engage The Donald B. and Catherine C. Marron Atrium at MoMA. After the coronavirus pandemic upended PS1's ability to present the show, Glenn worked with Peter S. Reed, then Senior Deputy Director, Curatorial Affairs, and Ramona Bannayan, Senior Deputy Director, Exhibitions and Collections, to ensure that the Atrium commission could yet be realized, and we are grateful to both of them. Chief Curators Christophe Cherix, Stuart Comer, Rajendra Roy, Martino Stierli, and Ann Temkin were crucial supporters, as was Sarah Suzuki, Deputy Director, Curatorial Affairs, who offered important advice. In the General Counsel's office, Alexis Sandler provided her customary thoughtful assistance. Erik Patton, Director of Exhibition Planning and Administration, gave the project his close attention. The Atrium installation, designed

in close collaboration with the artist, benefited
enormously from the professionalism and
creativity of Lana Hum, Director of Exhibition
Design and Production, and Mack Cole-
Edelsack, Senior Design Manager. Michael
Henry, Director of Exhibitions and Programs at
MoMA PS1, worked tirelessly on the exhibition in
the planning stages of our collaboration, as did
Jennifer Cohen, Associate Director, Exhibition
Planning and Administration, who then kept the
Atrium commission running smoothly.

On behalf of the artist, we extend our appre-
ciation to Chip and Lara Leavitt at Lumiere
Editions; Tim Stoenner at Coloredge, New
York; Josh Haycraft at Yōhk, Los Angeles; Brian
Ramirez at Olson Visual, Los Angeles; and Eder
Cetina at Wilson Cetina Group, Los Angeles —
all of whom assisted with fabrication.

At the heart of this collaboration is, of course,
the artist herself. Our profound gratitude goes to
Barbara Kruger, whose extraordinary vision and
ethic have been a constant inspiration. We are
deeply grateful for the privilege and gift of her
partnership in every aspect of this project. She
committed herself without reservation, attending
closely to the innumerable details of the exhi-
bition and accompanying publication. It was a
tremendous pleasure to fulfill her vision for this
monumental project. Barbara honored us with
her trust, insights, and generosity at every step
in the process.

Robyn Farrell
Associate Curator, Modern and
Contemporary Art
Art Institute of Chicago

Rebecca Morse
Curator, Wallis Annenberg
Photography Department
Los Angeles County Museum of Art

Peter Eleey
Former Chief Curator
MoMA PS1

List of Works in the Exhibition

All works are by Barbara Kruger (United States, b. 1945). Dimensions are listed in inches and centimeters. Measurements are given as height by width (by depth).

Advertisements for myself (project for the New York Times), 2014/2020
Digital print on vinyl wallpaper
Dimensions variable
Courtesy of the artist
p. 110

The Globe Shrinks, 2010
Four-channel video installation; color, sound; 12 min., 43 sec.
Courtesy of Sprüth Magers
pp. 49, 138–39

Justice, 1997
Painted fiberglass
108 × 57 × 48 in.
(274 × 145 × 122 cm)
Courtesy of Sprüth Magers, and David Zwirner, New York
pp. 53, 60, 147

Picturing "Greatness,"
1987/2020
Site-specific installation
Dimensions variable
Courtesy of the artist
p. 104

Pledge, 1988/2020
Single-channel video; sound; 1 min., 6 sec.
Courtesy of Sprüth Magers, and David Zwirner, New York
pp. 114–15

Public Service Announcements, 1996
16mm film transferred to video; silent; 2 min., 30 sec.
Courtesy of the artist

Untitled (Admit nothing/ Blame everyone/Be bitter), 1987/2020
Single-channel video on LED panel; sound; 17 sec.
78 ¾ × 157 ½ in.
(200.1 × 400.2 cm)
Courtesy of Sprüth Magers
pp. 124–25

Untitled (Admit nothing blame everyone be bitter), 1988
Photograph and type on paper
5 ⅝ × 9 ⅝ in. (14.3 × 24.4 cm)
Glenstone Museum, Potomac, Maryland

Untitled (Another), 2003
Chromogenic print
49 ¼ × 49 ¼ × 2 in.
(125 × 125 × 5 cm)

Private collection, Cologne
p. 136

Untitled (Artforum), 2016/2020
Two-channel video installation; silent; 4 min., 42 sec.
Courtesy of Sprüth Magers, and David Zwirner, New York
pp. 94–95

Untitled (Audio), 2020
Sound installation
Courtesy of the artist

Untitled (Brain), 2007
Digital print on vinyl
132 × 108 in. (335 × 274 cm)
Private collection, Delaware, courtesy of Art Finance Partners, LLC
p. 130

Untitled (Business as usual), 1987
Photograph and type on paper
6 ½ × 7 ⅝ in. (16.3 × 19.3 cm)
Courtesy of the artist

Untitled (Cast of characters), 2016/2020
Digital print on vinyl wallpaper
Dimensions variable
Courtesy of the artist
pp. 134–35

Untitled (Connect), 2015
Archival pigment print on paper
77 × 58 in. (196 × 147 cm)
Barasch Carmel Family Collection
p. 105

Untitled (Feel is something you do with your hands), 2020
Digital print on vinyl
84 × 96 × 2 ½ in.
(213.4 × 244 × 6.4 cm)
Courtesy of Sprüth Magers
p. 133

Untitled (Floor), 1991/2020
Digital print on vinyl
Dimensions variable
Courtesy of the artist

Untitled (Forever), 2017
Digital print on vinyl wallpaper and floor covering
Dimensions variable
Amorepacific Museum of Art (APMA), Seoul
pp. 45, 85, 100–103

Untitled (Free love), 1988
Photograph and type on paper
9 ⅜ × 5 ¼ in. (23.9 × 13.5 cm)
Private collection, Cologne

Untitled (Greedy schmuck), 2012
Digital print on vinyl
84 × 108 × 2 ½ in.
(213 × 274 × 6.4 cm)
Private collection
p. 140

Untitled (Headphones), 2020
Site-specific installation
Dimensions variable
Courtesy of the artist

Untitled (Heart), 1988
Photographic silk screen
on vinyl
111 ¾ × 111 ¾ × 2 ½ in.
(284 × 284 × 6.4 cm)
Emily Fisher Landau
AMART LLC
p. 132

*Untitled (How come only
the unborn have the right
to life?)*, 1986
Photograph and type
on paper
8 ⅝ × 5 ⅞ in. (22 × 14.9 cm)
Private collection, Cologne

*Untitled (I shop therefore
I am)*, 1987/2019
Single-channel video on
LED panel; sound; 57 sec.
137 ⅞ × 137 ⅞ in.
(350.1 × 351.1 cm)
Courtesy of Sprüth Magers
pp. 96–97

*Untitled (It's our pleasure
to disgust you)*, 1991
Photographic silk screen
on vinyl
90 × 77 in. (228.6 × 195.5 cm)
Gift from Vicki and Kent
Logan to the Collection
of the Denver Art Museum,
2001.771
pp. 84, 129

*Untitled (Money is like
shit)*, 2012
Digital print on vinyl
114 ¼ × 75 ⅛ in.
(290.2 × 190.8 cm)
Billur and Atilla Tacir
Collection, Istanbul, Turkey
pp. 142–43

Untitled (Money talks),
1984
Photograph and type
on paper
6 ½ × 8 in. (16.3 × 20.3 cm)
Courtesy of the artist

*Untitled (Never Perfect
Enough)*, 2020
Digital prints on vinyl
Three parts: 147 × 110 in.
(373.4 × 297.4 cm) each
Courtesy of Sprüth Magers
pp. 107–09

Untitled (No Comment), 2020
Three-channel video
installation; color, sound;
9 min., 25 sec.
Courtesy of Sprüth Magers,
and David Zwirner, New York
pp. 90–93

Untitled (Our Leader),
1987/2020
Single-channel video on LED
panel; sound; 24 sec.
137 ⅞ × 78 ¾ in.
(350.1 × 200.1 cm)
Courtesy of David Zwirner,
New York
pp. 122–23

Untitled (Our people),
1994/2017
Digital print on vinyl
108 × 67 ½ in. (274.3 × 171.5 cm)
Private collection, Chicago
p. 113

Untitled (Read My Lips), 1985
Photograph and type
on paper
5 × 6 ⅛ in. (12.7 × 15.6 cm)
Private collection, Berlin

Untitled (Remember me),
1988/2020
Single-channel video on LED
panel; sound; 23 sec.
137 ⅞ × 98 ½ in.
(350.1 × 250.1 cm)
Courtesy of Sprüth Magers
pp. 120–21

Untitled (Roy toy), 1986
Photograph and type
on paper

9 ¼ × 6 in. (23.3 × 15.2 cm)
Courtesy of the artist

Untitled (Rug), 1991–93
Vorwerk machine-woven
wool
78 ½ × 119 in. (199 × 302 cm)
Courtesy of Sprüth Magers,
and David Zwirner, New York
p. 86

Untitled (Selfie), 2020
Site-specific installation
Dimensions variable
Courtesy of the artist
pp. 144–45

*Untitled (That's the way we
do it)*, 2011/2020
Digital print on vinyl wallpaper
Dimensions variable
Courtesy of the artist and
Sprüth Magers

Untitled (Too big to fail), 2012
Digital print on vinyl
108 × 108 × 2 ⅜ in.
(274.3 × 274.3 × 6 cm)
Collection of Liz and Eric
Lefkofsky
p. 141

Untitled (Truth), 2013
Digital print on vinyl
70 ¼ × 115 in. (178.6 × 292.1 cm)
Collection of Margaret and
Daniel S. Loeb
p. 131

*Untitled (Unmaking
the World)*, 2008
Digital print on vinyl
143 × 103 in. (363 × 262 cm)
FWA-Foundation for
Woman Artists, Belgium
p. 112

*Untitled (The war for me
to become you)*, 2008
Archival pigment print
on paper
40 × 32 in. (101.6 × 80.8 cm)
Private collection, Cologne
p. 111

*Untitled (We are public
enemy number one)*, 1984
Photograph and type

on paper
8 ⅞ × 5 ⅞ in. (22.5 × 14.8 cm)
Private collection, Cologne

*Untitled (We don't need
another hero)*, 1987
Photograph and type
on paper
5 ¾ × 11 ⅜ in. (14.6 × 28.9 cm)
Glenstone Museum,
Potomac, Maryland
p. 148

*Untitled (We don't need
another hero)*, 1988
Photograph and type on
paper
3 ⅜ × 7 ½ in. (8.7 × 19 cm)
Private collection, Berlin

*Untitled (Who speaks?
Who is silent?)*, 1990
Photographic silk screen
on vinyl
52 × 197 × 2 ½ in.
(132 × 500 × 6.4 cm)
Collection of Everson
Museum of Art; museum
purchase, 90.253
p. 128

*Untitled (Why doesn't God
destroy Satan)*, 1994
Photoengraving on
magnesium
12 × 12 in. (30.5 × 30.5 cm)
S.E.A. family, Los Angeles
p. 137

*Untitled (The work is
about…)*, 1979/2020
Single-channel video;
silent; 5 min., 38 sec.
Courtesy of Sprüth Magers,
and David Zwirner, New York
pp. 98–99

*Untitled (Worth every
penny)*, 1987
Photograph and type
on paper
10 ⅞ × 6 in. (28.3 × 15.3 cm)
Courtesy of the artist

*Untitled (You are not
yourself)*, 1982
Photograph and type
on paper

10 ¾ × 7 ⅛ in. (27.3 × 18.1 cm)
Glenstone Museum,
Potomac, Maryland
p. 149

*Untitled (You have searched
and destroyed)*, 1982
Photograph and type
on paper
8 ⅛ × 9 ¾ in. (20.6 × 24.8 cm)
Glenstone Museum,
Potomac, Maryland

*Untitled (You invest in
the divinity of the
masterpiece)*, 1982
Photograph and type
on paper
10 ⅞ × 6 ⅞ in. (27.6 × 17.5 cm)
Glenstone Museum,
Potomac, Maryland

Untitled (You kill time), 1983
Photograph and type
on paper
8 ⅝ × 5 ¾ in. (22 × 14.5 cm)
Private collection, Cologne

*Untitled (Your body
is a battleground)*, 1989
Photograph and type
on paper
8 ¼ × 7 ½ in. (21 × 19.1 cm)
Glenstone Museum,
Potomac, Maryland
p. 151

*Untitled (Your body is a
battleground)*, 1989/2019
Single-channel video on LED
panel; sound; 1 min., 4 sec.
137 ⅞ × 137 ⅞ in.
(350.1 × 350.1 cm)
Courtesy of Sprüth Magers
pp. 43, 126–27

*Untitled (Your comfort
is my silence)*, 1981
Photograph and type
on paper
10 ⅞ × 7 ¾ in. (27.6 × 19.7 cm)
Glenstone Museum,
Potomac, Maryland

*Untitled (Your gaze hits
the side of my face)*, 1981
Photograph and type
on paper

9 ⅜ × 7 in. (23.8 × 17.8 cm)
Glenstone Museum,
Potomac, Maryland
p. 150

*Untitled (Your manias become
science)*, 1982
Photograph and type
on paper
7 ⅛ × 8 ¾ in. (18.1 × 22.2 cm)
Glenstone Museum,
Potomac, Maryland

*Untitled (You substantiate
our horror)*, 1983
Photograph and type
on paper
9 × 5 ⅞ in. (22.9 × 14.9 cm)
Glenstone Museum,
Potomac, Maryland

Vow, 1988/2020
Single-channel video; sound;
1 min., 15 sec.
Courtesy of Sprüth Magers,
and David Zwirner, New York
pp. 116–17

Will, 1988/2020
Single-channel video;
sound; 52 sec.
Courtesy of Sprüth Magers,
and David Zwirner, New York
pp. 118–19

Selected Exhibition History 2009–2021

Solo Exhibitions

2021
Questions, Art on theMART, Merchandise Mart, Chicago, April–August 2021.

2019
Barbara Kruger: Kaiserringträgerin der Stadt Goslar, Mönchehaus Museum Goslar, Germany, September 21, 2019–January 26, 2020.

Barbara Kruger: Forever, Amorepacific Museum of Art, Seoul, June 27–December 29, 2019.

2018
Barbara Kruger: 1978, Mary Boone Gallery, Fifth Avenue, New York, November 1–December 21, 2018.

2017
FOREVER, Sprüth Magers, Berlin, September 16, 2017–January 20, 2018.

Public Service Announcements, The Box at Wexner Center for the Arts, Ohio State University, Columbus, September 1–30, 2017.

Barbara Kruger: Gluttony, Museum of Religious Art, Lemvig, Denmark, February 5–May 28, 2017.

2016
In the Tower: Barbara Kruger, National Gallery of Art, Washington, DC, September 30, 2016–January 22, 2017.

2015
Barbara Kruger: Early Works, Skarstedt Gallery, London, February 10–April 25, 2015.

2014
Barbara Kruger, Modern Art Oxford, UK, June 28–October 22, 2014.

2013
Believe + Doubt, Kunsthaus Bregenz, Austria, October 19, 2013–January 12, 2014.

2012
Questions, Arbeiterkammer Wien, Vienna, November 23, 2012–April 30, 2013.

Belief + Doubt, site-specific installation, Hirshhorn Museum and Sculpture Garden, Washington, DC, August 20, 2012–ongoing.

2011
Edition 46: Barbara Kruger, Pinakothek der Moderne, Munich, Germany, November 18, 2011–January 8, 2012.

Barbara Kruger, L&M Arts, Venice, California, May 14–July 9, 2011.

2010
Barbara Kruger, Sprüth Magers, Berlin, September 3–October 23, 2010.

Barbara Kruger: Plenty, Guild Hall, East Hampton, New York, August 14–October 11, 2010.

The Globe Shrinks, Mary Boone Gallery, West Twenty-Fourth Street, New York, March 27–May 1, 2010; Sprüth Magers, London, April 21–May 21, 2011.

2009
Barbara Kruger: Paste Up, Sprüth Magers, London, November 21, 2009–January 23, 2010.

Barbara Kruger: Between Being Born and Dying, Lever House, New York, September 17–November 21, 2009.

Barbara Kruger: Pre-digital 1980–1992, Skarstedt Gallery, East Seventy-Ninth Street, New York, March 18–April 18, 2009.

Group Exhibitions

2020
20/20, David Zwirner, New York, October 29–December 19, 2020.

Push the Limits, Fondazione Merz, Turin, Italy, September 7, 2020–January 31, 2021.

Graphic Pull: Contemporary Prints from the Collection, Nasher Museum of Art, Duke University, Durham, NC, August 27, 2020–February 21, 2021.

Desire, Knowledge, Hope (with Smog), Broad Museum, Los Angeles, Summer 2020 (postponed).

Modern Women: Modern Vision Works from the Bank of America

Collection, Tampa Museum of Art, Tampa, FL, February 20–October 25, 2020.

2019
Inside – Out: Konstruktionen des Ichs, Kunstmuseum Wolfsburg, Germany, October 26, 2019–January 12, 2020.

Ekphrasis: Writing in Art, Boghossian Foundation, Villa Empain, Brussels, October 24, 2019–February 9, 2020.

Women Breaking Boundaries, Cincinnati Art Museum, Cincinnati, October 11, 2019–ongoing.

1989: Culture and Politics, Nationalmuseum, Stockholm, September 5, 2019–January 12, 2020.

The Foundation of the Museum: MOCA's Collection, The Geffen Contemporary at MOCA, Los Angeles, May 19, 2019–January 20, 2020.

Political Affairs: Language Is Not Innocent, Kunstverein in Hamburg, Germany, May 17–July 21, 2019.

Inaugural Exhibition, Skarstedt Gallery, East Sixty-Fourth Street, New York, April 12–May 4, 2019.

California Artists in the Marciano Collection, Marciano Art Foundation, Los Angeles, February 12–September 22, 2019.

2018
Local Histories, Hamburger Bahnhof, Museum für Gegenwart, Berlin, December 15, 2018–November 10, 2019.

The Street: Where the World Is Made, MAXXI, Rome,

December 7, 2018–April 28, 2019.

Believe, Museum of Contemporary Art Toronto, September 22, 2018–January 6, 2019.

Knock Knock: Humour in Contemporary Art, South London Gallery, September 22–November 18, 2018.

Herstory: Women Artists from the Private Collection of Patrizia Sandretto Re Rebaudengo, Contemporary Forward/Touchstones Rochdale Art Gallery, UK, July 28–September 29, 2018.

This Brush for Hire: Norm Laich & Many Other Artists, Institute of Contemporary Art, Los Angeles, June 3–September 2, 2018.

Breaking the Mold: Investigating Gender, Speed Art Museum, Louisville, Kentucky, April 7–September 9, 2018.

Brand New: Art and Commodity in the 1980s, Hirshhorn Museum and Sculpture Garden, Washington, DC, February 14–May 13, 2018.

The Art World We Want, Pennsylvania Academy of the Fine Arts, Philadelphia, February 13–April 8, 2018.

Faithless Pictures, National Museum of Norway, Oslo, February 9–May 13, 2018.

Unspeakable: Atlas, Kruger, Walker, Hammer Museum, Los Angeles, January 20–May 13, 2018.

2017
STEDELIJK BASE, Stedelijk

Museum Amsterdam, December 16, 2017–ongoing.

Like a Moth to a Flame, Fondazione Sandretto Re Rebaudengo, Turin, Italy, November 3, 2017–January 14, 2018.

Being Modern: MOMA in Paris, Fondation Louis Vuitton, Paris, October 11, 2017–March 5, 2018.

An Incomplete History of Protest: Selections from the Whitney's Collection, 1940–2017, Whitney Museum of American Art, New York, August 18, 2017–August 27, 2018.

Für Barbara, Hall Art Foundation, Schloss Derneburg Museum, Holle, Germany, July 1, 2017–October 1, 2018.

Von Christo bis Kiefer: Die Collection Lambert, Avignon, Kunstmuseum Pablo Picasso, Münster, Germany, June 2–October 1, 2017.

Never Enough: Monika Sprüth and the Art, MEWO Kunsthalle Memmingen, Germany, May 19–September 3, 2017.

Space Force Construction, V-A-C Foundation, Palazzo delle Zattere, Venice, Italy, May 13–August 25, 2017.

Double Take, Skarstedt Gallery, London, March 7–May 26, 2017.

Polygraphs, Gallery of Modern Art, Glasgow, Scotland, February 17, 2017–May 20, 2018.

2016
Toda percepción es una interpretación: You Are Part of It; Works from the

Ella Fontanals-Cisneros Collection, CIFO Art Space, Miami, November 30, 2016–March 12, 2017.

Portraits, Skarstedt Gallery, East Seventy-Ninth Street, New York, November 10–December 17, 2016.

Under Arms: Fire and Forget 2, Museum für Angewandte Kunst, Frankfurt am Main, Germany, September 10, 2016–March 26, 2017.

More than Words, Westport Arts Center, Connecticut, September 9–October 29, 2016.

Belief + Doubt: Selections from the Francie Bishop Good and David Horvitz Collection, NSU Art Museum, Fort Lauderdale, Florida, August 26, 2016–January 22, 2017.

The Making of a Fugitive, Museum of Contemporary Art, Chicago, July 16–December 4, 2016.

Co-thinkers, Garage Museum of Contemporary Art, Moscow, July 7–September 9, 2016.

Golden Eggs, Team Gallery, New York, June 23–August 12, 2016.

Don't Look Back: The 1990s at MOCA, The Geffen Contemporary at MOCA, Los Angeles, March 12–July 11, 2016.

MashUp: The Birth of Modern Culture, Vancouver Art Gallery, British Columbia, February 20–May 15, 2016.

2015
No Man's Land: Women Artists from the Rubell Family Collection,

Rubell Family Collection, Miami, December 2, 2015–May 28, 2016; National Museum of Women in the Arts, Washington, DC, September 30, 2016–January 8, 2017.

Eau de Cologne: Jenny Holzer, Barbara Kruger, Louise Lawler, Cindy Sherman, Rosemarie Trockel, Sprüth Magers, Berlin, September 17–October 21, 2015; Sprüth Magers, Los Angeles, June 28–August 20, 2016.

The Great Mother, Fondazione Nicola Trussardi, Milan, Italy, August 26–November 15, 2015.

Fire and Forget: On Violence, KW Institute of Contemporary Art, Berlin, June 14–August 30, 2015.

America Is Hard to See, Whitney Museum of American Art, New York, May 1–September 27, 2015.

Cannibalism? On Appropriation in Art, Zachęta National Art Gallery, Warsaw, Poland, March 7–May 31, 2015.

2014
Pop to Popism, Art Gallery of New South Wales, Sydney, November 1, 2014–March 1, 2015.

Pop Departures, Seattle Art Museum, October 9, 2014–January 11, 2015.

Urban Theater: New York in the 1980s, Modern Art Museum of Fort Worth, Texas, September 21, 2014–January 4, 2015.

No Problem: Cologne/New York 1984–1989, David Zwirner, New York, May 1–June 14, 2014.

Remain in Light: Photography from the MCA Collections,

Ipswich Art Gallery, Australia, March 29–May 31, 2014; Western Plains Cultural Centre, Dubbo, Australia, August 9–October 31, 2014; Maitland Regional Art Gallery, Australia, November 28, 2014–February 1, 2015; Bendigo Gallery, Australia, February 21–April 19, 2015; Artspace Mackay, Australia, May 22–July 5, 2015; Hawkesbury Regional Gallery, Windsor, Australia, August 7–October 4, 2015.

19th Biennale of Sydney, March 21–June 9, 2014.

Under Pressure: Contemporary Prints from the Collections of Jordan D. Schnitzer and His Family Foundation, Missoula Art Museum, Montana, February 18–May 31, 2014.

Take It or Leave It: Institution, Image, Ideology, Hammer Museum, Los Angeles, February 9–May 18, 2014.

2013
Zeichen. Sprache. Bilder: Schrift in der Kunst seit den 1960er Jahren, Städtische Galerie Karlsruhe, Germany, November 9, 2013–February 23, 2014.

Light My Fire: Some Propositions about Portraits and Photography, Part II, Art Gallery of Ontario, Toronto, October 26, 2013–May 18, 2014.

Incontri: Zeitgennösische italienische Kunst, Schauwerk, Sindelfingen, Germany, October 20, 2013–September 21, 2014.

Not Yet Titled: Neu und für immer im Museum Ludwig, Museum Ludwig, Cologne, Germany, October 11, 2013–January 26, 2014.

Homebodies, Museum of Contemporary Art, Chicago, June 29–October 13, 2013.

WWTBD: What Would Thomas Bernhard Do?, Kunsthalle Wien, Museumsquartier, Vienna, May 17–26, 2013.

DLA Piper Series: Constellations, Tate Liverpool, UK, May 2013–March 2015.

10th Anniversary Exhibition: All You Need Is Love; From Chagall to Kusama and Hatsune Miku, Mori Art Museum, Tokyo, April 26–September 1, 2013.

2012
Color Bind: The MCA Collection in Black and White, Museum of Contemporary Art, Chicago, November 10, 2012–April 28, 2013.

Now's the Time: Recent Acquisitions, Solomon R. Guggenheim Museum, New York, November 3, 2012–January 2, 2013.

Visual Conversations: Selections from the Collection, Fisher Landau Center for Art, Long Island City, New York, September 28–December 31, 2012.

Making Places, Stedelijk Museum Amsterdam, September 23–November 3, 2012.

Regarding Warhol: Sixty Artists, Fifty Years, Metropolitan Museum of Art, New York, September 18–December 31, 2012.

Bye Bye American Pie, MALBA, Museo de Arte Latinoamericano de Buenos Aires, Argentina, March 30–June 4, 2012.

Art and Press: Kunst. Wahrheit. Wirklichkeit, Martin-Gropius-Bau, Berlin, March 23–June 24, 2012; ZKM Zentrum für Kunst und Medien, Karlsruhe, Germany, September 15, 2012–March 10, 2013.

This Will Have Been: Art, Love & Politics in the 1980s, Museum of Contemporary Art, Chicago, February 11–June 3, 2012; Walker Art Center, Minneapolis, June 30–September 30, 2012; Institute of Contemporary Art, Boston, November 15, 2012–March 3, 2013.

Domination, Hegemony and the Panopticon: Works from the Farook Collection, Traffic, Dubai, United Arab Emirates, February 2–March 31, 2012.

2011
Tales of the City: Art Fund International and the GoMA Collection, Gallery of Modern Art, Glasgow, Scotland, December 16, 2011–December 1, 2012.

American Exuberance, Rubell Family Collection, Contemporary Art Foundation, Miami, November 30, 2011–July 27, 2012.

Doublespeak, Salt Lake Art Center, Salt Lake City, October 7, 2011–January 7, 2012.

September 11, MoMA PS1, Long Island City, New York, September 11, 2011–January 9, 2012.

Phantasie an die Macht, Galerie Stihl der Stadt Waiblingen, Germany, July 8–September 25, 2011.

KUB-Billboards: Signs of Solidarity, Kunsthaus Bregenz, Austria, July 4–October 16, 2011.

Sympathy for the Devil, Vanhaerents Art Collection, Brussels, April 30, 2011–November 30, 2013.

So machen wir es: Techniken und Ästhetik der Aneignung, Kunsthaus Bregenz, Austria, April 16–July 3, 2011.

Unsettled: Photography and Politics in Contemporary Art, Philadelphia Museum of Art, April 9–September 19, 2011.

No Substitute, Glenstone Museum, Potomac, Maryland, April 2011–February 2013.

American Dream, DZ Bank Kunstsammlung, Frankfurt am Main, Germany, January 26–April 2, 2011.

The Deconstructive Impulse: Women Artists Reconfigure the Signs of Power, 1973–1990, Neuberger Museum of Art, Purchase College, State University of New York, January 15–April 3, 2011; Nasher Museum of Art, Duke University, Durham, North Carolina, September 15–December 31, 2011; Contemporary Arts Museum, Houston, January 21–April 15, 2012.

2010
The Right to Protest, Museum on the Seam, Jerusalem, October 14, 2010–May 1, 2011.

Taking Place, Stedelijk Museum Amsterdam, August 28, 2010–January 8, 2011.

The Original Copy: Photography of Sculpture, 1839 to Today, The Museum of Modern Art, New York, August 1–November 1, 2010.

Pictures by Women: A History of Modern Photography, The Museum of Modern Art,

New York, May 7, 2010–April 18, 2011.

I LOVE YOU, Aros Kunstmuseum, Aarhus, Denmark, March 27–September 12, 2010.

Your History Is Not Our History, Haunch of Venison, New York, March 5–May 1, 2010.

In the Vernacular, Art Institute of Chicago, February 6–May 31, 2010.

PressArt. Die Sammlung Peter und Annette Nobel, Kunstmuseum St. Gallen, Switzerland, January 30–June 20, 2010; Museum der Moderne, Salzburg, Austria, July 3–October 24, 2010.

Collecting Biennials, Whitney Museum of American Art, New York, January 16–November 28, 2010.

2009
Beg, Borrow and Steal, Rubell Family Collection, Miami, December 2, 2009–May 29, 2010.

Twentysix Gasoline Stations ed altri libri d'artista: una collezione, Museo Regionale di Messina, Italy, November 28, 2009–January 10, 2010.

We Are the World: Figures & Portraits, Fisher Landau Center for Art, Long Island City, New York, November 15, 2009–April 3, 2010.

Dress Codes: The Third ICP Triennial of Photography and Video, International Center for Photography, New York, October 2, 2009–January 17, 2010.

Silent Writings, Espace Culturel Louis Vuitton,

Paris, September 24–October 31, 2009.

A Tribute to Ron Warren, Mary Boone Gallery, West Twenty-Fourth Street, New York, September 12–October 24, 2009.

Wall Rockets: Contemporary Artists and Ed Ruscha, Albright-Knox Art Gallery, Buffalo, New York, July 24–October 25, 2009.

elles@centrepompidou, Centre Georges Pompidou, Paris, May 27, 2009–February 21, 2011.

The Pictures Generation, Metropolitan Museum of Art, New York, April 21–August 2, 2009.

You Will Never Wake Up from This Beautiful Dream, Vanmoerkerke Collection, Ostend, Belgium, January 4–April 15, 2009.

Public Projects

2020
Mask designs, produced by the Museum of Contemporary Art, Los Angeles; the Wedel Art Collective; Visionaire, 2020.

Untitled (Who?), Sprüth Magers façade, Los Angeles, October 2020–January 2021.

Untitled (The Greats), cover for "The Greats" issue, *T: The New York Times Style Magazine*, October 2020.

Untitled (Questions), bandana, Artists Band Together and eBay Charity, August 2020.

Cover for *Zeit Magazin*, June 18, 2020.

A Corpse Is Not a Customer, *New York Times*, Op/Art, April 30, 2020.

Untitled, cover for *New York* magazine, March 30, 2020.

Untitled (Questions), Frieze Projects, Los Angeles, February 10–16, 2020.

Untitled (Another Question), project for Housing Is A Human Right, Sunset Boulevard, Los Angeles, January 2, 2020–ongoing.

2019
Untitled (look like us, talk like us, think like us, pray like us, love like us), exterior wall project, Art Night London, June 22–September 17, 2019.

Untitled (Questions 3), Frieze Projects, Los Angeles, February 15–17, 2019.

2018
Untitled (Questions), 1990/2018, exterior wall project, The Geffen Contemporary at MOCA, Los Angeles, October 20, 2018–November 30, 2020.

Untitled (No puedes vivir sin nosotras / You Can't Live Without Us), Art Basel Cities, Silos de la Antigua Junta Nacional de Granos, Buenos Aires, September 6–12, 2018.

Prump - Tutin, cover for *New York* magazine, July 9, 2018.

Untitled (It), LAXART façade, Los Angeles, June 3–December 31, 2018.

2017
Untitled (The Drop), Performa 17, New York. November 1–19, 2017.

Untitled (Skate), LES Coleman Skatepark, Performa 17, New York, November 1–19, 2017.

2016

Empatía, site-specific installation at Metro Bellas Artes subway station, Mexico City, November 22, 2016–February 28, 2017.

Untitled, cover for "Election" issue, *New York* magazine, October 31, 2016.

Untitled (Blind Idealism Is… after Franz Fanon), outdoor mural for High Line, New York, March 21, 2016–March 2017.

Cover for "Art and Identity" issue, *Artforum* 54, no. 10 (Summer 2016).

2014

Advertisements for myself, cover for *T: The New York Times Style Magazine*, October 19, 2014.

2013

Bus wraps, Museum Ludwig/Kölner Verkehrs-Betriebe AG, Cologne, Germany, from December 5, 2013.

Set and costumes for *Reflections*, Benjamin Millepied/L.A. Dance Project production, Théâtre du Châtelet, Paris, May 23–25, 2013; Theatre at Ace Hotel, Los Angeles, February 20–22, 2014; Brooklyn Academy of Music, October 16–18, 2014.

2012

For sale, *New York Times*, Op/Art, November 24, 2012, A21.

Bus wraps and billboard, in support of the Los Angeles Fund for Public Education, October 2012.

2011

Untitled (Be here now), *New York Times*, Op/Art, June 5, 2011, WK8.

2010

Circus, site-specific installation, rotunda, Schirn Kunsthalle, Frankfurt am Main, Germany, December 15, 2010–January 30, 2011.

Cover of *W* magazine, November 2010.

Whitney on Site: New Commissions Downtown, outdoor installation at the future site of the Whitney Museum of American Art, Gansevoort and Washington Streets, New York, September 1–October 17, 2010.

Map for the London Tube, London Underground stations, London, May 21, 2010–January 10, 2011.

Untitled (It), façade installation, Art Gallery of Ontario, Toronto, May 1–October 3, 2010.

Selected Bibliography
2010–2020

Books

2019
Kittelmann, Udo. *Barbara Kruger: Kaiserringträgerin der Stadt Goslar 2019*. Goslar, Germany: Mönchehaus, 2019.

Seungchang, Jean, and Kim Kyoungran. *Barbara Kruger: Forever*. Exhibition catalogue. Seoul: Amorepacific Museum of Art, 2019.

2018
Jetzer, Gianni, ed. *Brand New: Art & Commodity in the 1980s*. Exhibition catalogue. New York: Rizzoli Electa; Washington, DC: Hirshhorn Museum and Sculpture Garden, 2018.

2014
Dziewior, Yilmaz, ed. *Barbara Kruger: Believe + Doubt*. Exhibition catalogue. Bregenz, Austria: Kunsthaus Bregenz, 2014.

Ellegood, Anne, and Johanna Burton, eds. *Take It or Leave It: Institution, Image, Ideology*. Exhibition catalogue. Los Angeles: Hammer Museum; Munich: DelMonico Books/ Prestel, 2014.

Kruger, Barbara, and Ciara Moloney. *Barbara Kruger*. Oxford, UK: Modern Art Oxford, 2014.

2011
Pfeiffer, Ingrid, and Max Hollein, eds. *Barbara Kruger: Circus*. Cologne, Germany: Walther König, 2011.

2010
Kruger, Barbara. *Barbara Kruger*. New York: Rizzoli, 2010.

Articles

2020
Amend, Christoph. "Noch ein Morgen." *Zeit Magazin*, June 18, 2020.

Cascone, Sarah. "Rabble-Rousing Artist Barbara Kruger on Why She's Plastering LA's Buildings With Questions 'About What It Means to Live Another Day.'" *Artnet News*, February 11, 2020. https://news.art net.com/market/barbara -kruger-frieze-los-angeles -1772982.

O'Grady, Megan. "Barbara Kruger." *T: The New York Times Style Magazine*, October 19, 2020, https:// www.nytimes.com/inter active/2020/10/19/t-mag azine/barbara-kruger.html.

Goldstein, Caroline. "'The Availability of My Work Is Important to Me': Watch How Barbara Kruger Coopts the Language of Advertising to Reach to Audiences Beyond the Art World." *Artnet News*, August 13, 2020. https://news.artnet.com /art-world/art21-barbara -kruger-1901703.

La Force, Thessaly, Zoë Lescaze, Nancy Hass, and M. H. Miller. "The 25 Most Influential Works of American Protest Art Since World War II." *T: The New York Times Style Magazine*, October 15, 2020, https://www.nytimes .com/2020/10/15/t-magazine /most-influential-protest -art.html.

Ruiz, Cristina. "The Artwork." *The Gentlewoman*, no. 22 (Autumn/Winter 2020).

Selvin, Claire. "Barbara Kruger's Biggest Exhibition in 20 Years to Open at Art Institute of Chicago in November." *Artnews*, February 6, 2020. https:// www.artnews.com/art-news /news/barbara-kruger -exhibition-art-institute -chicago-1202677299/.

———. "Barbara Kruger's Strange, Alluring Text-Based Artworks: How the Artist Critiqued Advertising and Rose to Fame." *Artnews*, August 6, 2020. https://www. artnews.com/feature /barbara-kruger-art-exhib itions-1202696145/.

Simmons, William J. "Love and the Paraliterary: On Barbara Kruger's Picture/Readings." *Flash Art*, April 1, 2020. https:// flash---art.com/article/love -and-the-paraliterary-on-bar bara-krugers-picture-readings/.

2019

Brown, Kate. "Did This K-Pop Girl Group Rip Off a Classic Barbara Kruger Installation for Its New Video? It Certainly Looks Like It." *Artnet News*, December 9, 2019. https://news.artnet.com/art-world/barbara-kruger-mamamoo-1725993.

Reed, Patrick J. "Barbara Kruger." *Spike*, Summer 2019.

Solomon, Tessa. "Artist Barbara Kruger, Long Loyal to Recently Jailed Mary Boone, Heads to David Zwirner Gallery." *Artnews*, November 21, 2019. https://www.artnews.com/art-news/market/barbara-kruger-david-zwirner-gallery-1202668686/.

Stoeber, Michael. "Barbara Kruger Kaiserringträgerin der Stadt Goslar 2019." *Kunstforum*, no. 264 (November/December 2019): 234–36.

Timm, Tobias. "Auch ich fragte: Was soll das?" *Die Zeit*, no. 38 (September 12, 2019): 68.

Trevisan, Bianca. "La donna come assenza nell'opera di Barbara Kruger (1981–1983)." *Spazi Bianchi* (2019): 423–32.

Uttam, Payal. "In So Many Words." *Hong Kong Tatler*, March 2019, 58–63.

2018

Miranda, Carolina A. "In Advance of the Midterms, Barbara Kruger Reprises MOCA Mural That Asks 'Who Is Beyond the Law.'" *Los Angeles Times*, October 18, 2018. https://www.latimes.com/entertainment/arts/miranda/la-et-cam-barbara-kruger-moca-mural-2018 1018-story.html.

Stoeffel, Kat. "Barbara Kruger Forever. The Essential Artist Talks Ikea, Trump, Hypebeasts, Sex, and Power." *The Cut*, February 2, 2018. https://www.thecut.com/2018/02/profile-barbara-kruger-on-trump-supreme-and-harassment.html.

2017

Chow, Andrew R. "MetroCards with Barbara Kruger Art Are Coming to New York City." *New York Times*, October 29, 2017. https://www.nytimes.com/2017/10/29/arts/barbara-kruger-designed-metro cards-are-coming-to-new-york-city.html.

Keiles, Jamie Lauren. "Barbara Kruger's Supreme Performance." *New Yorker*, November 12, 2017. https://www.newyorker.com/culture/culture-desk/barbara-krug ers-supreme-performance.

Lorch, Catrin. "Großformat." *Süddeutsche Zeitung*, October 14–15, 2017, 24.

Moss, Hilary. "Barbara Kruger Heads to Berlin, with Virginia Woolf in Tow." *T: The New York Times Style Magazine*, September 15, 2017. https://www.nytimes.com/2017/09/15/t-magazine/art/barbara-kruger-berlin.html.

Obler, Bibiana. "Barbara Kruger in Washington." *Artforum* 55, no. 6 (February 2017): 97.

2016

Allwood, Emma Hope. "Barbara Kruger: Back to the Futura." *Dazeddigital.com*, October 7, 2016. https://www.dazeddigital.com/artsandculture/article/33 251/1/barbara-kruger-inter view-2016-pop-culture-reality-tv.

Landström, Erika. "77 Portrait Barbara Kruger." *Spike*, no. 46 (Winter 2015/2016): 76–87.

Pogrebin, Robin. "Emoji Art in Vancouver." *New York Times*, January 21, 2016. https://www.nytimes.com/2016/01/22/arts/design/the-new-cherries-on-top-of-the-minneapolis-sculpture-garden.html.

Swanson, Carl. "Barbara Kruger on Blind Idealism, Trump, and the Brussels Terrorist Attacks." *New York*, March 22, 2016. https://nymag.com/intelligencer/2016/03/barbara-kruger-on-blind-idealism-trump-isis.html.

2015

"Jenny Holzer, Barbara Kruger, Louise Lawler, Cindy Sherman, Rosemarie Trockel at Sprüth Magers, Berlin." *Artnews*, September 28, 2015. https://www.artnews.com/art-news/news/jenny-holzer-barbara-kruger-louise-lawler-cindy-sherman-rosemarie-trockel-at-spruth-magers-berlin-5012/.

Nungesser, Michael. "Fire and Forget. On Violence." *Kunstforum*, no. 235 (August/September 2015): 240–42.

Sachs, Brita. "Ich kaufe, also ich bin." *Frankfurter Allgemeine Zeitung*, January 26, 2015.

2014

"Barbara Kruger to Present Major New Exhibition at Modern Art Oxford." *Artlyst*, May 10, 2014. https://www.artlyst.com/news/barbara-kruger-to-present-major-new-exhibition-at-modern-art-oxford/.

Beesley, Ruby. "Challenging Normality." *Aesthetica*, June/July 2014, 52–57.

Gosling, Emily. "I Shop Therefore I Am: New Barbara Kruger Retrospective Comes to Oxford." *Design Week*, June 10, 2014. https://www.designweek.co.uk/issues/may-2014/i-shop-therefore-i-am-new-barbara-kruger-retrospective-comes-to-oxford/.

Kruger, Barbara. "Questionnaire." *Frieze*, no. 165 (September 2014): 176.

2013

"Barbara Kruger 'Believe + Doubt' at Kunsthaus Bregenz." *Mousse Magazine*, November 24, 2013. http://moussemagazine.it/bkruger-kunsthausbregenz/.

"Barbara Kruger. The Resistance of Doubt." *Arte al Limite*, no. 56 (March/April 2013): 12–21.

Fessler, Katrin. "Worte als Bühnen des Zweifelns." *Der Standard*, November 5, 2013. https://www.derstandard.at/story/1381370983172/worte-als-buehnen-des-zweifels.

Kruger, Barbara. "Barbara Kruger." Interview by Christopher Bollen. *Interview* (March 2013): 256–65, 271.

Pryor, Riah. "Artist Sued by Reluctant YouTube Star." *Art Newspaper* 22, no. 244 (March 2013): 8.

Schmidt, Kristin. "Barbara Kruger — Botschaften in radikaler Klarheit." *Kunst*

Bulletin, no. 12 (December 2013): 70–71.

Weiland, Florian. "Künstlerin Barbara Kruger übt Kultur- und Konsumkritik." *Südkurier*, November 5, 2013. https://www.tagblatt.ch/kultur/zwischen-spass-und-ernst-ld.922539.

2012
"Barbara Kruger." *Artdaily*, August 21, 2012.

Fessler, Anne Katrin. "Barbara Kruger." *Der Standard*, November 23, 2012.

Finkel, Jori. "Barbara Kruger and Catherine Opie Resign from MOCA Board." *Los Angeles Times*, July 14, 2012. https://www.latimes.com/entertainment/arts/la-xpm-2012-jul-14-la-et-cm-barbara-kruger-and-catherine-opie-resign-from-moca-board-20120714-story.html.

Häntzschel, Jörg. "Disco statt Kunst." *Süddeutsche Zeitung*, July 16, 2012.

Kruger, Barbara. "On Barbara Kruger." *Artforum* 51, no. 1 (September 2012): 94.

Kruger, Barbara, "Interview: Barbara Kruger Talks Her New Installation and Art in the Digital Age." Interview by Cedar Pasori. *Complex*, August 21, 2012. https://www.complex.com/style/2012/08/interview-barbara-kruger-talks-her-new-installation-and-art-in-the-digital-age.

Lieberman, Rhonda. "Broadcast Muse." *Artforum* 51, no. 1 (September 2012): 125–26.

"New Barbara Kruger Installation at Hirshhorn Museum." *Jungle Gym Magazine*, August 8, 2012.

Petersen, Hans-Joachim. "Die Sensationelle." *Bild*, March 27, 2012, 10.

Riess, Jeanie. "Look at the Writing on the Wall: Barbara Kruger Opens Soon at the Hirshhorn." *Smithsonian Magazine*, August 6, 2012. https://www.smithsonianmag.com/smithsonian-institution/look-at-the-writing-on-the-wall-barbara-kruger-opens-soon-at-the-hirshhorn-14015401/.

Rosenbaum, Ron. "Barbara Kruger's Artwork Speaks Truth to Power." *Smithsonian Magazine*, July/August 2012, 20–24.

Wahjudi, Claudia. "Art and Press." *Kunstforum*, no. 215 (April/June 2012): 276–79.

Weil, Rex. "Barbara Kruger." *Artnews* 111, no. 11 (December 2012): 116.

2011
"Barbara Kruger—The Globe Shrinks," *Artlyst*, April 26, 2011. https://www.artlyst.com/whats-on-archive/barbara-kruger-the-globe-shrinks-sprth-magers-london/.

Field, Emma. "Barbara Kruger." *Big Issue*, May 2, 2011, 32.

Hug, Catherine. "Barbara Kruger." *Bad Day*, November 2011, 80–91.

Huther, Christian. "Barbara Kruger." *Kunstforum*, no. 207 (March/April 2011): 332–33.

Marcus, Jacqueline. "Barbara Kruger: The Globe Shrinks, 2010." *i-D*, April 21, 2011.

Roux, Caroline. "Slogans That Shake Society." *The Independent, Viewspaper*, May 9, 2011, 18–19.

Stoeber, Michael. "Barbara Kruger." *artist*, no. 86 (February/May 2011): 34–41.

Ziegler, Ulf Erdmann. "Ultrafett: In Frankfurt stellt Barbara Kruger allein eine komplette Demo dar." *Monopol*, no. 2 (February 2011): 102.

2010
"Barbara Kruger." *Monopol*, no. 9 (September 2010): 103.

Frankel, David. "Barbara Kruger: Mary Boone Gallery." *Artforum* 48, no. 10 (Summer 2010): 348.

Maak, Niklas. "Der Mond ist nicht nur schön, er ist auch weit weg." *Frankfurter Allgemeine Zeitung*, September 4, 2010, 35.

McLean-Ferris, Laura. "A Sloganeer Who Continues to Cut It." *The Independent*, January 7, 2010, 16.

Poostchi, Becky. "Barbara Kruger." *POP*, September 2010, 118–20.

Robecchi, Michele. "Barbara Kruger. Sprüth Magers London." *Flash Art*, no. 270 (January/February 2010): 92.

Spears, Dorothy. "Resurgent Agitprop in Capital Letters." *New York Times*, August 24, 2010. https://www.nytimes.com/2010/08/29/arts/design/29kruger.html.

Index

Page numbers in italics denote illustrations. Works of art are by Barbara Kruger, unless otherwise indicated.

Contributors

Peter Eleey is the curator of Barbara Kruger's commission for The Donald B. and Catherine C. Marron Atrium at The Museum of Modern Art, New York. He was previously Chief Curator of MoMA PS1, where he organized more than forty exhibitions between 2010 and 2020, including *Theater of Operations: The Gulf Wars 1991–2011* (co-organized with Ruba Katrib).

Robyn Farrell is Associate Curator of Modern and Contemporary Art at the Art Institute of Chicago. Since joining the museum in 2013, she has worked on exhibitions and special projects with artists including Kara Walker (2013), Amar Kanwar (2013), Monika Baer (2014), Anri Sala (2015), Frances Stark (2015), Kemang Wa Lehulere (2016), Andrea Fraser (2016), Rodney McMillian (2017), Cauleen Smith (2018), Martine Syms (2018), and Moyra Davey (2019). In 2019, she co-organized the Chicago presentation of *Gregg Bordowitz: I Wanna Be Well* with Solveig Nelson.

Michael Govan is the CEO and Wallis Annenberg Director at the Los Angeles County Museum of Art.

Rebecca Morse is Curator in the Wallis Annenberg Photography Department at the Los Angeles County Museum of Art. Recent projects include *Larry Sultan: Here and Home* (2015), *Sarah Charlesworth: Doubleworld* (2018), and *Thomas Joshua Cooper: The World's Edge* (2019). Upcoming projects include *Objects of Desire: Photography and the Language of Advertising*, which examines the ways in which artists have mined the language of commercial photography for their own work.

James Rondeau is President and Eloise W. Martin Director of the Art Institute of Chicago.

Dr. Zoé Whitley is Director of Chisenhale Gallery, a contemporary art gallery in London. Previously, she was Senior Curator at London's Hayward Gallery at Southbank Centre. In 2019, she curated Cathy Wilkes's British Council commission in the British Pavilion at the 58th Venice Biennale.

Published in conjunction with the exhibition BARBARA KRUGER: THINKING OF ~~YOU~~. I MEAN ~~ME~~. I MEAN YOU. at the Art Institute of Chicago (April 25–August 23, 2021) and Los Angeles County Museum of Art (October 3, 2021–May 22, 2022), and a related site-specific installation at The Museum of Modern Art, New York (July 2, 2022–January 2, 2023).

The exhibition was organized by the Art Institute of Chicago, the Los Angeles County Museum of Art, and The Museum of Modern Art, New York.

At the Art Institute of Chicago, lead support for this exhibition is generously provided by Liz and Eric Lefkofsky.

Major funding is contributed by The Andy Warhol Foundation for the Visual Arts, Margot Levin Schiff and the Harold Schiff Foundation, Shawn M. Donnelley and Christopher M. Kelly, Constance and David Coolidge, and the Auxiliary Board Exhibition Fund.

Additional support is provided by Helyn Goldenberg and Michael Alper and the Susan and Lewis Manilow Fund.

Members of the Luminary Trust provide annual leadership support for the museum's operations, including exhibition development, conservation and collection care, and educational programming. The Luminary Trust includes an anonymous donor; Neil Bluhm and the Bluhm Family Charitable Foundation; Jay Franke and David Herro; Karen Gray-Krehbiel and John Krehbiel, Jr.; Kenneth C. Griffin; Caryn and King Harris, The Harris Family Foundation; Josef and Margot Lakonishok; Robert M. and Diane v.S. Levy; Ann and Samuel M. Mencoff; Sylvia Neil and Dan Fischel; Anne and Chris Reyes; Cari and Michael J. Sacks; and the Earl and Brenda Shapiro Foundation.

At the Los Angeles County Museum of Art, the exhibition is presented by

This exhibition is part of The Hyundai Project at LACMA, a joint initiative between Hyundai Motor Company and LACMA since 2015.

Itinerary
The Art Institute of Chicago
April 25–August 23, 2021

Los Angeles County Museum of Art
October 3, 2021–May 22, 2022

The Museum of Modern Art,
New York
July 2, 2022–January 2, 2023

Copublished in 2021 by
Los Angeles County Museum of Art
5905 Wilshire Boulevard
Los Angeles, CA 90036
(323) 857-6000
www.lacma.org
and
DelMonico Books · D.A.P.

Available through
ARTBOOK | D.A.P.
75 Broad Street, Suite 630
New York, NY 10004
artbook.com
delmonicobooks.com

For LACMA
Publisher: Lisa Gabrielle Mark
Editor: Polly Watson
Proofreader: Claire Crighton
Rights and reproductions:
Dawson Weber, with Sarah Applegate
Administrative support: Tricia Cochée
Designers: IN-FO.CO (Adam Michaels, Marina Kitchen)

For DelMonico Books
Production Director: Karen Farquhar

This book is typeset in Unica77 LL and Times Ten.

Library of Congress Cataloging-in-Publication Data
Names: Eleey, Peter, editor. | Farrell, Robyn, editor. | Govan, Michael, editor. | Morse, Rebecca, editor. | Rondeau, James, editor. | Whitley, Zoé. Enough about you. | Art Institute of Chicago, organizer, host institution. | Los Angeles County Museum of Art, organizer, host institution. | The Museum of Modern Art (New York, N.Y.), organizer, host institution.
Title: Barbara Kruger : thinking of you, I mean me, I mean you / edited by Peter Eleey, Robyn Farrell, Michael Govan, Rebecca Morse, James Rondeau ; essays by Peter Eleey, Robyn Farrell, Michael Govan, Rebecca Morse, James Rondeau, Zoé Whitley.
Other titles: Barbara Kruger (Los Angeles County Museum of Art)
Description: Los Angeles, California : Los Angeles County Museum of Art ; Munich ; New York : DelMonico Books·D.A.P., 2021. | "Special syllabus section with introduction by Rebecca Morse." | Includes bibliographical references. | Summary: "Published in conjunction with the exhibition Barbara Kruger : thinking of you, I mean me, I mean you at the Art Institute of Chicago (April 25-August 23, 2021) and Los Angeles County Museum of Art, Los Angeles, California (October 3, 2021-May 22, 2022), and at The Museum of Modern Art (July 2, 2022-January 2, 2023)"-- Provided by publisher.
Identifiers: LCCN 2020038058 | ISBN 9781942884774 (hardcover)
Subjects: LCSH: Kruger, Barbara, 1945---Exhibitions. | Words in art--Exhibitions. | Political art--United States--Exhibitions.
Classification: LCC N6537.K78 A4 2021 | DDC 700.92--dc23
LC record available at https://lccn.loc.gov/2020038058

A CIP record for this book is available from the British Library